THE HOUSE & GARDEN BOOK OF
KITCHENS & DINING ROOMS

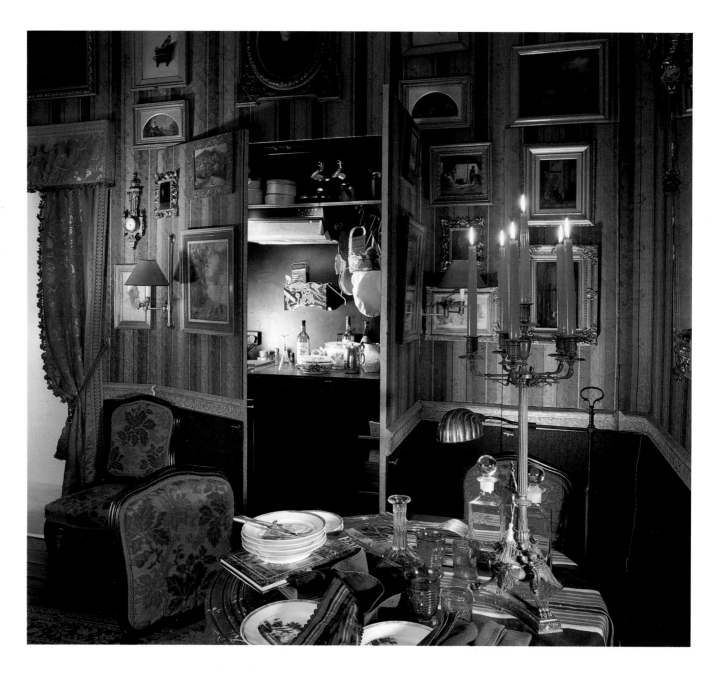

The kitchen opening off a dining room in a flat decorated by Christophe Gollut was once a corridor and measures less than two metres by three-quarters of a metre. It makes the most of every bit of space; even behind the refrigerator there is a 'trough' for bottles. The double doors are designed to integrate with the dining-room scheme, complete with pictures. Colin Radcliffe's plan for a kitchen (opposite) for Olga Polizzi had to take into account durability – it needs to be able to cope with entertaining fifty or sixty people at one time – and generous wine storage. The units, including the handles, are made entirely of stainless steel; the frosted glass inset in the doors was laminated to make it shatterproof. The high-level wine rack holds 400 bottles and is reached by a ladder which slides along a rail. The lighting is by low-voltage, car light bulbs; the floor is Westmorland green slate.

THE HOUSE & GARDEN BOOK OF
KITCHENS & DINING ROOMS

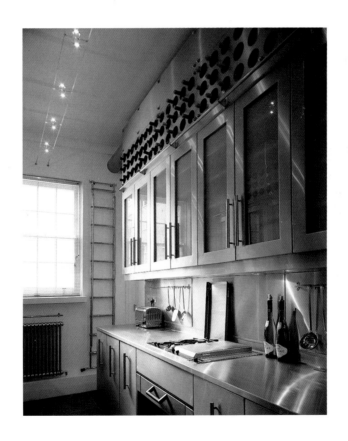

LEONIE HIGHTON

EBURY PRESS
LONDON

First published in 1999 by Ebury Press, Random House, 20 Vauxhall Bridge Road, London SW1V 2SA

Random House Australia (Pty) Limited, 20 Alfred Street, Milsons Point, Sydney, New South Wales 2061, Australia

Random House New Zealand Limited, 18 Poland Road, Glenfield, Auckland 10, New Zealand

Random House South Africa (Pty) Limited, Endulini, 5a Jubilee Road, Parktown 2193, South Africa

Random House UK Limited Reg. No. 954009

A CIP catalogue record for this book is available from the British Library.

Designed by Alison Shackleton

ISBN 0 09 186570 0

Printed and bound in Singapore by Tien Wah Press

CONTENTS

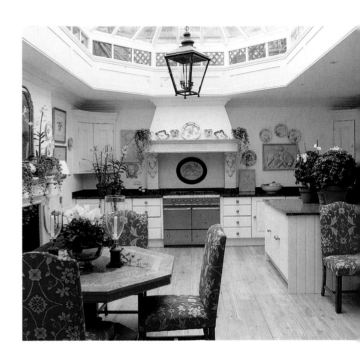

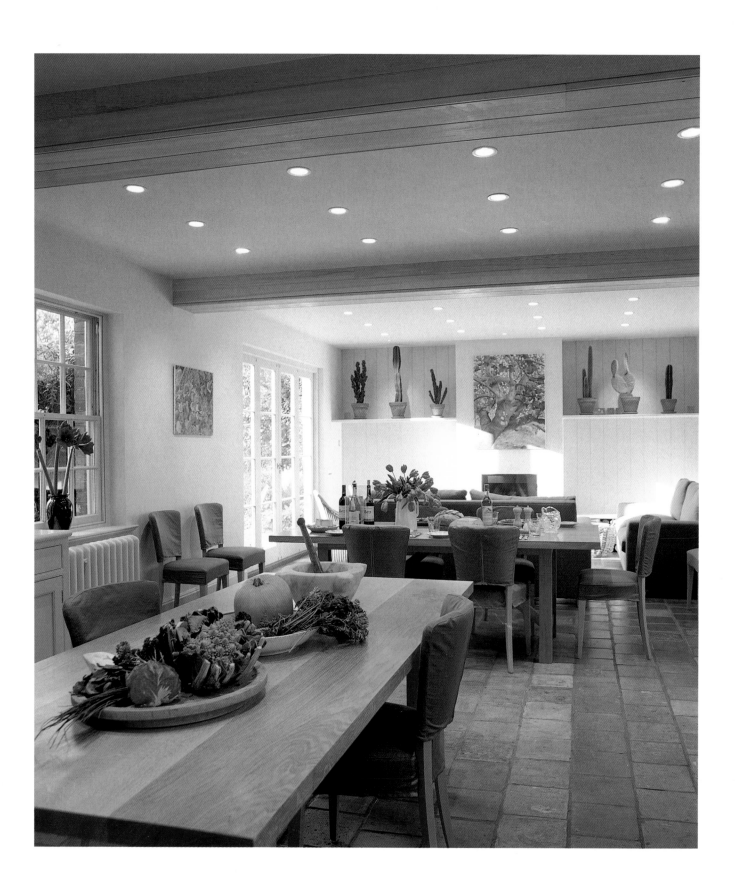

INTRODUCTION

There is no such thing as a home – a *real* home, that is – without a kitchen. It may consist of little more than a means of heating food but, since man progressed beyond a diet of raw plants and meat, a kitchen has been central to his life. Even cavemen and early nomads had kitchens of a sort, as one of their first priorities was to build a fire – not just for warmth and scaring off wild animals but for use in cooking. Such primordial kitchens had minimal equipment but they supplied the means to turn food into something more interesting than mere nourishment for survival. They made eating more enjoyable and they provided a social focus around which the family and tribe could gather.

As life became more organized and the need to be on the move receded, the concept of a permanent, 'built' home developed and, within it, a fixed place where food could be prepared. In a way, those early kitchens *were* the home, as all life was conducted in a single room, with food at its heart.

The kitchen is still the heart of the home. However sophisticated we like to consider ourselves, and however successfully some people have turned the way they cook and eat into an artform, we are fooling ourselves with these refinements: behind the rituals is the basic, animal need for food. Even the richest of rich cannot escape this fact, though there is no denying that good food and a well-designed room in which to prepare and consume it are major enhancements to our lifestyle.

For the rich man with a large house, the possibility of having a separate kitchen has existed for centuries but a separate dining room was not considered important until comparatively recently. In medieval times, grandees saw no reason not to eat in the all-purpose Great Hall, and the early Georgians simply set up tables in whatever room they fancied. It was not until the late eighteenth and early nineteenth centuries that houses were laid out with designated dining rooms. From then on, every sophisticated household regarded a separate place for eating as essential – though, paradoxically, there is now a definite move away from this towards incorporating the dining area in the kitchen.

But whether cooking and eating take place in the same room or in separate spaces, the interior decoration is crucial. It creates a mood which can have a noticeable effect on the room's occupants. Every interior is more than the sum total of its parts: it has a discernible 'spirit'. Look at the interiors reproduced

In Gilly and Geoffrey Newberry's late-Georgian house in East Anglia, the kitchen was extended and redesigned by Geoffrey to create a large, family room with a cooking area at one end and a sitting area at the other. In the middle are two oak trestle tables (also designed by Geoffrey) that can be placed together to form one big table for parties. The table at the kitchen end (foreground) is for food preparation and family meals; the further one is used if the Newberrys simply decide they would rather be 'away from the cooking' or are entertaining informally. (The house also has a separate dining room.) The scheme succeeds in being modern whilst sitting easily within an old building.

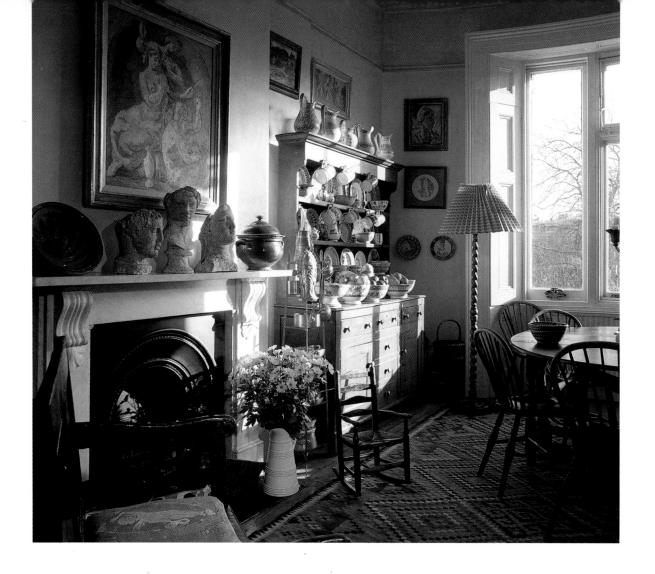

The kitchen/dining area shown above was designed specifically to have the friendliness and intimacy of a family room rather than a functional workspace. Contributing to the warm, comfortable mood are a dresser laden with china and an original Victorian chimneypiece, plus numerous other elements – such as a standard lamp, colourful rug and paintings – normally associated with sitting rooms. One of the most remarkable features of the room is the collection of art and objects by the Bloomsbury Group. Warmth also characterizes the striking kitchen (opposite) in a flat in Geneva decorated by Françoise de Pfyffer, where the once rather clinical-seeming walls have been given a radiant glow with deep-red paintwork and floral pictures. The double sink is let into a central, marble-topped workbench-cum-bar housing a dishwasher and other appliances.

in this book and note their ambiences, not simply their layouts, colours and individual pieces of furniture. When you are decorating, you should aim to balance functionalism – especially important in kitchens, of course – with aesthetics and mood. And you need to have in mind right from the outset just what that feeling is to be: lively, cosy, serene, stimulating, reassuring, or maybe a combination which can be altered by, for example, skilful lighting.

This book is not intended to be a technical manual for kitchen planning – it is to do with decoration – but there are certain fundamentals which should be

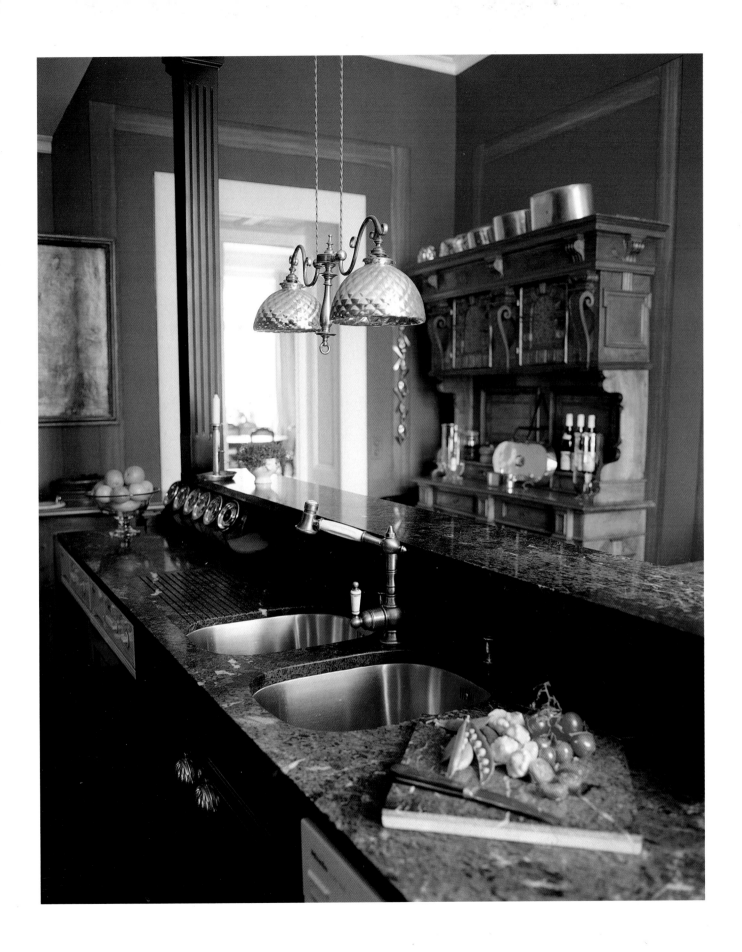

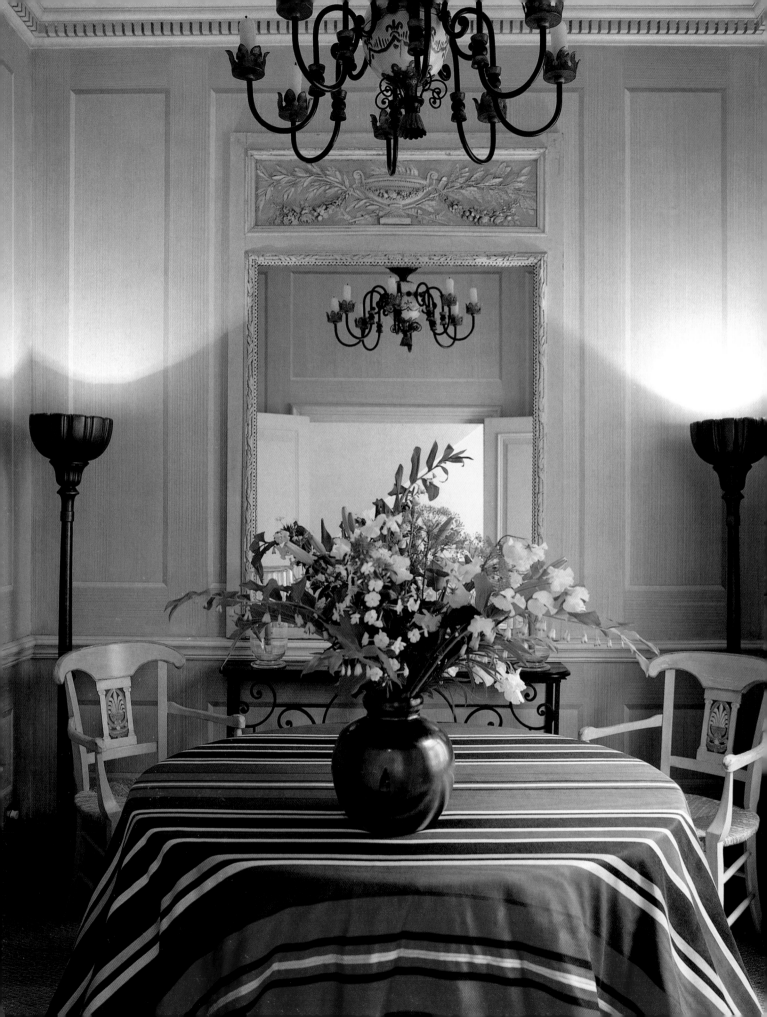

taken into account. A kitchen is primarily a practical room which must 'work' in more than one sense: the overall plan has to be safe and efficient for the cook to operate in; and each component must do its task effectively. Although the basic rules governing the layout of an easy-to-use kitchen remain constant, there is now so much high-tech equipment to be included that the design of a kitchen is no longer simply a matter of ensuring everything is within comfortable reach, worktops are at the right height, there are heat-proof surfaces near the hob and oven on which to rest hot dishes, and heavy pans of boiling water do not have to be carried a long way to the sink. It goes without saying these are still important considerations, but they are now only half the story. Many cooks want, for instance, a professional-scale cooker and an extra-large, 'American-style' fridge, as well as a microwave oven and dishwasher. All these things have led to more space being devoted to the kitchen – as well as more thought to its looks.

The appearance of kitchens has become much more influenced by fashions in interior decoration generally, not only by what is smart in other areas of the house but by trend-setting restaurants where the design of the interior is a crucial element in their success. In many restaurants, the kitchen – or, at least, part of it – is exposed to view, and the sight of gleaming stainless steel has had a major impact on the choice of finishes in domestic kitchens. There are many instances shown in this book, one of the most stylish being the room designed by Brian Murphy and Fro Vakili for Patrick Prinster, shown on page 26, but perhaps the most direct example is the converted schoolhouse owned by Julian and Melanie Metcalfe. Julian Metcalfe started the stylish, fast-food chain, Prêt à Manger, the interiors of which are characterized by aluminium floor plate. You will see the same material in his own home on pages 98-101.

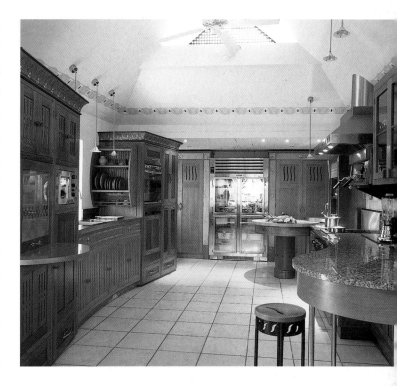

Formerly a small, dark, internal kitchen off a hall, the dining room (opposite) designed by Dominique Lubar overcomes the spatial disadvantages by having a dramatic edge, engendered by the bold fabric and pools of light cast up in the corners. (The new kitchen in the same flat is shown on pages 20-21.) Lighting is also a significant feature in the kitchen designed by Johnny Grey for the Caribbean holiday house of Felix Dennis. A series of small hanging lamps and recessed ceiling lights defines the outline of the room and illuminates the work surfaces while, by day, natural light beams down from the skylight. As there is 95 per cent humidity on the island, the American walnut cabinets have been designed to allow air to circulate through pierced panels. The choice of materials and the overall feel of the scheme skilfully arrive at a half-way point between a professional kitchen for a resident chef and a room for domestic enjoyment by the family.

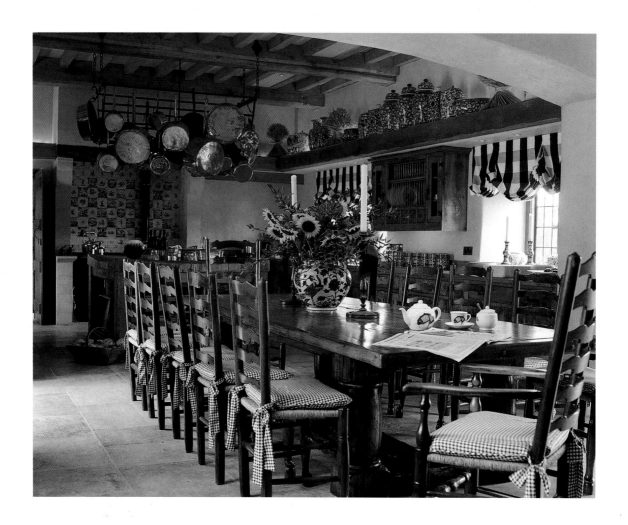

Copper pans and jelly moulds, a reassuringly solid table and rush-seated ladderback chairs all work together to create the quintessential, English, country kitchen. Check cushions and blinds add to the pleasing informality of a large room – the table can seat twelve –which emits a tangible feeling of hospitality. The scheme was devised by interior designer Alison Henry for her own house in the Cotswolds.

In fact, food has become such a fashion item that it has effected the way in which we arrange the entire cooking/eating side of our lives. Many families now prefer to have an open-plan kitchen and dining area which is big enough for everyone to be together in while the food is being prepared, not just at family meal times but when there are guests, too. There is a certain chic in having so-called 'casual' supper parties rather than more formal dinner parties – but only if the kitchen/dining area is well planned and decorated.

The two parts of the room can be integrated by using the same decorative elements throughout or they can be given a subtle feeling of separation by using different, though harmonizing, colours and finishes. The rooms in this book show inspirational ideas for both approaches, ranging from the vivid red-throughout scheme by Jane Taylor and Richard Parr shown on pages 62-65 to the soft-white kitchen on pages 76-77, where the dining area has the same basic colouring but with an infusion of green.

In some situations, it is more logical to have a separate kitchen and dining room, either because the owners' lifestyle demands it or because the layout and scale of the house make it impossible to create an all-in-one room. In this case, the dining room can be more formal in its decoration: there is no technical machinery in view, and therefore no aesthetic conflicts, but, even so, the old, stuffy styles once much favoured are no longer attractive nor conducive to present-day ideas of enjoyment.

Enjoyment of interior decoration is what this book is all about. It is broadly sorted into six chapters, all of which illustrate in some form or another the dining aspect of our lives, either as part of a kitchen or in a specially designated room. The first and longest chapter covers combined kitchen and dining areas. In the main, these are generously proportioned rooms and many of them are sufficiently sophisticated in their appearance to allow them to be used for parties as well as for family meals. Inevitably, they have an informal air but they are all highly considered and adapt easily for social occasions. Some have a modern appearance derived primarily from the choice of surface finishes – such as sleek metal and plain, pale wood, – and the advanced technological character of the 'machinery'. Others feel more homely or are hybrids, successfully mixing both styles.

Then there is a chapter covering kitchens that not only include a dining area but also comfortable seating. In some examples, the sitting area is supplementary to the main sitting room but, in others, it provides the only seating in the house. These totally open-plan rooms are living areas in the widest sense: in many ways, they represent a way of life thoroughly in keeping with today. The interior by Nico Rensch (pages 90-93) typifies this: it was designed for a family who had previously lived in a conventional, compartmented manner but felt that

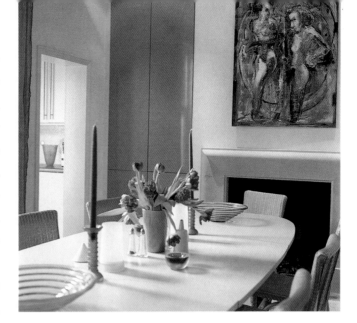

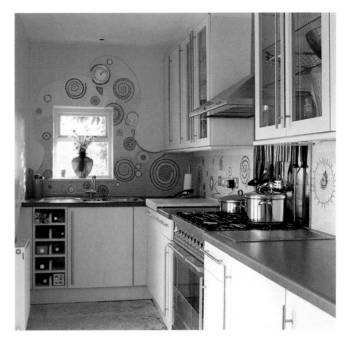

Having been an unashamed traditionalist, interior design consultant Fleur Rossdale 'went modern' and commissioned Charles Rutherfoord to help with her new-image dining room (top). To either side of the fireplace are tall, flush-doored cupboards made from high-sheen, laminated MDF. The kitchen (below) opens immediately off the dining room and was designed by Charles Bateson incorporating a wall decoration by Donna Reeves Mosaics. Reflecting the whirling pattern of some of Fleur's collection of glass vases, the mosaics make an interesting frame for an otherwise unremarkable window.

an all-in-one layout would now suit them better, so they abandoned the traditional floor-plan of their home and transformed it into a modern, open 'shell'.

In contrast, there is a chapter reflecting the fact that some people who live in older houses prefer to keep a sense of continuity by including historical design references, even in the kitchen. The room by Anthony Paine (pages 120-123) takes this stance: he has followed the Arts-and-Crafts style of the house but re-interpreted it in a sympathetic, practical manner for present-day living. Gill Hornby, who lives in a Gothick rectory, has reiterated the pointed-arch motif of its architecture for the kitchen units and dresser, and she has ensured that the room's new windows match the existing ones (page 118-119).

Windows – or, rather, whole walls of glass – are the theme of the chapter devoted to kitchens and/or dining areas with a conservatory ambience. By their nature, these are light, cheerful rooms, Fiona Hindlip's scheme on page 136 makes the point well.

Today, informality is something of a keynote in most rooms where eating takes place. Even in homes with a traditional style of decoration and a separate dining room, this room has tended to become a more relaxed, convivial setting which echoes the current approach to entertaining, as can be seen in the penultimate chapter which deals specifically with dining rooms. These rooms are smart without being intimidating: the schemes on pages 174-177 (designed by Federica Palacios) and 170-171 (by Prue Lane) are typical. Finally, there is a group of rooms that do double duty. Some, as represented on pages 196 and 202, have a combined role as libraries – a practical arrangement with an aesthetic spin-off, since books give such a cosy ambience – while others are halls.

In all these rooms, the decoration is intended to make the surroundings interesting to be in whilst people are eating. What constitutes an 'interesting' style for a dining room is, nowadays, very fluid, but in the past it gave rise to more words of advice than almost any other area of the house. Arbiters of taste – in both uses of the word – had strong views on what was appropriate. Traditionally, red was considered a particularly good background for dining, and portraits were thought to be the right form of art to decorate the walls. Solid colours were deemed better

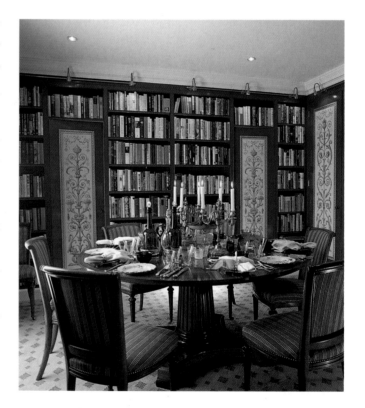

Renowned for her understanding of colour and comfort, interior decorator Nina Campbell has turned the basement of her house in London into a library/dining room (above and opposite) painted in one of her favourite hues, a deep amethyst. Giving the room a dual purpose is not only a practical use of space but the bookish element also infuses visual warmth and interest – something that is lacking in many dining rooms, where the 'chill' of being under-used is all too apparent.

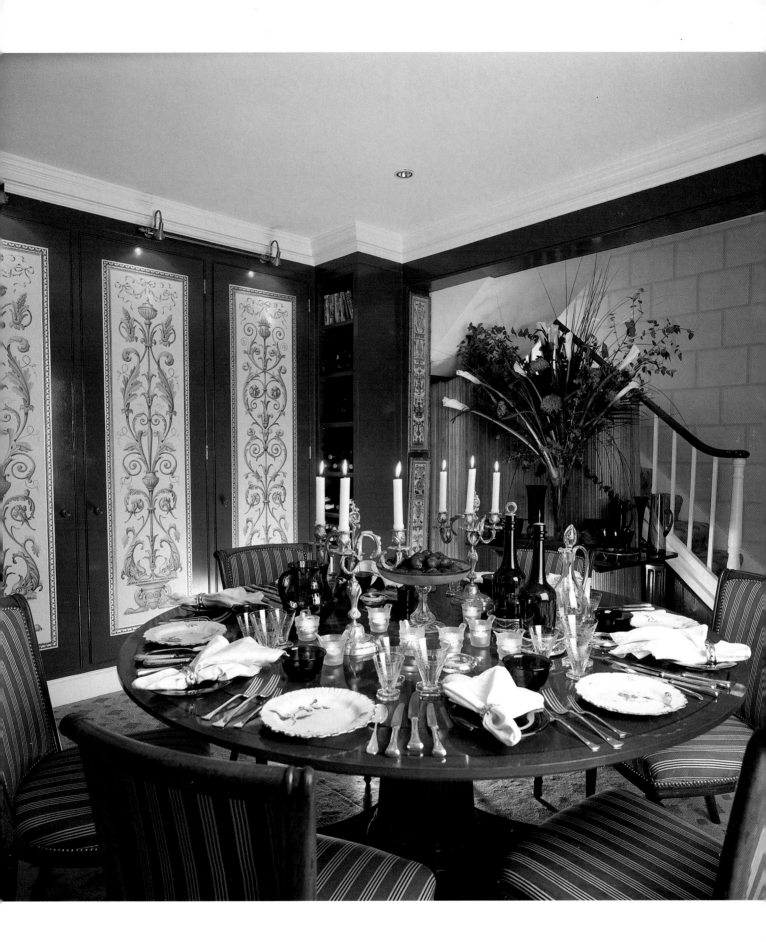

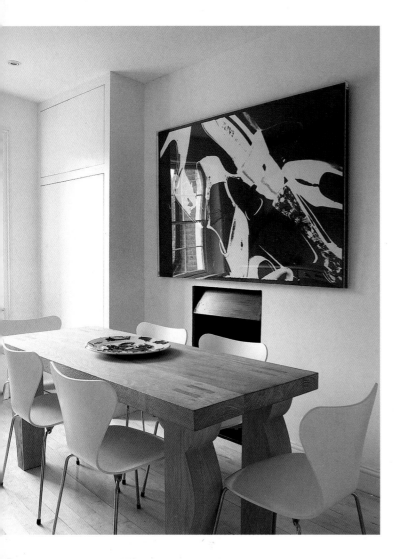

Art dealer Gül Coskun's home in London is also her gallery, specializing in contemporary pictures. The interior is kept simple, so that her clients can wander round without being distracted by the decoration. The dining room has a minimal, hole-in-the-wall fireplace and is furnished with a table inspired by the French, early twentieth-century designer Jean-Michel Frank, making a chunky contrast with the chairs designed in the Fifties by Arne Jacobsen. The black-and-white screen print is by Andy Warhol. (The kitchen, similarly restrained and light, is on pages 30-31.)

than pale colours as, supposedly, they were warmly hospitable and would allow diners to concentrate on the food; and strong patterns were reckoned to be a challenge to the digestion.

Maybe digestions are less sensitive now, as there are no longer any absolutes for decorating dining rooms. People happily eat surrounded by lively patterns and still manage to taste the food. Equally, they may dine in very plain rooms and barely notice what is on their plates. Perhaps the ambience is what really counts. Generally, though, if a room's decoration is too minimal, it can make diners feel uncomfortable – as if they were in some hallowed temple where food is the ultimate deity and comfort or visual considerations are secondary.

Obviously, the table is the single most important piece of furniture in the dining room but it does not have to be an especially good piece. A pretty or elegant cloth can cover a multitude of sins, providing it is chosen to integrate with the room and does not give the impression of being an after-thought. Crisp white linen always looks good and marries as well with classic modern settings as with traditional ones, while the sheen of a more opulent fabric can look fabulous in a formal room, particularly at night with the sparkle of candlelight (see page 152). If you have a dining table made of really fine wood, with a good patina, then it is a shame to hide it. Attractive table mats may be preferable.

Generally, plainish single-colour cloths and mats are easier to put with patterned china, but there are always exceptions: plates with geometric motifs can look fine against a flowery fabric or vice versa, so long as the colours are right. Then there are table decorations. Keep them low – or tall and thin – so that they do not obscure the view across the table.

Well considered lighting is especially important in dining rooms. Some people love candlelight; others

like the sparkle but do not enjoy seeing a naked flame. Candle shades are the answer – but not too many at eye level as they form a barrier across the table. You also have to ensure that there are no bright lights against the walls – such as table lamps – which could be dazzling when people are sitting down and looking straight at them. Dimmer switches are useful here. Overhead lighting is undoubtedly practical – and, again, a dimmer will give the right control for producing an attractive ambience. Picture lights are another means of providing unobtrusive lighting.

Lighting is also one of the most crucial considerations in kitchens. Practicality is essential for safety and efficiency, but there is no need to end up with a cell-like harshness. The room should have a good, overall degree of illumination, supplemented by lighting for specific areas and tasks. So long as they do not cause harsh, uncomfortable contrasts, 'pools' and 'washes' of light give a functional room a more pleasant atmosphere in which to cook.

Of course, what makes a pleasant kitchen depends entirely on your viewpoint. Assuming you have established what functional items you need and where they should be placed, how much storage space is required (probably much more than you originally calculated) and the approximate length of work surface to be included, you then have to decide on the look of the kitchen. This book aims to show some of the possibilities, ranging from a chalet-style wooden scheme in Switzerland (page 58-59) to a high-tech, metal-unit interior in London (page 3). In addition, there are painted illusions (pages 128-129), units made of dark wood (pages 140-141) and of light wood (pages 78-81); there are big rooms, small rooms, conservatories – and many more. There is inspiration for wall finishes, floor finishes, worktops, splashbacks, tiles and blinds. Some rooms are nostalgic, others are forward-looking. All of them offer an

abundance of ideas and have been chosen from the wide range of interiors that have appeared in *HOUSE & GARDEN* magazine.

But however modern a kitchen or dining room may appear on the surface, it still evokes in us a primitive enjoyment, a sense of 'home', satisfying a hunger not solely for food but for companionship and visual stimulation, too.

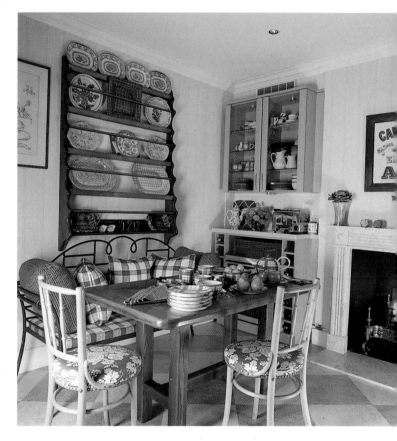

Nina Campbell – whose library / dining room is illustrated on pages 14-15 – has turned a corner of her kitchen into an eating area. Imbued with great charm, it has a fruitwood, country table and a metal bench beneath an antique plate rack. The medley of blue-and-white fabrics and ceramics is cheerful and fresh against the subtly striped, warm-beige wallpaper. The chequered 'stone' floor is linoleum. The wall cupboard and open shelving unit (with wicker storage baskets) match the kitchen units in the opposite corner of the room.

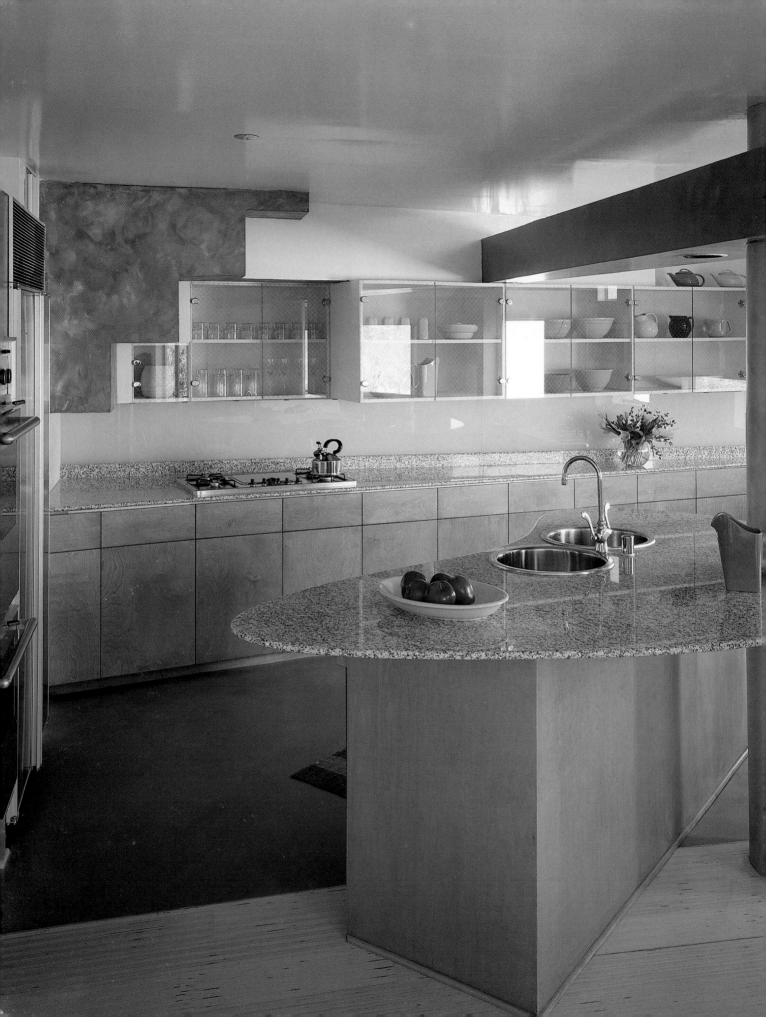

Cooking and Eating

'Eating in the kitchen' means different things in different situations. It can suggest a small table for breakfast or supper – a quick, informal eating area which supplements a separate dining room – or it can be something more significant, the main place for taking meals, both for the family and for entertaining. The kitchens shown in this section all include a table and chairs, but in some cases the emphasis of the room is on its function for cooking, as seen on pages 72-73, while in others (pages 68-69, for instance) the dining aspect is of equal importance. Combining a kitchen and dining area need not impose a particular style of interior decoration, in spite of the fact that cooking inevitably requires equipment with modern lines and practical detailing. Several of the schemes illustrated here ingeniously integrate the kitchen with a dining area that is distinctly traditional: Amanda Hedley's room on pages 22-25 is, perhaps, the most integrated room of all, with the cooking area disguised as a library by using fake books to face the units. Contrastingly, the interior by Will White (pages 40-43), is a thoroughly contemporary scheme with metal panels which can be slid across to screen the cooking. Eating in the kitchen, whatever its style of decoration, may imply a latterday casualness but, contradictorily, an obviously modern room can sometimes seem more formal than a traditional one in which an element of clutter injects a relaxed cosiness.

This scheme in a house in Los Angeles, designed by Craig Hodgetts and Ming Fung for John Bernadello, has an organically-shaped worktop beneath a rectangular, hollow 'girder' which houses lighting. Both features are wrapped round a pillar which rises through the gallery above. The geometric theme of the kitchen is echoed in the deployment of colour to draw out different shapes and planes. Etched glass, used for the splashback, is juxtaposed with clear glass for the wall-unit doors. Alongside the low-level window (which continues the line of the splashback) is an eating area with angular modern furniture.

FAIR **EXCHANGE**

Interior decorator Dominique Lubar, who is in partnership with François Gilles at IPL Interiors, lives and works in London but was born in Paris, and while her style defies being pigeonholed, one can nevertheless detect Continental influences in her rooms. She has no hesitation in putting together contemporary and antique design, as can be seen in this relatively austere kitchen. When she redesigned the apartment, she converted the existing, small, dark kitchen – an internal space off the hall – into a dining room (see page 10) and made what was previously the dining room – a big, light space at the front of the building – into a new kitchen. She did this because the front room is filled with natural light and is therefore well suited to frequent use during the day. In order to maximize the unusual size and clarity of the interior, Dominique kept the windows free of curtains and she lined the walls with an architectural paper

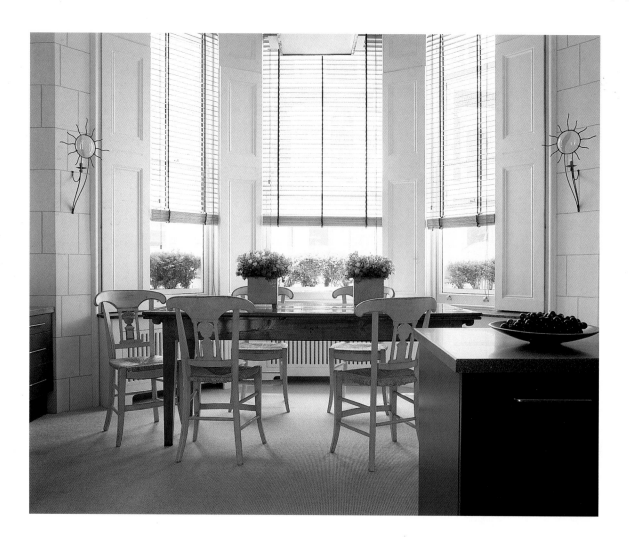

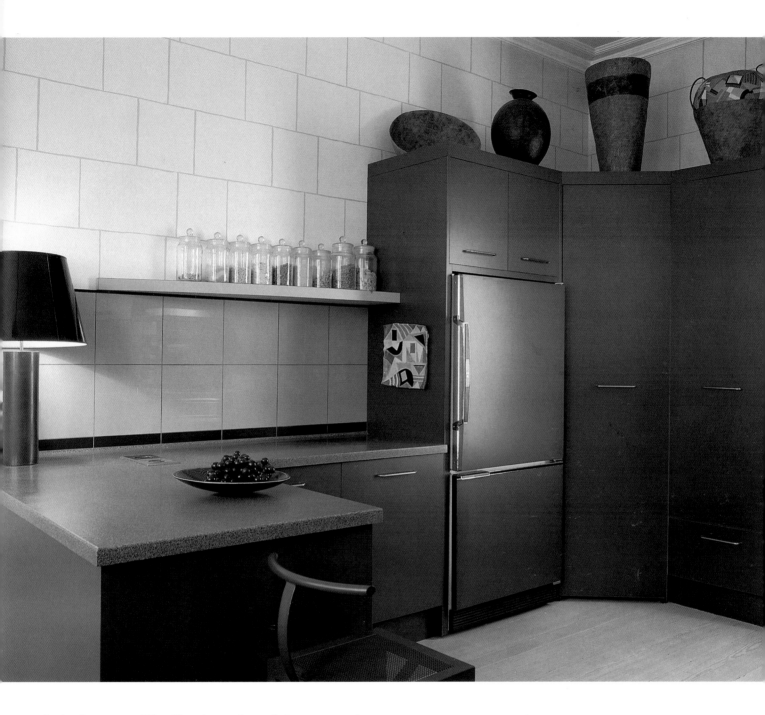

imitating stone. The Continental touch is apparent in the lack of clutter and in the furniture, which includes Provençal chairs. These and a nineteenth-century, polished oak table fill the window bay, to either side of which are modern wall lights by André Dubreuil. The deep-toned kitchen units have a granite worktop and, high up, a display of papier-mâché pots and bowls by Bernadina Lloyd.

■ Rethinking the layout of the apartment has taken advantage of natural light where it is most needed.

■ Large-scale tiles look less fiddly than small ones for a splashback in a comparatively austere setting.

■ Blinds allow the unusually generous size of the windows to be appreciated.

MORE LIKE **A LIBRARY** THAN A KITCHEN

There comes a point in many people's lives when their children have grown up and they no longer need a large, family home. Moving to something smaller is challenging from a practical viewpoint – what to keep from a lifetime's accumulation of possessions and how to re-use them in a different situation – but, for anyone with an interest in interior decoration, it is also a wonderful opportunity to put into practice ideas which, before, had just not been feasible. When Amanda and Martyn Hedley down-scaled to a 1950s house in central London, Amanda Hedley was able to follow up something which had come to mind a while earlier, when she saw some leather book-spines being sold by the metre. 'If I ever have a new kitchen,' she thought, 'I'd like it to look more like a library.' In her new house, the kitchen and dining area take up the whole of the basement which, previously, accommodated the boiler. The floor, which was excavated by two feet in order to gain sufficient ceiling height for comfortable living, is laid with

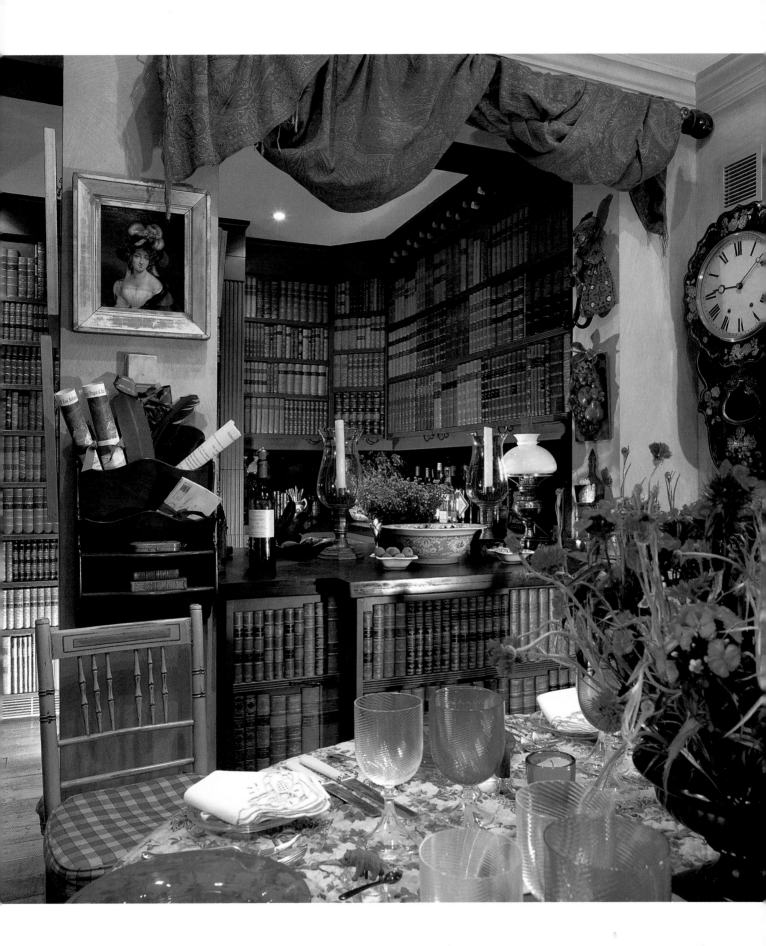

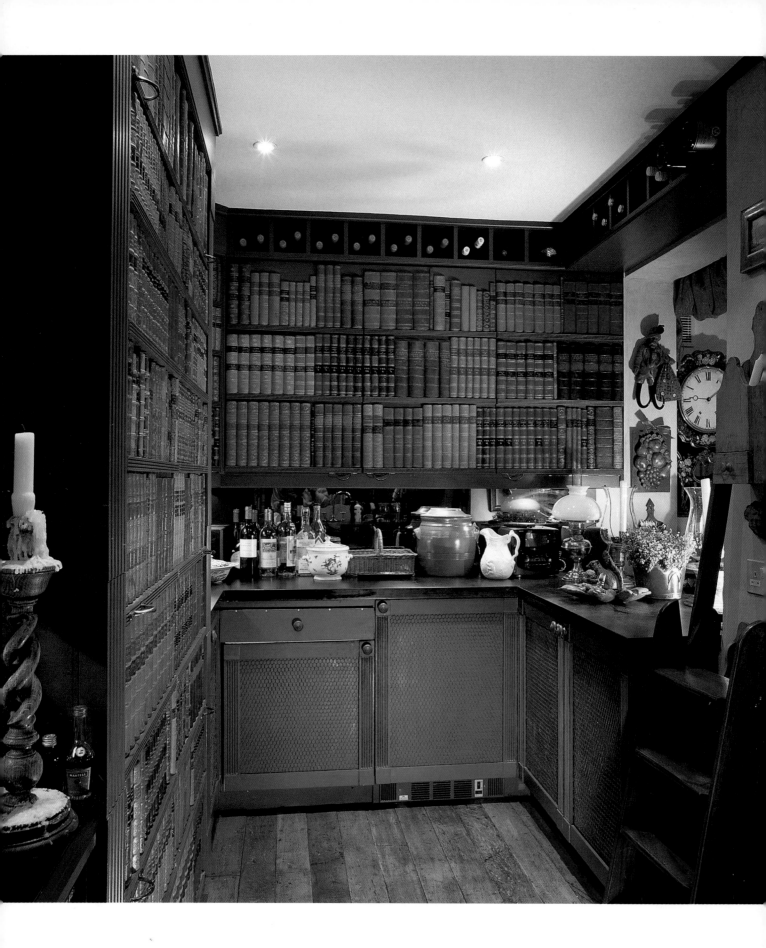

beautifully mellowed floorboards reclaimed from an old army barracks. The kitchen has custom-built floor units painted battleship-grey, overlaid with chickenwire to continue the library theme. The doors of the wall units and full-length cupboards are faced with the fake books; there is even a pair of library steps to enable Amanda to open the ventilator hood (concealed behind 1897 volumes of Punch). Just below the ceiling are open shelves for wine bottles. The walls in the adjoining dining area are painted in a specially mixed colour which reminds Amanda of 'parchment paper from a medieval monastery'. Seating is provided by a comfortable banquette, mak-

ing good use of space in the corner, in conjunction with faux-bamboo chairs. The circular table is covered with a beautiful antique quilt, its colours picked up by the crimson glassware.

■ Dark paint and chickenwire for the kitchen's base units and equipment, such as the dishwasher, plus rows of fake books, create the impression of a library when seen from the dining area.

■ The floor unit in the arch separating the kitchen from the dining area has cupboards accessed from both sides. The top is a useful surface for serving.

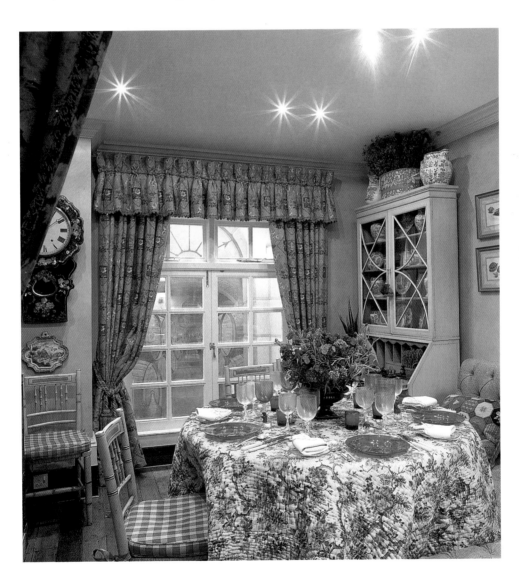

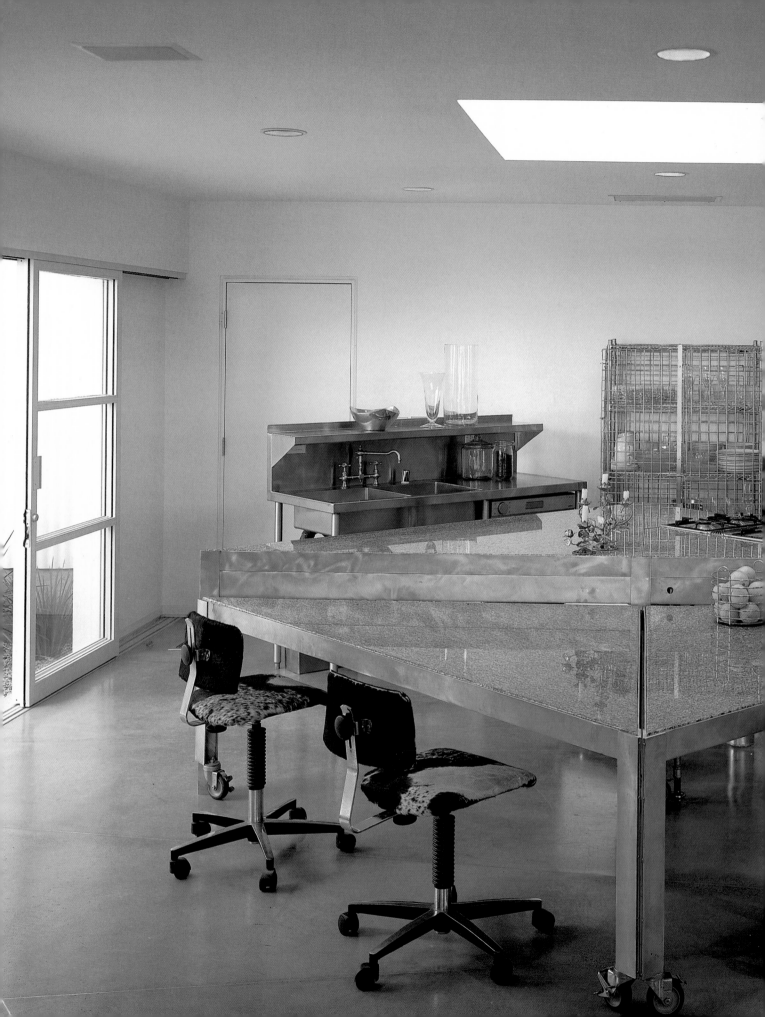

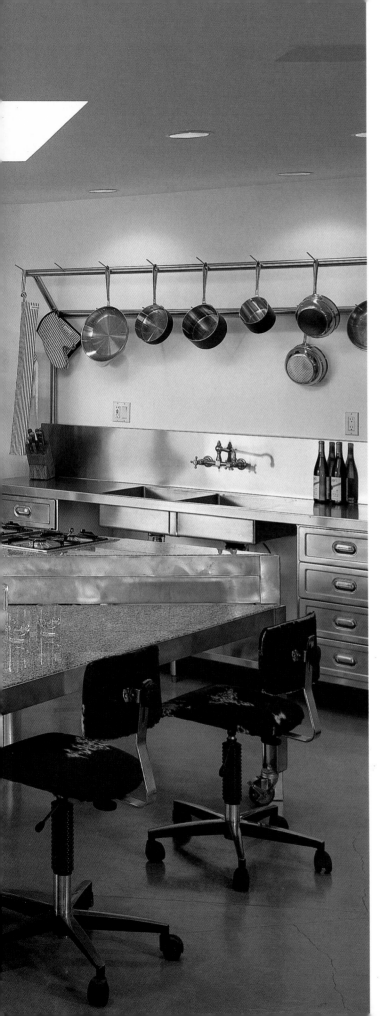

PROFESSIONAL
BUT SOCIABLE

This kitchen is in a remarkable modern house in the Hollywood Hills, designed by Brian Murphy with project architect Fro Vakili for Patrick Prinster. The central living area is a five-and-a-half-metre-high, barrel-vaulted space; to either side of this, the rooms are deliberately low-ceilinged in order to instill a contrasting sense of intimacy and protection. The kitchen is one of these more intimate spaces and was conceived as the hub of the house, both for Patrick Prinster himself and for his guests. It is undeviatingly simple in its execution and uses industrial fittings, but the warm pink-grey of the polished granite counteracts the steeliness of the professional-style equipment and units. On the dining side of the island, which is set at 45 degrees to the room's axis, two triangular-shaped tables on wheels can be swung round and joined together to form a separate table.

■ Two double sinks allow for food preparation, cooking and clearing away to be carried out simultaneously.

■ Chairs on wheels are practical and quiet in a room with a hard-surface floor.

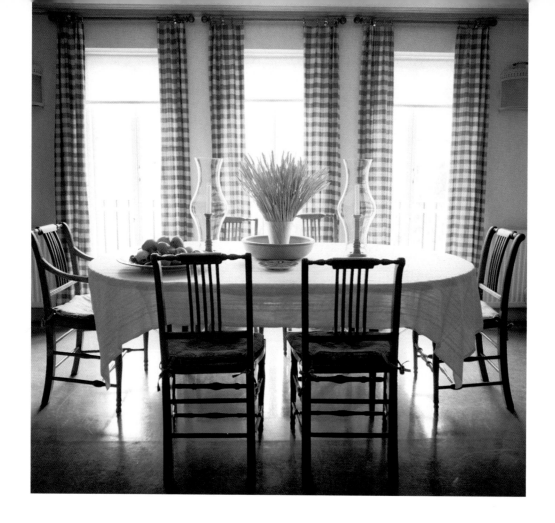

SCANDINAVIAN INTRODUCTIONS

This room is right at the top of a solid, mid-Victorian mansion. The flat's previous decoration scheme was an agreeable combination of warm pinks, dark green and cream, but the owner, though having lived very happily with it for several years, began to find her taste moving towards a lighter, more contemporary look. With the help of Hugh Henry – who had also been involved in the first scheme – she banished the dark colours and here, in the kitchen, introduced a Scandinavian feeling. Natural light pours in through the three large windows, which are hung very simply with blue-and-white check curtains on narrow poles. The walls are painted in the palest grey-blue, with a subtly darker shade used for the cornice. The furniture has an unpretentious, country appearance and includes a freestanding cupboard which is both useful and handsome. An open fire is a cosy focal point.

■ The still-life painting above the chimneypiece has a traditional impact but is hung without a frame, which makes a less formal statement and is more in keeping with a kitchen setting.

■ Uncluttered design and plain surface finishes maintain the room's light atmosphere.

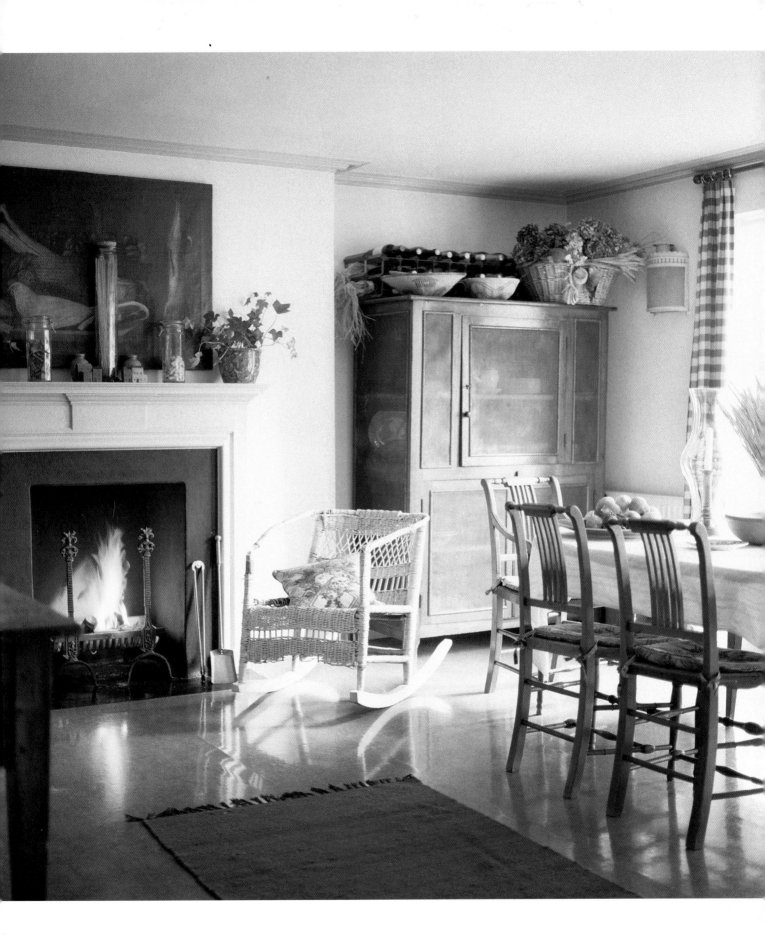

A LIVING – AND WORKING – **ENVIRONMENT**

For Gül Coskun, a dealer specializing in modern and contemporary art, working from home has had a tangible influence on her choice of interior decoration: 'It had to be simple, with plain white walls and pale wooden floors. I wanted an uncluttered background against which each work of art would stand out.' Reflecting this controlled simplicity of style, her kitchen has a double bank of wall units with clean, flat facings in light wood which harmonizes with the floor. The chunky table complements the rectangular format of the room and the linearity of the units. The Fifties-style chairs – now modern classics – are contrastingly lightweight and also feature in Gül Coskun's dining room (see page 16).

■ Plate glass protects the surface of the table whilst allowing the grain of the wood to be enjoyed and giving interesting reflections.

■ An extra-thick table-top confers modernity and presence in a simple setting.

CONCENTRATED **COLOUR**

In order to provide an informal, attractive eating area as an alternative to the main dining room, Carolyn Sheffield has made her kitchen as un-kitchenlike as possible. 'We spend too much time here to want it to look like a kitchen,' she says. The fresh colour scheme of cornflower-blue and white is carried through from the kitchen tiles (which incorporate views of the Sheffields' previous houses, painted by Deborah Sears of Isis Ceramics) to the cabinet, with picked-out mouldings, which is a handsome focal point in the dining part of the room. The group of small pictures and painted accessories (Carolyn Sheffield's company specializes in these) contributes to the room's un-kitchenlike style of decoration.

■ Keeping to the same palette for different surfaces and elements – walls, tiles, plates, furniture – gives a room a strong identity.

■ Unlike a built-in cupboard, a freestanding piece of furniture with an interesting shape can 'make' a room, yet still provide practical storage space.

■ Introducing touches of red, even in small quantities, is an enhancement to many colour schemes.

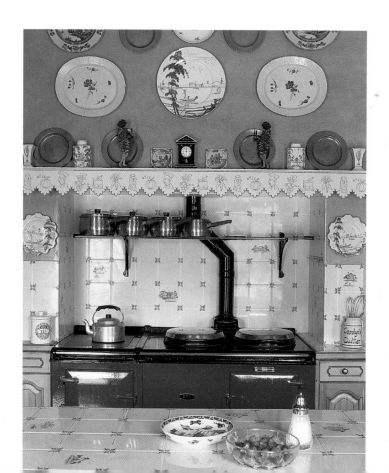

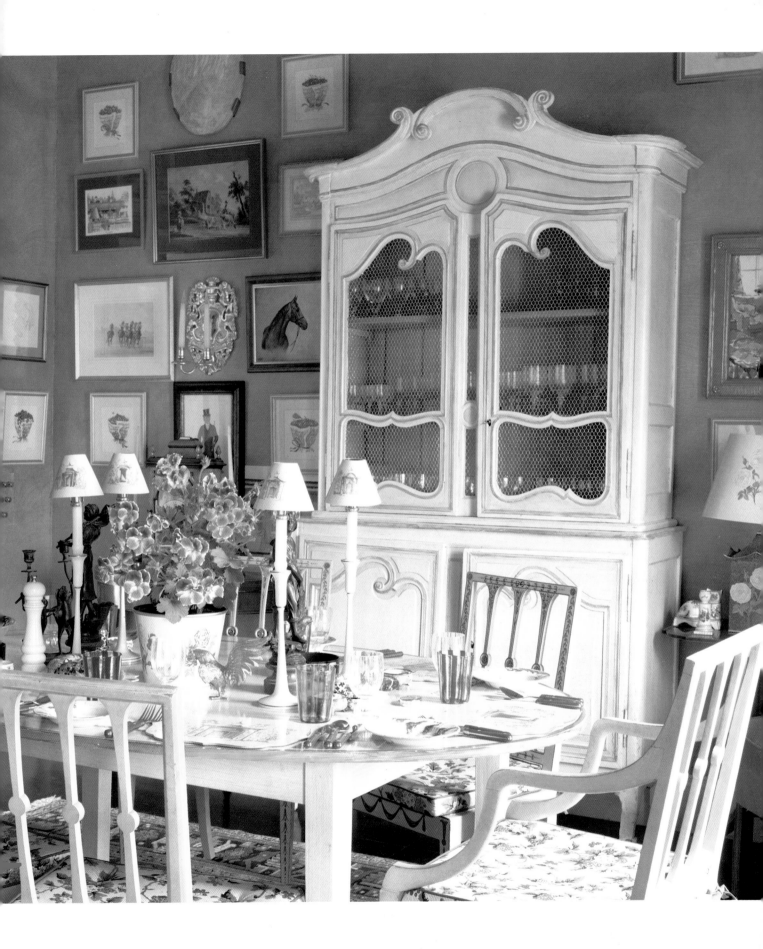

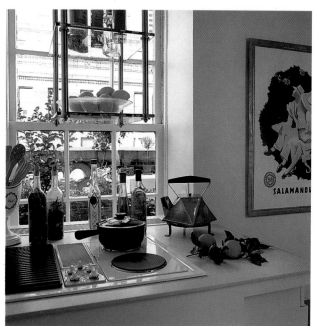

MIXING WITH **AUTHORITY**

Photographer Keith Scott Morton and his journalist/designer wife Chris Churchill live in an apartment on the twelfth floor of a 1920s block on New York's Upper East Side. They have similar ideas on interior decoration, and their home is very much a reflection of their shared taste, but it was Chris who, according to her husband, 'had the confidence to mix styles, and it has paid off.' For the design of the kitchen, they consulted architect Claus Rademacher, who was sympathetic

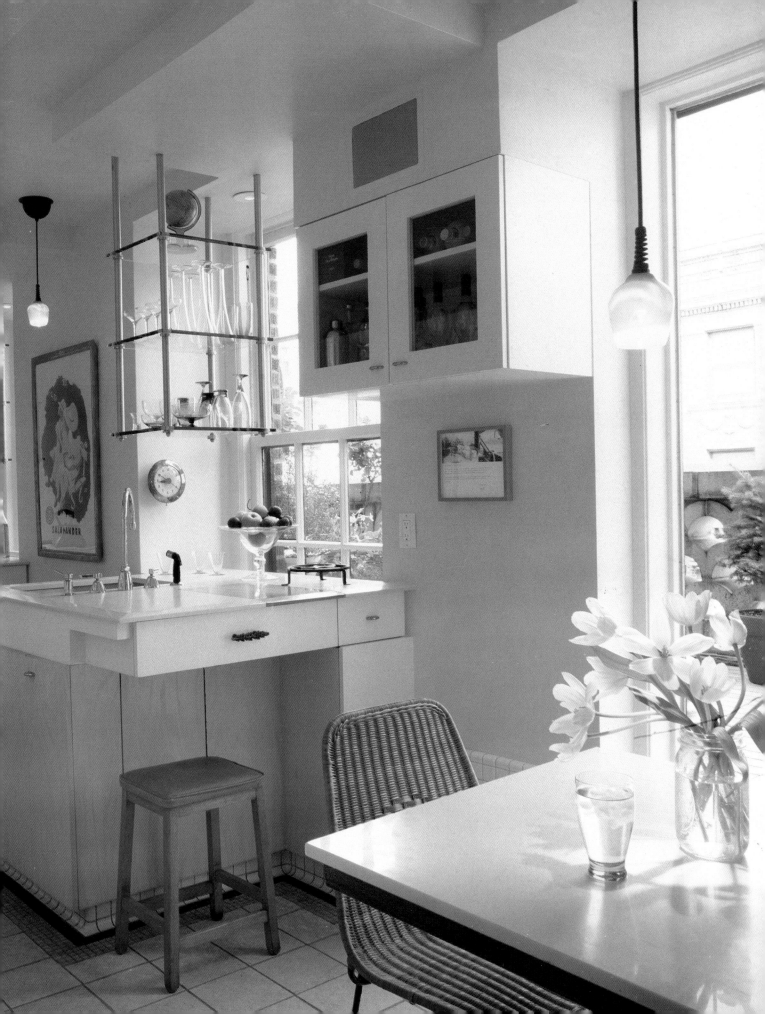

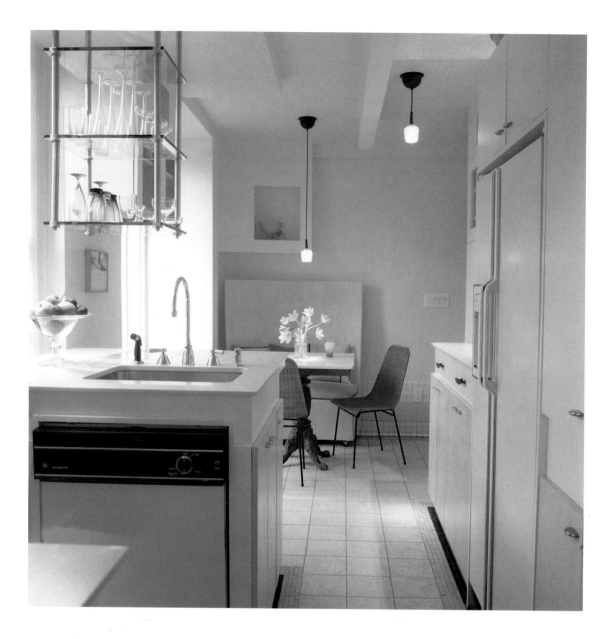

to the room's pre-war date but also understood the need for present-day practicality. The elaborate ceiling was designed to balance – and therefore minimize – the visual bulk of kitchen units, which can often spoil the appearance of a room. 'See-through' shelving, suspended in front of the windows, provides storage space whilst not obliterating natural light. At one end of the room is a small table with a sculptural, high-backed banquette against the wall. Opening off to the right is a terrace, a major luxury in an inner-city situation.

■ Suspended glass shelving in front of the windows provides storage without blocking too much light.

■ A tiled skirting, curved at the join with the floor, facilitates cleaning.

■ A combination of recessed and suspended light fittings gives flexible illumination, both practical and atmospheric.

■ An interesting ceiling configuration draws attention away from the visual bulk of kitchen units.

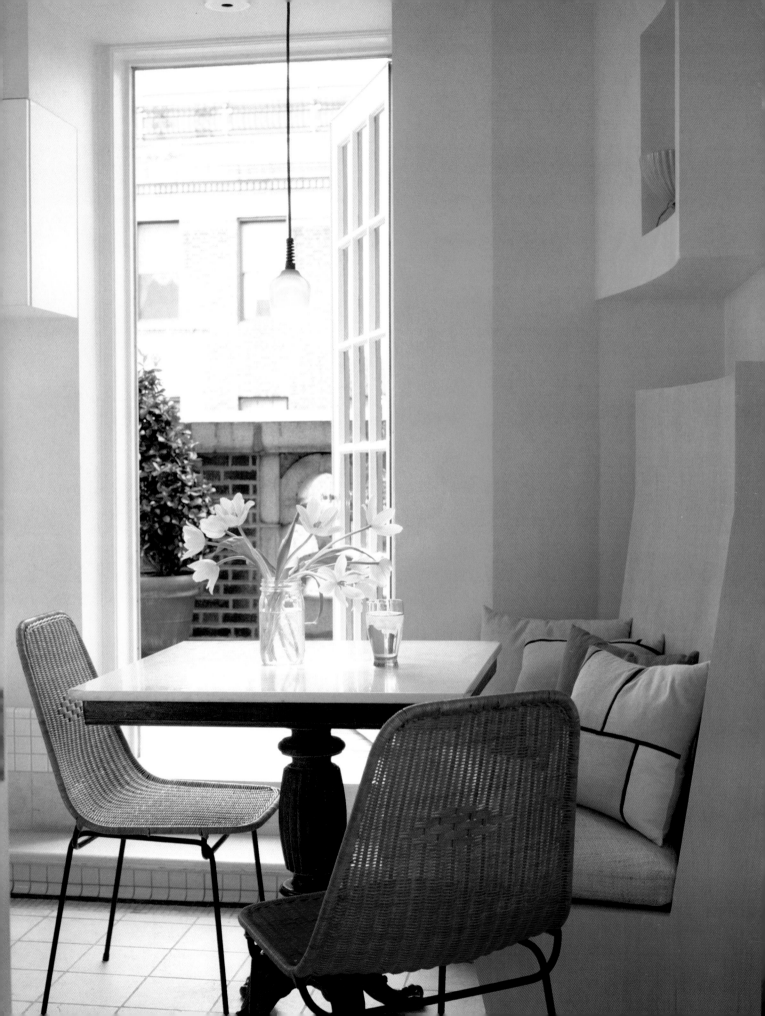

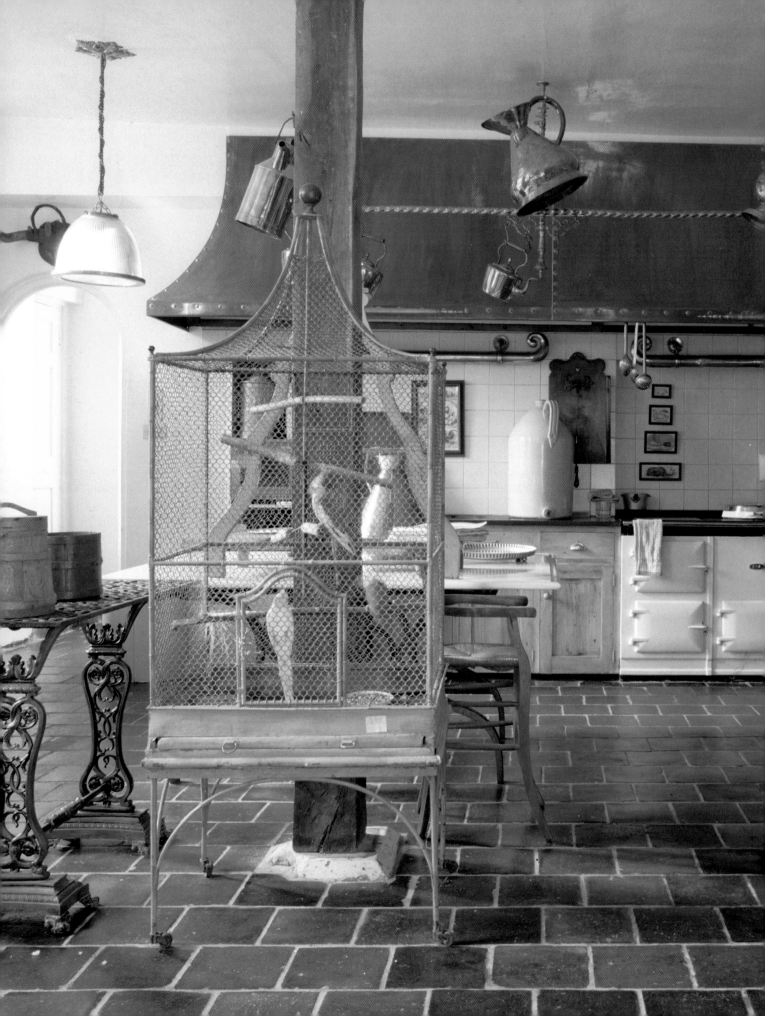

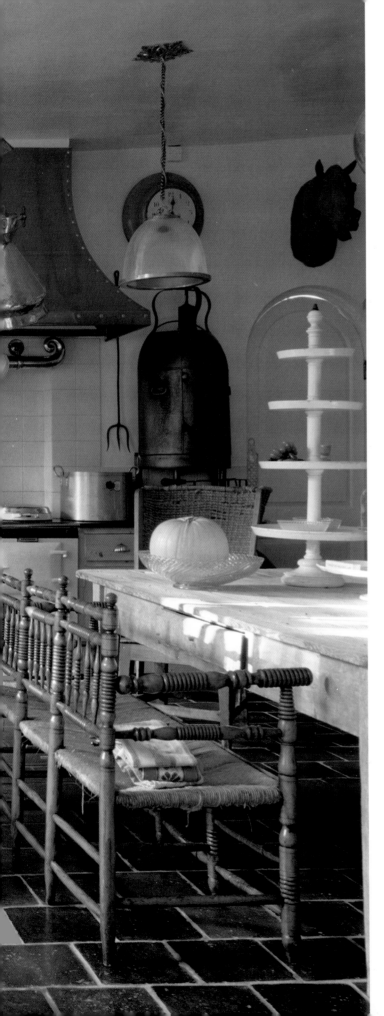

SCALING UP FOR
EFFECT

Antiques dealer Keith Skeel is an inveterate and imaginative collector who has strong ideas on interior decoration. 'I hate any form of starchiness or stiffness in a home – it has to have warmth and atmosphere, otherwise you might as well be living in an art gallery or museum. I don't see any reason why furniture of different periods shouldn't be mixed. For me, there's no such thing as good or bad taste, but what I really dislike is that non-offensive, safe look.' The kitchen he devised for his house in Suffolk more than illustrates his dramatic style. The theatricality of it can be tracked back partly to his preference for 'scaling up' – never flinching from design which is vigorously proportioned. Typically, he installed an enormous copper hood, not just above the Aga but across almost the entire width of the room. A sturdy table contrasts with rush-seated chairs, and an elegant, Victorian aviary houses a pair of cockatiels. The glazed terracotta floor tiles came from a disused mill in Lancashire.

■ Antique copper jugs, hung from the ceiling, make attractive, high-level decoration.

■ The multi-shaded floor tiles are laid in a staggered pattern, rather than in a chequerboard, which effectively breaks up the large expanse.

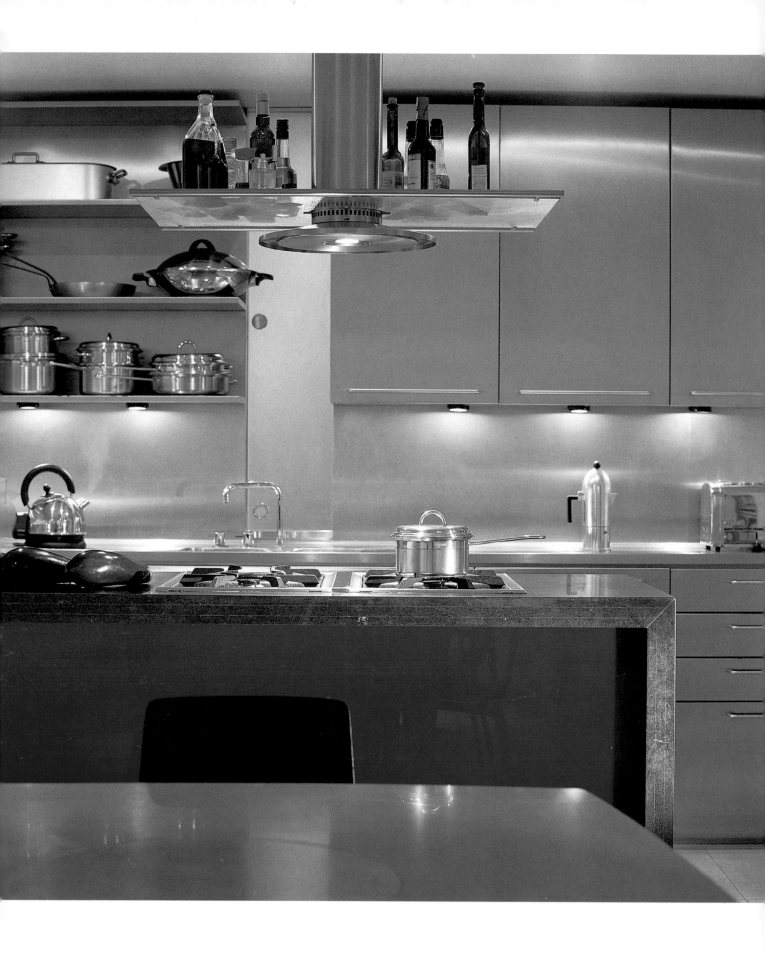

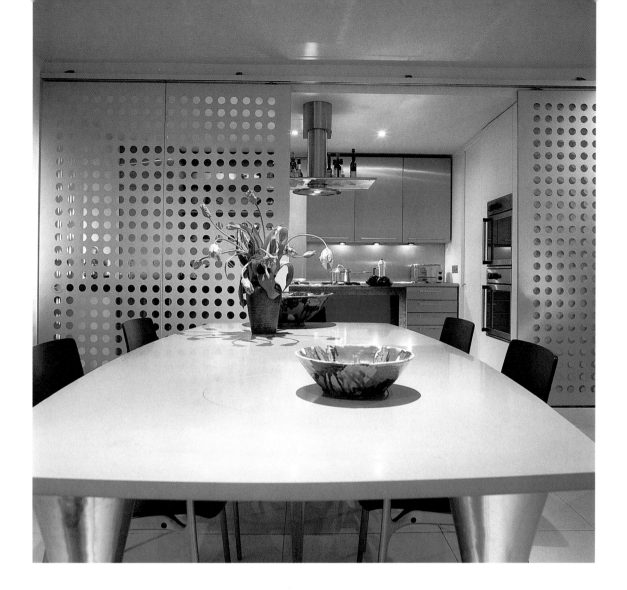

KEEPING THE **OPTIONS OPEN**

In many family homes, a room used exclusively for formal dining would be an inefficient use of space yet there are occasions when eating in the kitchen, with its stove and sink in full view, is inappropriate. This modern kitchen designed by architect Will White is in a Victorian house in London and provides a solution to the problem by having an open plan and a series of sliding panels which can be used to screen the cooking area and create a separate dining room for dinner parties. The panels include a small, glazed one which draws across to divide the kitchen and eating area from the children's room. The larger screens, used to separate the kitchen from the dining area, are made of metal to echo the finish of the kitchen cupboards but are perforated for a lighter feeling and to allow diners glimpses of the kitchen whilst obscuring food preparation and clearing up. The lighting has also been skilfully designed to manipulate these glimpses and accentuate the flashes of bright colour incorporated in the interior design. During the day,

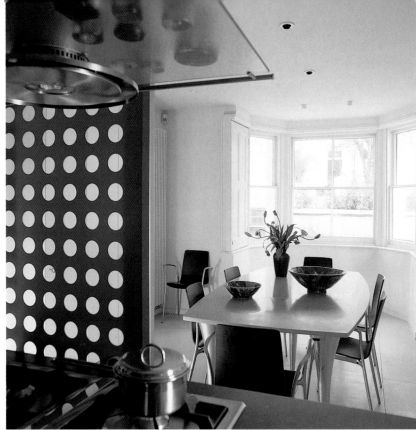

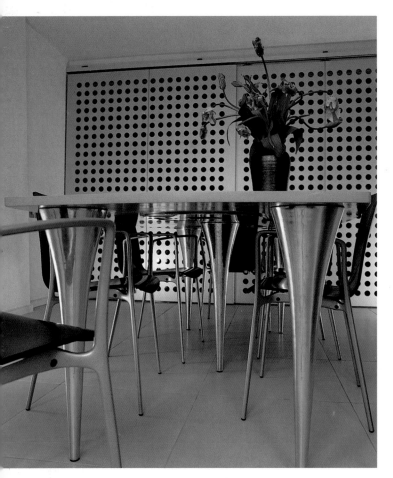

the screens are usually drawn back to make one large space in which the children can congregate and family meals be taken while whoever is cooking is not cut off from the rest of the activity. The dining area has a plain, hole-in-the-wall fireplace with an unusual source of heat: as Will White remains unconvinced that gas 'log' and 'coal' fires look real, he has used a prototype 'hedgehog' – a single, perforated tube which, when lit, emits flames seemingly flickering in a black void. The tabletop is made of tough resin; the worktops are of black granite.

■ Sliding screens can be positioned to separate cooking and dining areas when necessary.

■ Large, 60-cm-square limestone slabs for the floor enhance the sense of space.

■ The extractor-fan motor is installed in the garage to keep noise away from the kitchen.

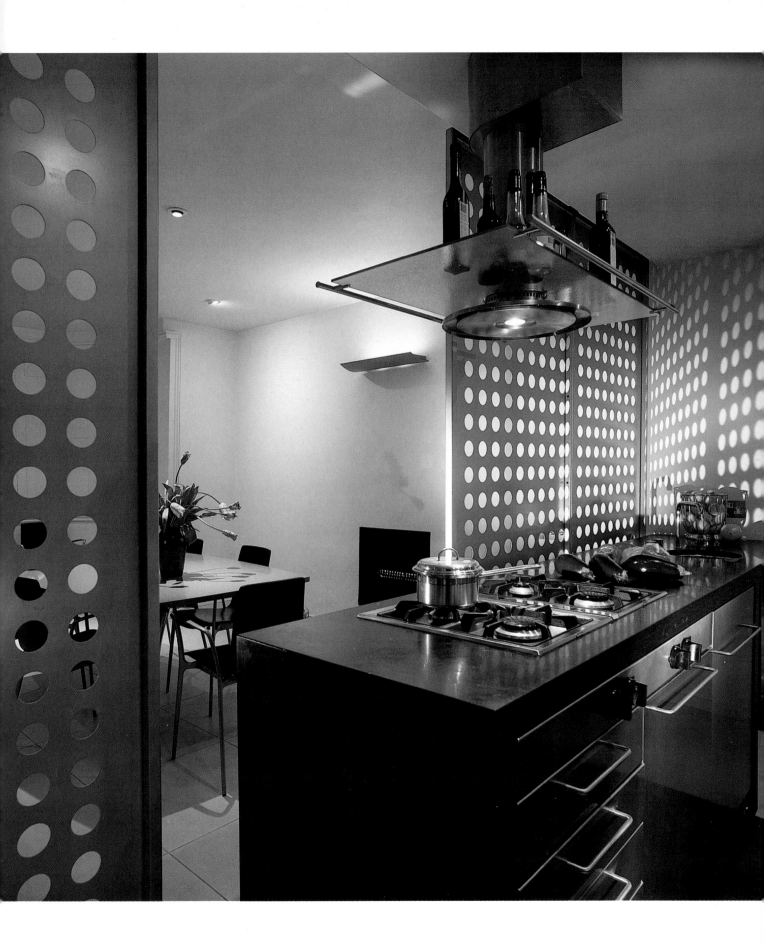

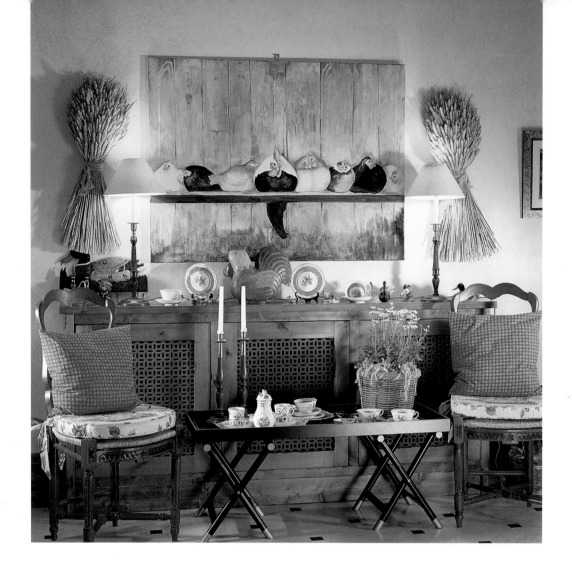

RURAL ASSOCIATIONS

Many city dwellers harbour a yearning for the country which they satisfy by imbuing a part of their home with an idealized rural countenance. More often than not, it is the kitchen/dining area that assumes the bucolic character. The room seen here, designed by Paula Swinstead for her own home in London, is a charming spin on rural domesticity. The colours and materials have an obvious warmth, and there is even an Aga in the cooking area to suggest a room away from the urban mêlée. The walls, painted with a basket-weave effect by John Brown, are hung with sheaves of corn and many pictures, including an amusing painting of a family of cheery chickens by Ada Dawnay.

■ Natural wood and other country attributes are given a chic edge when used alongside smart objects and fabrics.

■ Country pieces of furniture, whatever their style or provenance, usually have a family harmony. Here, the chairs are French but they settle happily in a room with English-style cabinetry.

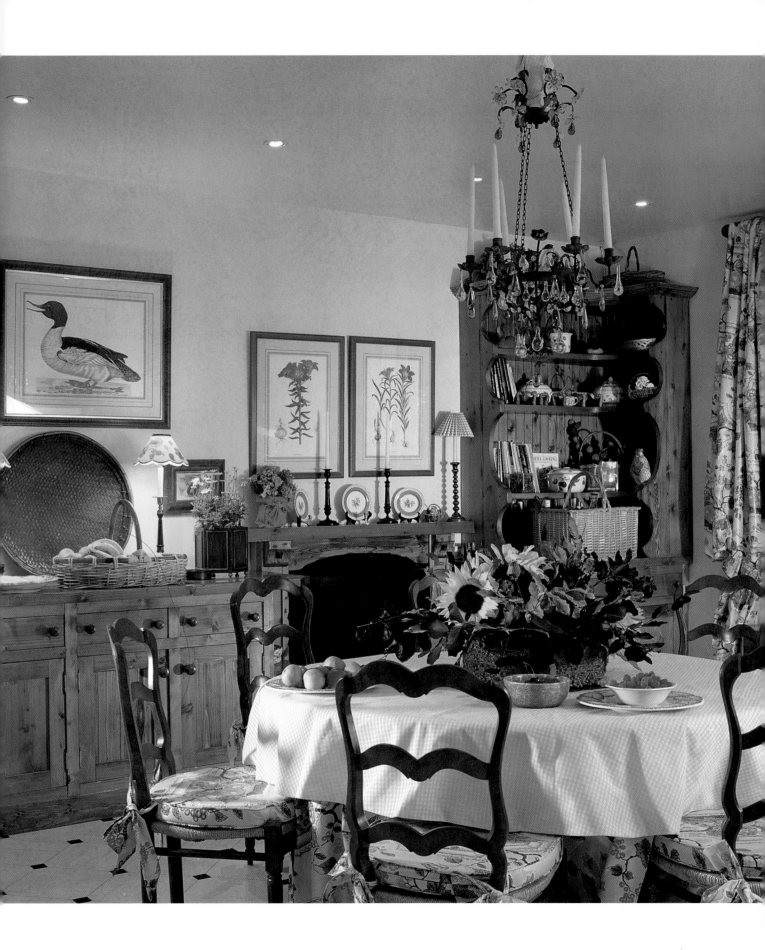

A FINELY MEASURED
CLARITY

There is a beautifully spare quality about the lines of this uncompromisingly modern kitchen designed by Eva Jiricna for the fashion guru Joseph Ettedgui. The units are defined by a rythmic series of rectangles, with the doors of the lower cupboards faced in stainless steel, and the ones above made of etched glass. The sink was welded into the worktop to give the neatest possible join. Aluminium chairs and a round table on a metal pedestal, plus a stone floor, match the uncluttered, smooth-surfaced style of the interior. The only soft texture is the half-curtain at the window.

■ Handles with interesting profiles bring restrained decoration to the ultra-simple lines of the units.

■ The aqueous colour and discreet luminosity of etched glass is in sleek harmony with the sheen of stainless steel.

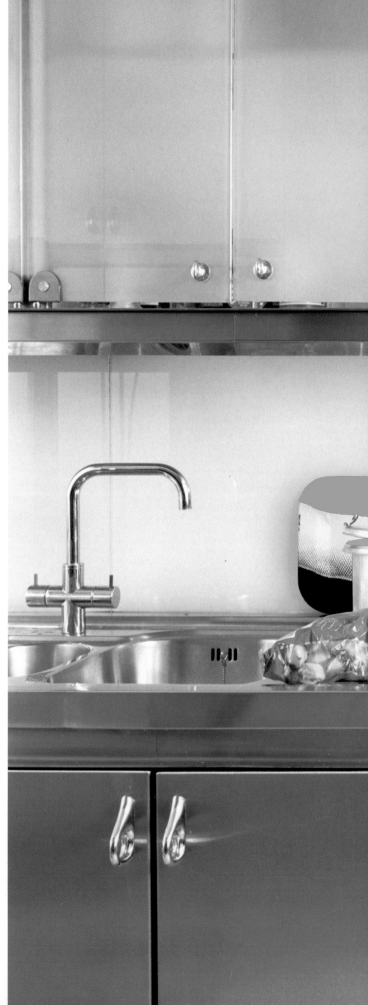

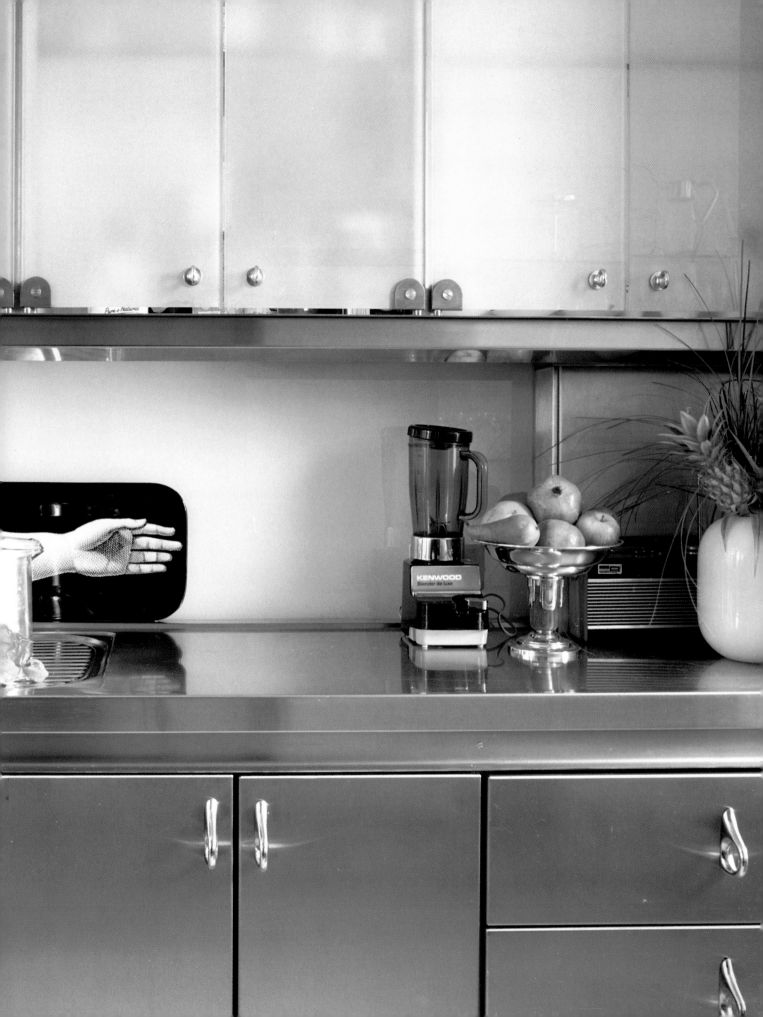

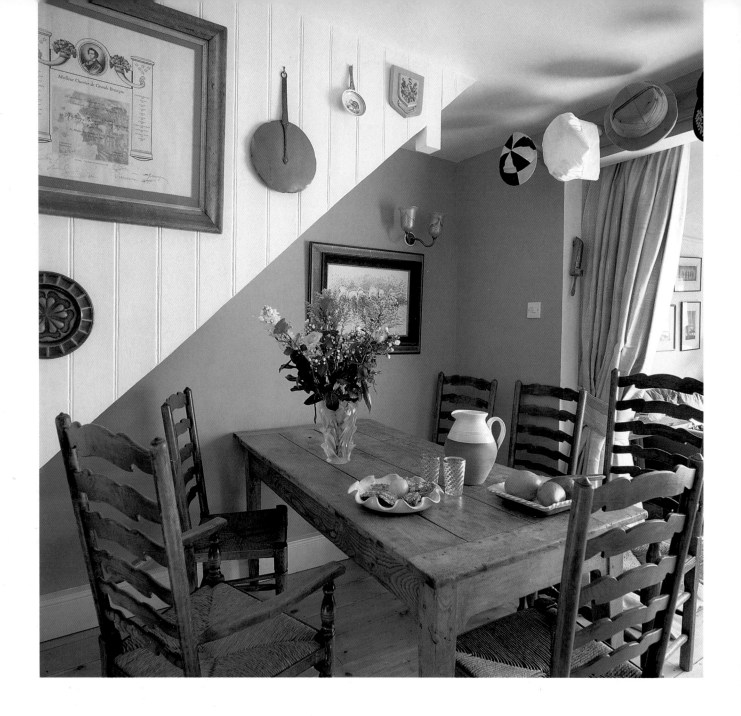

HOMELY AND EFFICIENT

When restaurant owner and television chef Antony Worrall Thompson had a new kitchen installed in the riverside cottage in Oxfordshire that used to belong to his grandmother, he had two specific thoughts: firstly, the room should retain its homely atmosphere and, second, it should be a thoroughly efficient place in which to cook and devise recipes for his books. Homeliness is engendered by the cream units by Mark Wilkinson, which have hints of Edwardian kitchens, particularly in the built-in plate-racks above

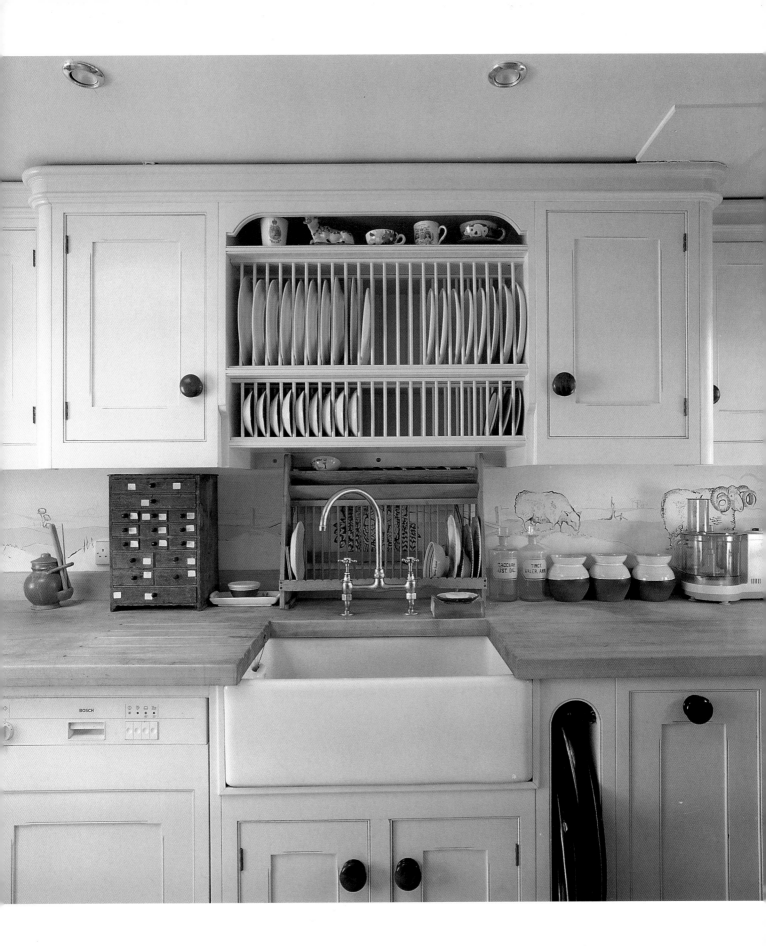

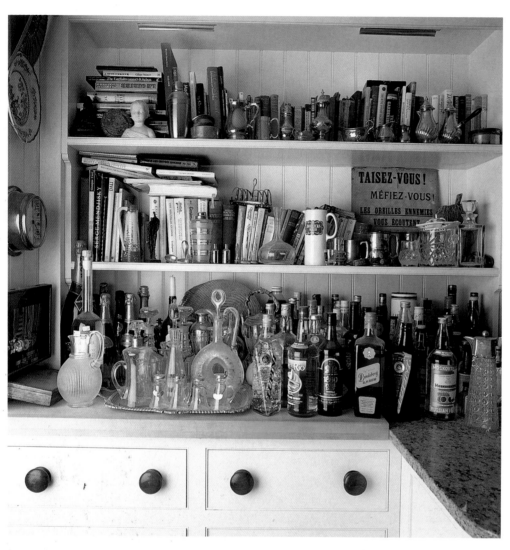

the original Belfast sink and taps. Practically, the units are topped with three different finishes: 5cm-thick maple, stainless steel and, for pastry-making, granite. Opposite the Belfast sink is a worktop-height, commercial refrigerator, a large French stove and a second, stainless-steel sink. The bulkiness of the second, tall fridge (not shown) is disguised by high cupboards to either side. Scenes of rural life, painted by Sam Allkins, provide decoration. Under the stairs is a dining area.

■ Heavy-duty, rosewood door-knobs are handsome and easy to grasp.

■ A slot for trays is a useful detail.

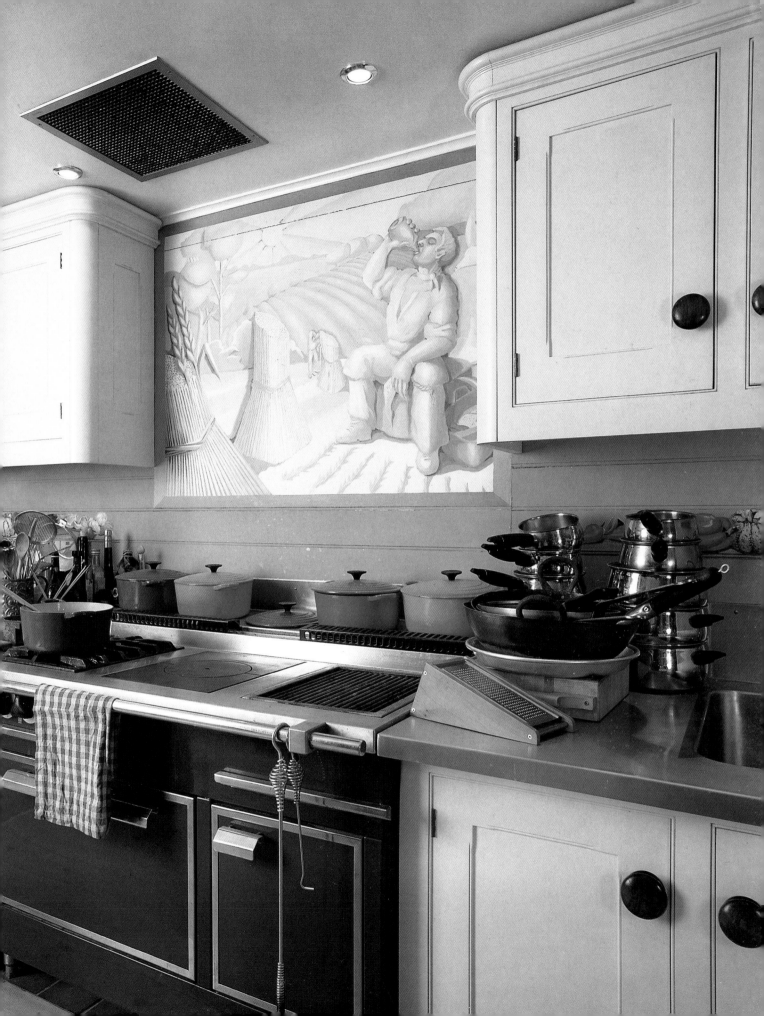

STIMULATING THE EYE AND MIND

The individual components of this kitchen and dining area share a graphic directness of character: solid planes of black and yellow are offset by striped fabrics and chequered tiles. The simple framing of the early-nineteenth-century French engravings of Egypt makes an effective contribution to the room's linear clarity. Chinese-yellow is a splendid foil for the prints as well as the modern kitchen, but black is the single most significant factor in bringing the room together and linking its diverse elements. The scheme was designed by John Wright, who has a keen architectural eye and a knack for devising interiors that are visually and intellectually stimulating. In this example, even the plates and drying-up cloths are architectural in spirit.

■ Using the same colour for tiles and cupboards gives a unified, modern look.

■ Variations on the same pattern – such as different widths of stripes – is less confusing than putting together several contrasting patterns.

■ A pendant-style pelmet is simple and graphic but adds a dash of flamboyance.

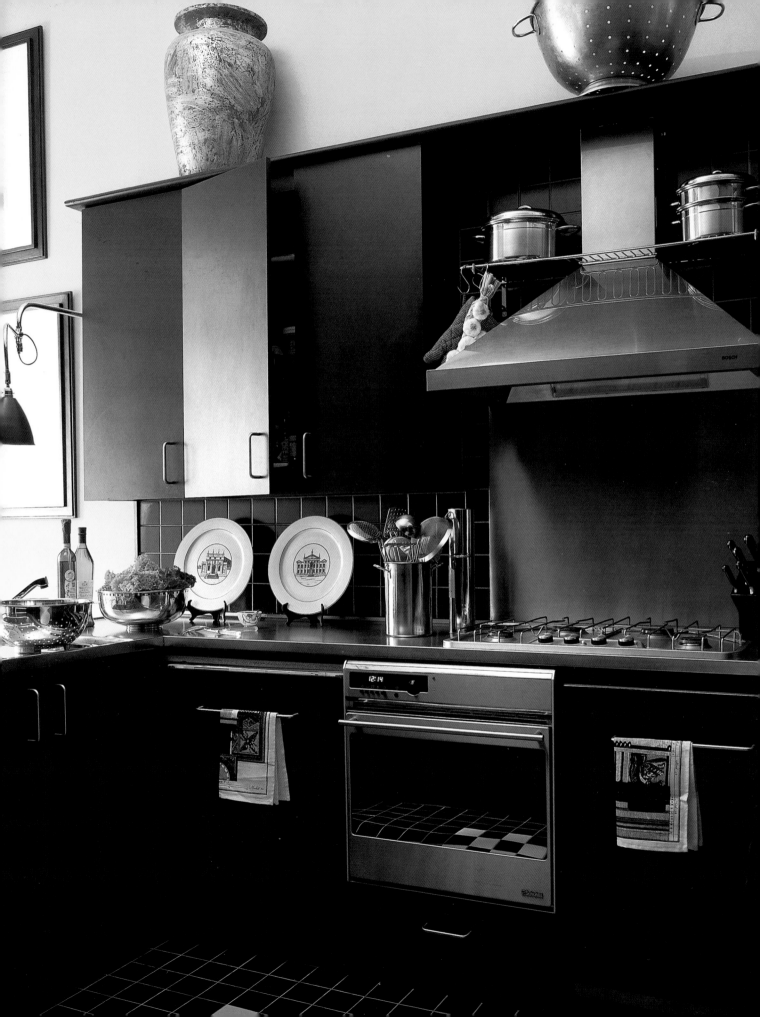

CHARMING
REMINISCENCES

For a Regency country house decorated with under-stated, traditional elegance, this kitchen strikes the right note: a sympathetic balance between being practical to use and slightly old-fashioned to look at. In a previous incarnation, the kitchen had been fitted out with melamine units. Giles Vincent, who was the architect and interior decorator for the refurbishment of the house as seen here, replaced the inappropriate units in the kitchen with specially made chestnut cupboards and he re-laid the floor with antique terracotta tiles. Good pieces of antique, country furniture create an agreeable eating area. Blue-and-white tiles never fail to look well in a kitchen with period overtones, and here the theme is picked up by the gingham fabric. Two very simple devices which in this context have great charm are the gingham valance above the range and the edging to the shelves in the adjoining pantry.

■ Providing it has a vernacular quality, antique furniture suits a traditional kitchen/dining area.

■ Laying an antique floor, such as reclaimed tiles, is an instant means of reinstating a mellow atmosphere when restoring a period house.

PANELLED AND **PAINTED**

For this scheme, where eating takes place close to the cooking/clearing area, designer Sasha Waddell rejected ready-made kitchen cabinets as their uniformity would have overwhelmed the dining area. Instead, she designed each unit slightly differently and housed the sink in a 'dressser' with shelves displaying a collection of blue-and-white china. In the dining area by the window, an attractively layered effect has been created to offset the room's high ceiling. Unlined curtains made from Victorian pillowcases filter light coming through the top of the windows; beneath are shutters for greater privacy. The walls are clad with MDF, routed to look tongued-and-grooved and aligned with the top of the shutters, so that the room appears almost as if enclosed by a continuous, painted, wooden screen. The blue shelving unit is backless, allowing the boarding on the wall behind to show through, giving a lighter effect than if the shelves had their own backing. The lowest layer in the room is formed by the radiator cover, with a Scandinavian-inspired fret pattern. The painted floor co-ordinates the colour scheme.

■ To avoid the uniformity of bought kitchen cabinets, which would dominate and detract from the eating area, the units were specially made and vary in design and height.

■ Housing the sink in a purpose-designed 'dresser' plays down the sink's functional appearance.

■ What looks like matchboarding is, in fact, routed MDF. MDF has the advantage of coming in large sheets.

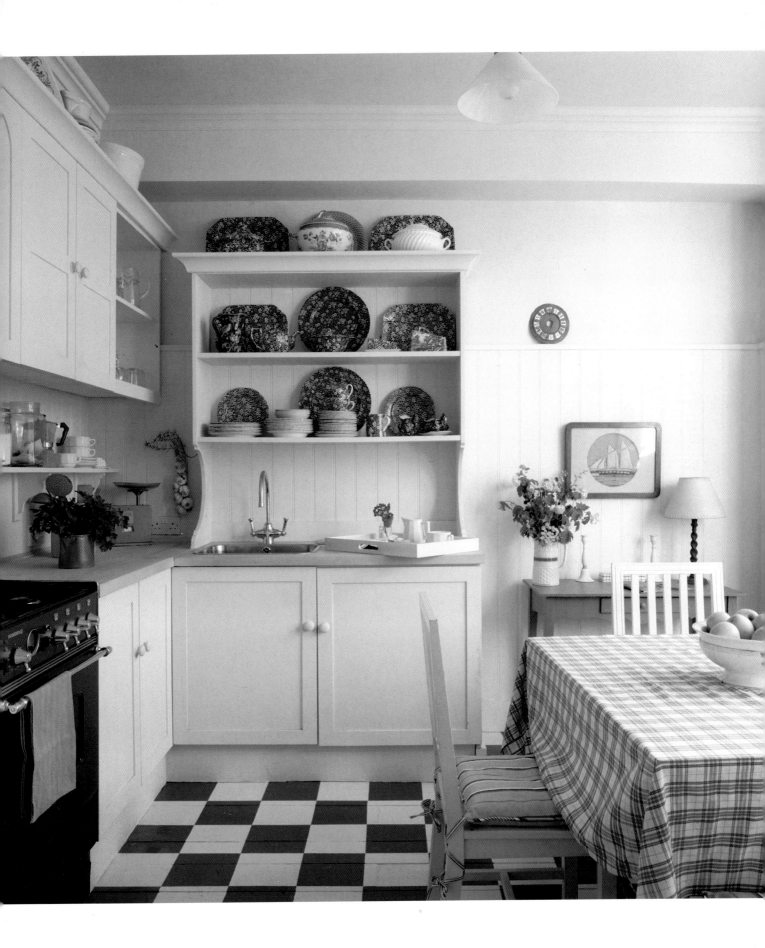

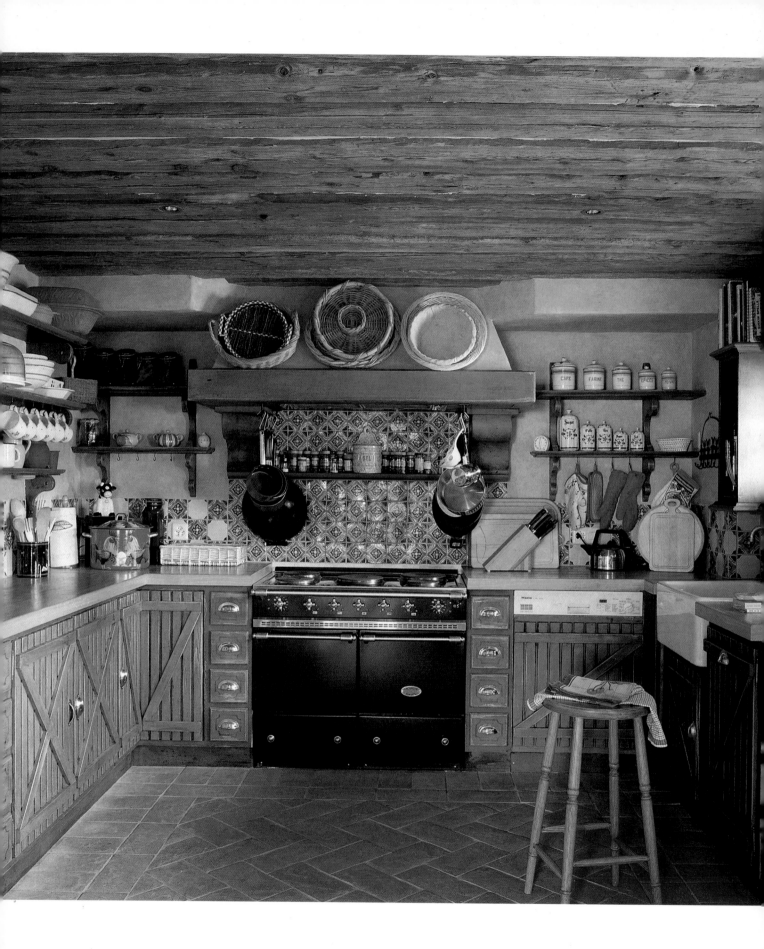

RESPECTING THE **VERNACULAR**

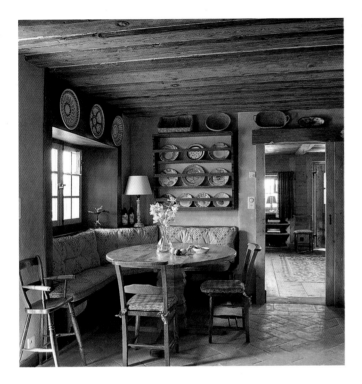

As we all know, looks can be deceptive – but this chalet in the Swiss mountain resort of Verbier is a particularly remarkable example of that old adage. Seeming for all the world as though it has been there for generations, in reality it was built within the last few years. This is credit indeed to the owners, who were anxious to respect the surrounding vernacular architecture and took an active part in the project. The consultant architect was locally-based Raymond Bruchez of Bruchez and Fellay. For the interior, the owners enlisted the help of London-based designer, Emily Todhunter. In spite of the architect's and designer's offices being in different countries, the arrangement worked extremely well. The 'old' appearance of the chalet is due largely to the use of reclaimed building materials and to the inclusion of traditional, small windows rather than the plate-glass expanses that characterize many of the modern houses in the area. The colours of the interior, plus the simple style of the antique furniture – much of which was bought in London – also accentuate the aged look. The kitchen units, designed by Emily Todhunter, have a distressed paint finish by Adam Calkin. One corner of the room is given over to a breakfast area with a small table and cushioned banquette. For fine days, there is a terrace for eating outdoors.

■ 'Cup' handles give an appositely old-fashioned appearance to the cupboard doors.

■ Densely patterned tiles complement the warm colours and rustic note of the cupboards and walls.

ULTRA-SIMPLE
CONTEMPORARY ELEGANCE

The kitchens illustrated here are both in mid-nineteenth-century buildings. Whilst there is a common denominator in that they are modern and very spare in concept, they demonstrate a different approach to similar architectural settings. In the one shown below, the cornice and skirting board remain as testimony to the age and style of the original interior. Within this setting, Simon Lowe has infiltrated an urbanely styled scheme with the horizontal and vertical lines of the kitchen units tempered by an elegant swathe of

stainless steel on the wall behind. In the kitchen at right, the celebrated minimalist architect John Pawson created a kitchen divested of all period detail. Here, as in the rest of the apartment, he used American white oak floors and white Venetian blinds. One wall is lined with white laminated cupboards; opposite this is a grid of open shelving. After the apartment had been converted by John Pawson, it was taken on by an American, Mark Mascarenhas, who had asked designer Michael Reeves to find him a London *pied à terre*. The pared-down interior appealed to Michael who saw it as a beautiful carapace which needed little adapting to his client's needs. Michael's main input was on the furnishing side. In this view, the wood-and-metal chairs were his choice, made because he felt that their curving outline contrasted well with the existing table and the room's predominently straight lines. At the far end of the room, in front of the window, is a marble block incorporating a sink, worktop, dishwasher and fridge.

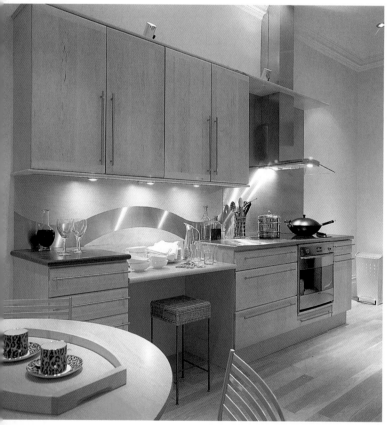

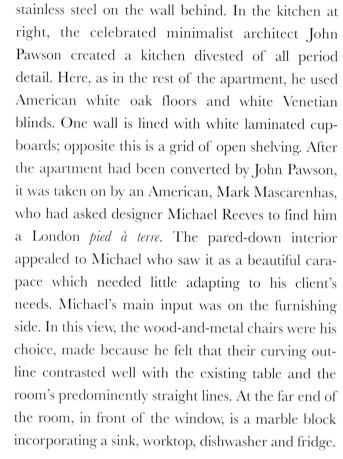

■ Pale-wood floors harmonize with modern furniture.

■ A Venetian blind has a tailored simplicity that conforms to a room where the architectural detail is extremely plain.

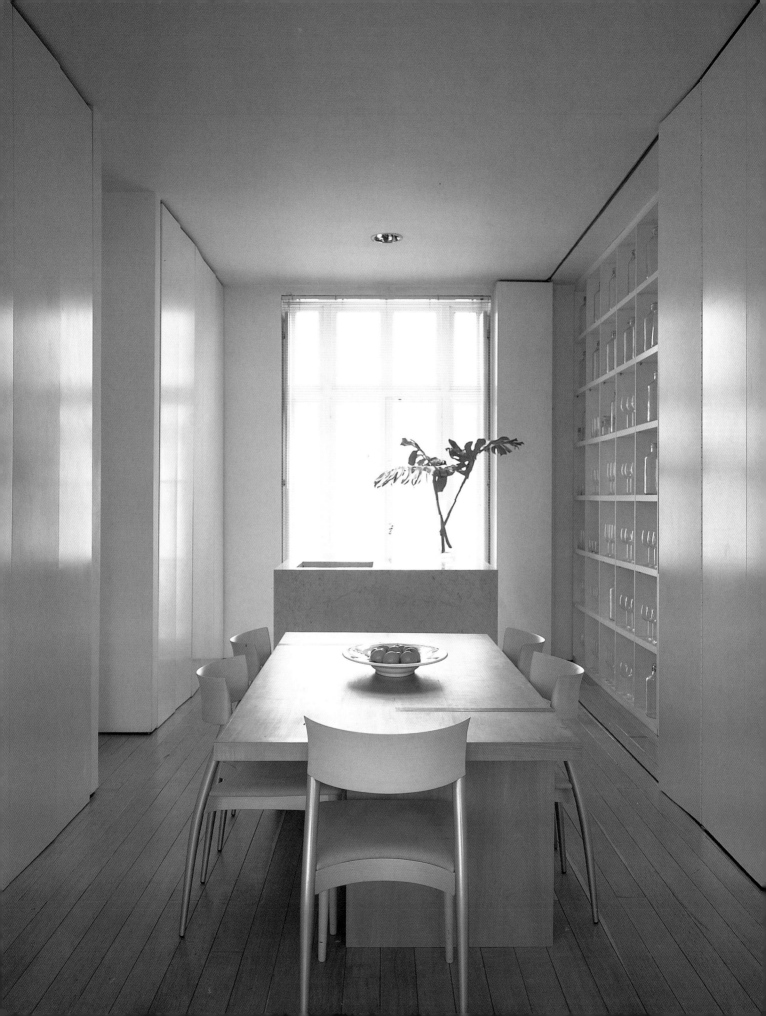

THE END OF **A ROUTE**

There is a real sense of arrival in this spectacular and highly original kitchen by designers Jane Taylor and Richard Parr for singer/songwriter Roland Orzabel and his artist wife Caroline. Though both Roland and Caroline are passionate cooks, they had such confidence in their designers' abilities that they virtually gave them carte-blanche and interfered very little in the design process. Their only stipulation was that the room should be dual-purpose, for cooking and eating. Jane Taylor conceived the space as 'the end of a route of passage.' She expounds: 'From the top of the house, the route winds down the staircase and culminates in the kitchen. One progresses past preparation and cooking areas, then arrives in the eating area.' With its warm, all-embracing colour and periphery curves, the room enwraps its occupants in a cocoon-like ambience. A particularly striking element in the design scheme is

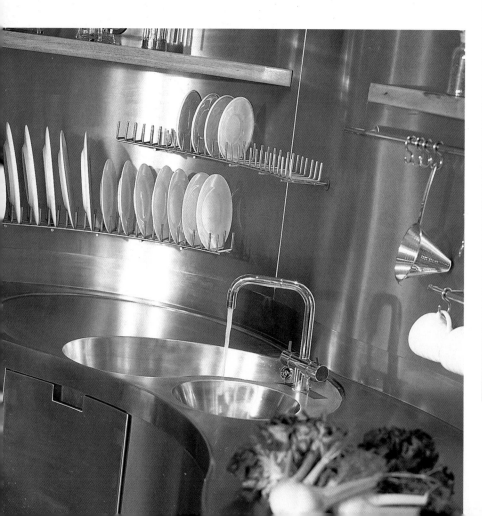

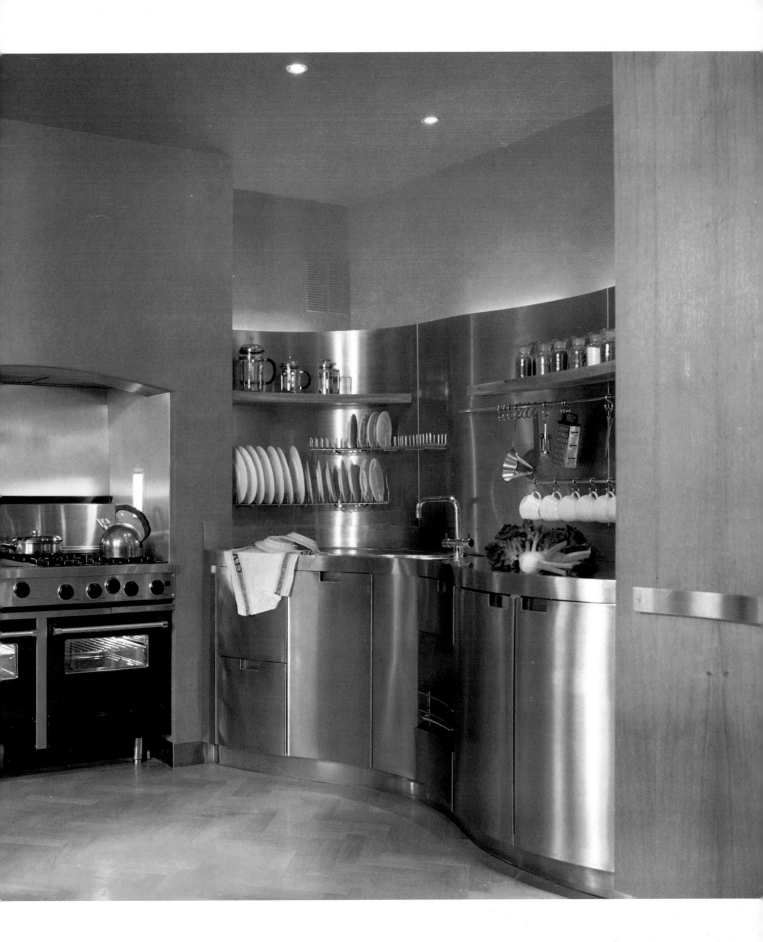

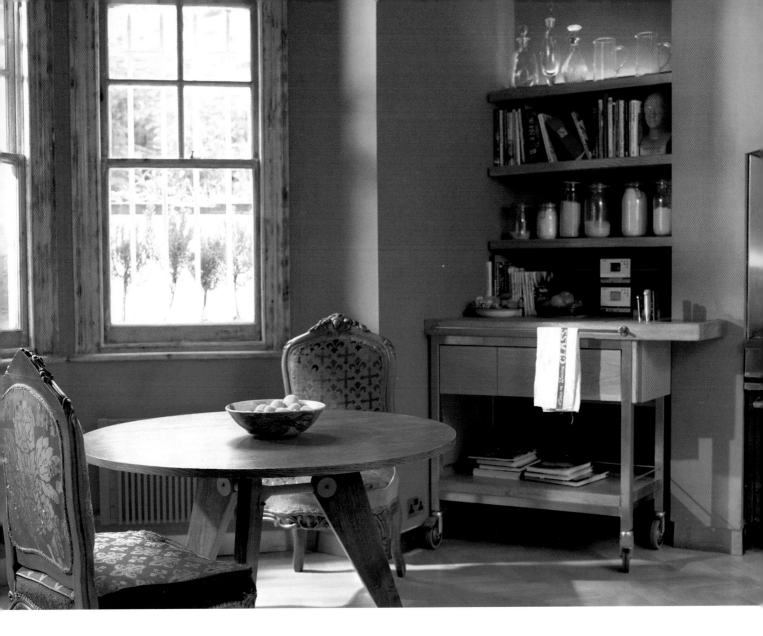

the serpentine, stainless-steel sink unit, which stands forward from the wall and has lighting behind. Three different finishes are used for the stainless steel: the splashback and doors have a satin finish; the sink bowls are polished; and the draining area is sand-blasted. The design of the integral plate-racks is a reference to the interior styling of a dishwasher. The oak-veneered doors to the storage cupboards slightly overlap one another, creating a gentle undulation, and have handles designed to coordinate with the organic-shaped sink unit. Also specially designed is the dual-function trolley which is a cutlery canteen as well as a chopping block/work station. Opening off the kitchen is a utility room with emerald-green walls – a vivid contrast with the kitchen.

■ Sinuous lines and a warm colour scheme create a cocoon-like periphery.

■ Well detailed door handles on the cupboards give continuity with the sink unit.

■ The chimneybreast houses the stove, maintaining the traditional concept of the fireplace as the focus of a room.

INTEGRATING **NEW** AND **OLD**

This kitchen by interior designer Kathrine Palmer in association with Jane Taylor of Taylor & Parr shows a good solution to the dilemma of integrating modern, functional equipment in a period setting. The key is simplicity. The owner's preference for plain design is reflected in the clean lines and straightforward wall finishes – and even in the glass decanters and jugs on the shelves – but the stone

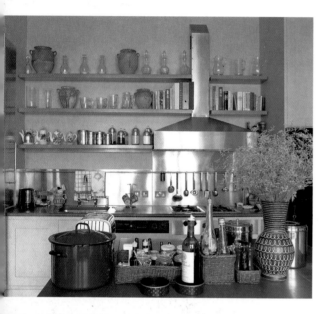

chimneypiece, panelled doors and wooden floor have traditional associations. They also provide a visual warmth which is particularly valued when the room is used for entertaining. The tall cupboards have a subtly scumbled 'stone' finish, while the island unit has a work surface of deep ocean-green slate. The splashback behind the sink and stove is a wide band of brushed steel which rises up beneath the extractor hood. The same material is used to face the fridge. At the opposite end of the room there is a long dining table with banquette seating spanning the window bay. To the left is a neatly built-in wine store.

■ Brushed steel makes a sleek upstand behind the sink and stove.

■ A chimneypiece gives the room a focus and visual warmth, especially when entertaining. The inclusion of a substantial painting reinforces the un-kitchenlike ambience.

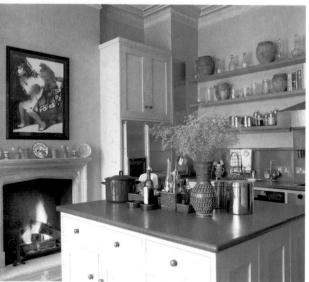

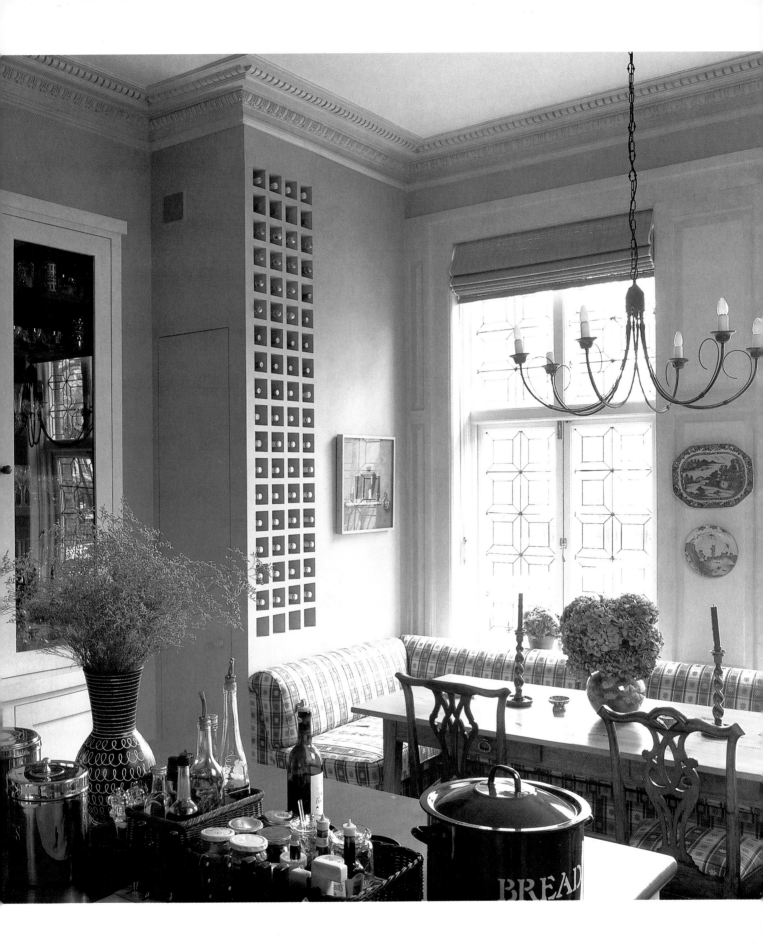

OPENING UP A
VICTORIAN VILLA

Neil and Amelia Mendoza bought a handsome Victorian villa which had been converted into three flats but, now, with the help of their architect friend Sophie Hicks, is back to its original status as a single-occupation home. The re-conversion gave the Mendozas the opportunity to open up the interior by removing partitition walls, replacing the unfortunate windows installed for the flats at the rear of the building, and introducing a wonderful feeling of light and space. The kitchen and dining area in the semi-basement are a design entity, with French limestone used throughout and two tables designed by Sophie Hicks, both in ash (one at workbench height and the other, lower, for dining). The kitchen units, also faced with ash, have stainless-steel worktops. The dining chairs and high chairs are in different designs but are all made of aluminium. At the far end of the room, glass doors lead to a small terrace with wide, Inca-inspired steps to the formal garden above.

■ The splashback is made of opalescent glass.

■ Tables are of different heights for different functions: one is a workbench but can also be used for quick meals; the other is for dining and can seat twelve. The two are related by both having tops in pale ash.

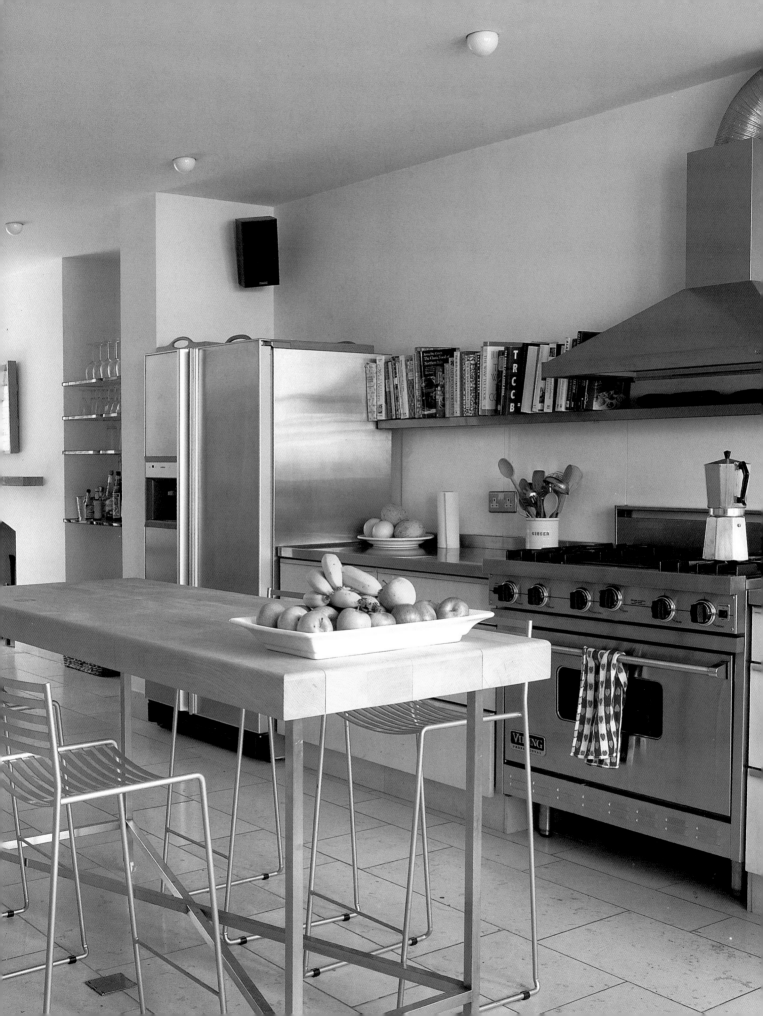

ARTISTIC INSPIRATION

A painting by Michael di Canio, bought in New York, inspired the colour scheme for this cheerful kitchen in London, designed by Arrelle von Hurter. It also suggested the decoration of the chimneypiece, which consists solely of cacti – and there are more of these on the refectory table. The green theme extends to the table itself, with its painted base, and to the chair squabs. The recess to the right of the chimneypiece is filled by a stove, behind which is open shelving for storing regularly-used items. In the window bay is a metal rack, again with open shelving, which looks busily practical and ensures that every-thing is readily to hand. The room has a slightly rural feeling, enhanced by the metal candle-holder en-twined with dried flowers.

■ A big, bold painting can not only inspire a decoration scheme but hold it all together.

■ Natural terracotta pots suit the architectural shapes and primitive-looking character of plants such as cacti.

■ A 'hard' floor, such as the slate seen here, laid diagonally can look more interesting than one laid on the straight.

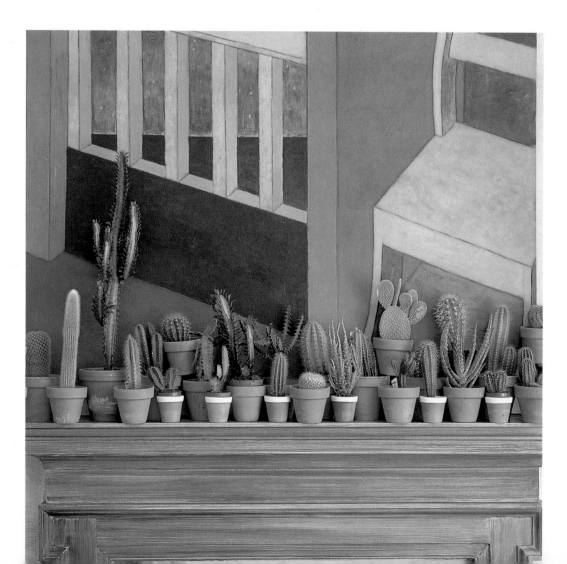

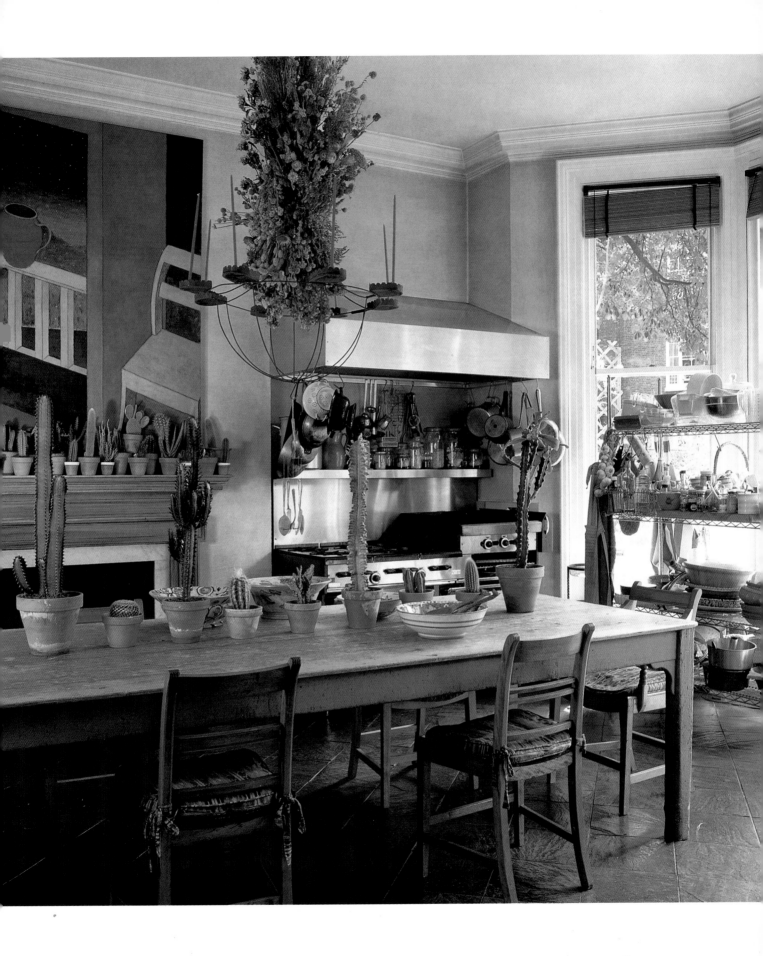

A DIFFERENT **ATMOSPHERE**

As you can see in the view (right) looking back through the door, this kitchen is in daring contrast to the rest of the house, all of which was extensively reworked and updated with Peter Wood and Partners as architects. Through the opening can be glimpsed the spectacular Gothick dining room (see page 173) which is part of a highly considered, period-style scheme in an 1830s house on a site where Kensington Palace orchards once were. The kitchen is the only room to have a truly modern treatment, as it was considered that, where functionalism is paramount, a contemporary approach is best. The finishes include brushed stainless steel, shiny white lacquer and frosted glass. At the window end of the room is a dining area with 1920s chairs looking perfectly attuned to the setting. The ceiling, with recessed lighting, is sculpted to echo the shape of the room and circular table.

■ Black-and-white flooring is a classic design which suits modern as well as period decoration schemes.

■ Black-and-white photographs are appropriate in a functional room and, with simple black frames, go well with today's decoration ideas.

■ Partially lowering the ceiling creates interest, conceals services and allows for recessed lighting.

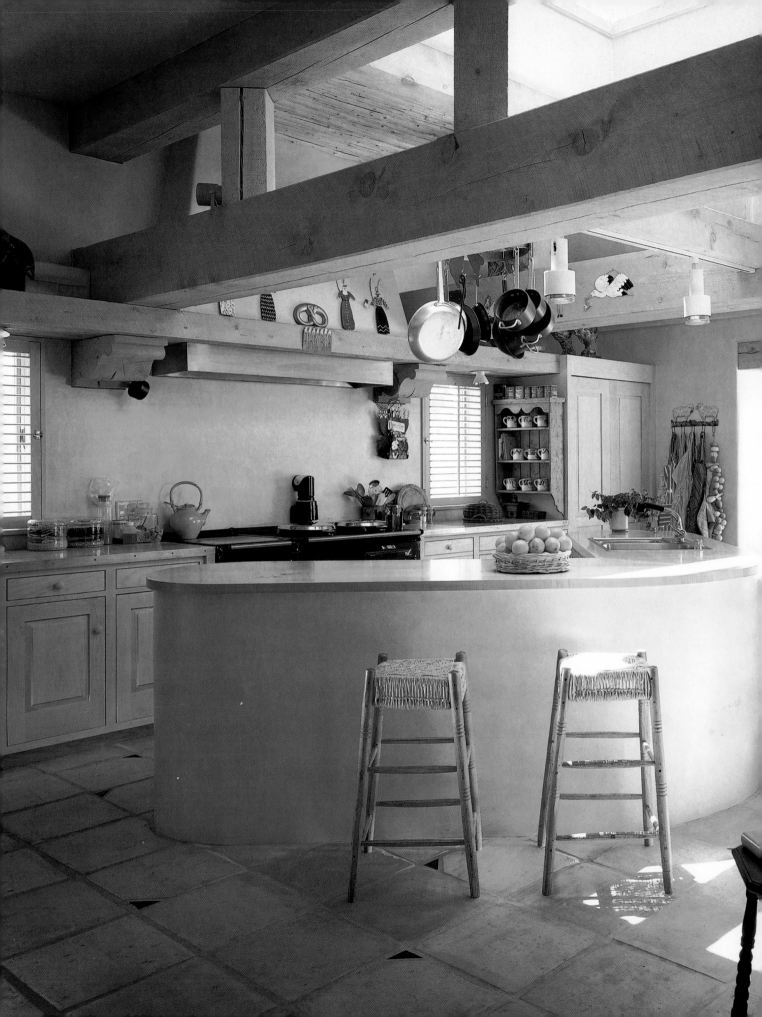

OPEN-PLAN LIVING

A kitchen with an integrated dining area is not especially rare but one that also includes a comfortable place for sitting is less usual. Yet, considering we spend so much time in and around the kitchen, it makes perfect sense to give as much space as possible to this room and have a truly useful, livable-in space. The schemes shown on the following pages are open-plan living areas in that they enable family and friends to be together before, during and after meals, and they ensure the cook is no Cinderella while everyone else is chatting elsewhere. In Sue de Zulueta's design (pages 88-89), the seating area is an adjunct to a more formal drawing room, but architect Nico Rensch went a step further when his clients wanted to do away with a separate drawing room altogether. Their undivided room, with its plain, light colour scheme and minimal architectural detail, illustrates what Nico Rensch calls 'maximalism' – that is, you seem to get more space when you not only remove walls but all extraneous decoration (pages 90-93). The room is in an old house but its new incarnation has something in common with the big, open spaces associated with converted industrial buildings: the loft rooms (pages 96-97) and estwhile telephone exchange (pages 104-107) are examples of domestic interiors created within industrial shells.

In this room in a ranch-house in New Mexico, vernacular building materials and construction techniques establish the informal character of the interior decoration. The heavy timbers of the open-trussed roof rest on corbel brackets supporting a hefty shelf above the range. The curved island unit is more graceful than an angular one would be and gives greater concealment for the functional part of the room. Adjacent to the island is a seating area where objects from other countries complement the room's New Mexican heritage: in addition to colourful kilim rugs, there is a carved-wood Balinese pig which acts as a foot-rest. The house was remodelled for Rutgers and Leslie Barclay with the help of architect Ken MacKenzie and interior designer Hutton Wilkinson.

MERGING COUNTRY WITH CITY

Extending across the full width of a large, nineteenth-century town house, this kitchen is comfortable and easy to live with. When the owners bought the house, they commissioned Emily Todhunter to redecorate it in line with their brief for a traditional country-house feeling – in the broadest sense – but with an urban slant. The existing kitchen happened to fit the brief fairly closely so there was no call for radical alterations: all that was needed was a little tweaking. The window treatment was simplified, check-covered armchairs were added and accessories chosen, resulting in a room which is ideal for informal entertaining as well as for day-to-day family life. The wooden units in the kitchen area, simply panelled and painted soft white, are relieved by open shelves displaying blue-and-white plates and by a frieze of wicker baskets. The tones and textures of the baskets are echoed by the matting. The same colours are seen in the furniture and floorboards. It is all extremely restrained – there are no curtains, just shutters – and restful. At the other end of the room is a comfortable sitting area with check-covered armchairs drawn up by the fireside. The predominant colour here is green, which is fresh but, again, restful.

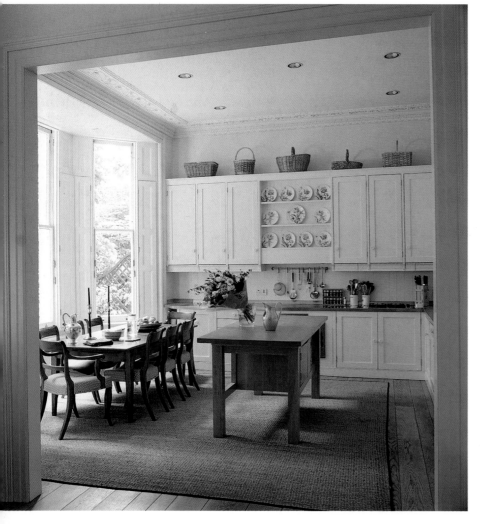

■ Simple painted-wood units are appropriate in a room with an adjacent, traditionally decorated sitting area.

■ Lighting is recessed in the ceiling to give good overall illumination; table lamps give a cosier ambience in the sitting area.

■ Open shelves displaying plates counteract the relentlessness of a long run of wall units.

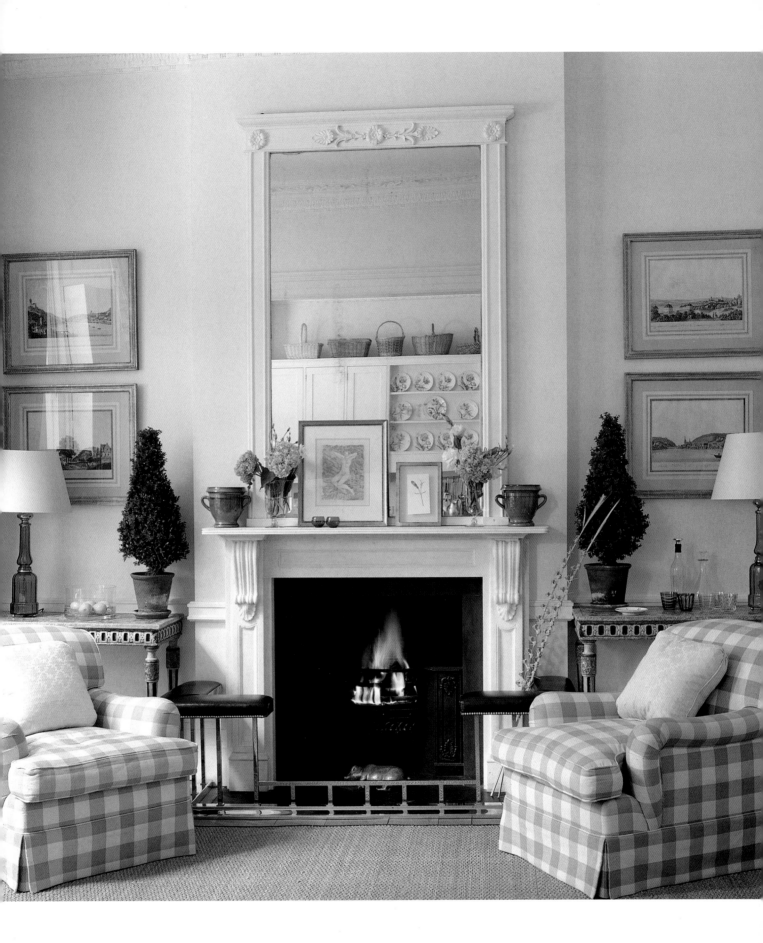

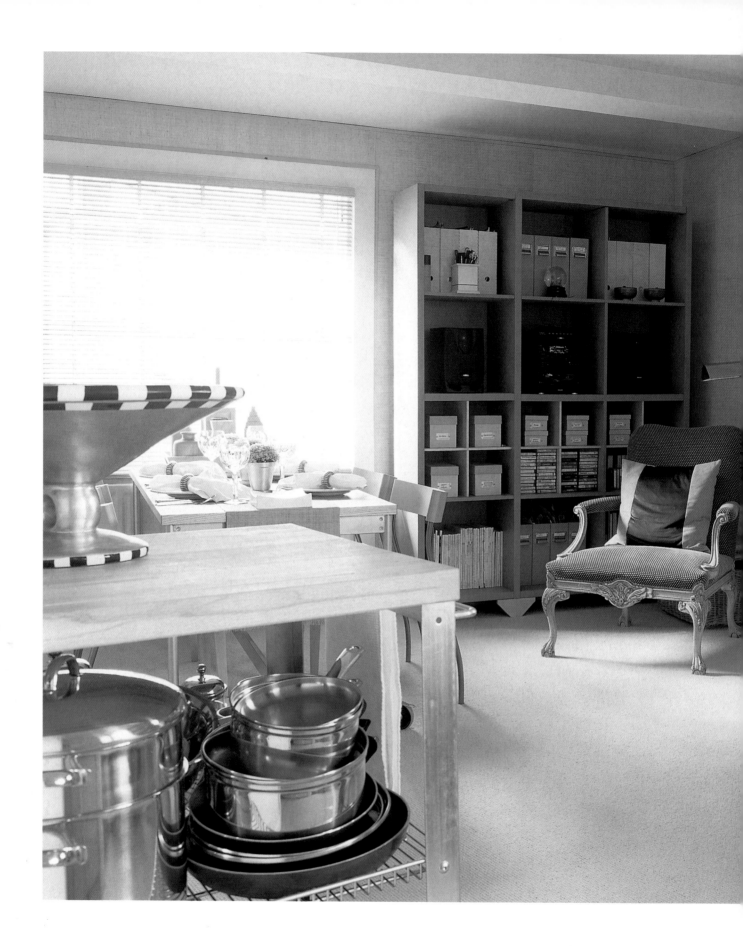

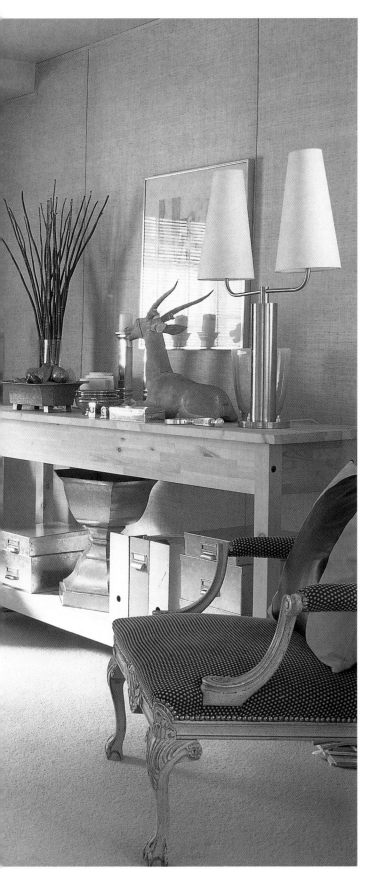

A SOPHISTICATED
MIX

Michael Reeves is not one of those blinkered designers who cannnot mix the costly with the economical. If he can find an object that is inexpensive but 'right', then he is more than happy to include it alongside much more valuable pieces. This attitude is evident in the wedge-shaped flat he designed for his own home above his shop in London. The multifunctional living/dining/cooking/working/entertaining area is decorated in a neutral palette to harmonize with the timber floors and bring unity to the room's quirky outline. For the furnishings, he chose what he describes as 'a mixture of different periods and styles combined with a modern edge to give the place something of a Manhattan manner.' The simple,

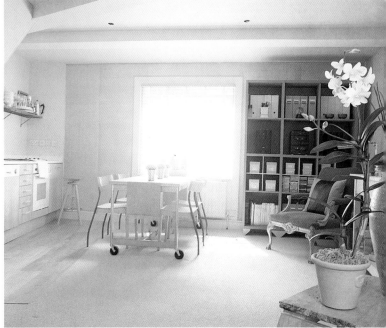

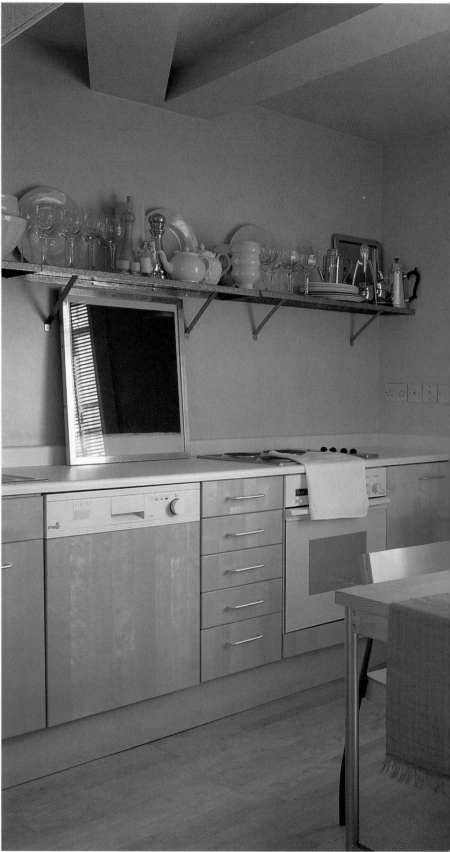

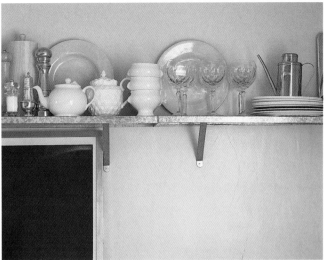

low-cost, wood-fronted units from Ikea make the point especially well about getting the right look for less. They and the aluminium shelving above are combined with Michael's 'real indulgence', a natural raffia wallcovering. As a foil for the timber floor, cedar blinds and cream rug, the texture and colour of the raffia seemed so perfect to Michael that this comparative extravagance was inevitable. The dining table is placed at right-angles to the window; next to it the wall is filled with open storage for music equipment and files. The urbane, eclectic mix of furniture successfully contrasts a chunky wooden side-table with elaborate armchairs. Leather-and-suede cushions and other stylish accessories, arranged as still-lifes, complete the *mise en scène*.

■ Keeping within a limited colour range gives cohesion to awkwardly-shaped spaces.

■ Mixing the costly with the thrifty has a more interesting result than sticking to one price bracket – and the mix creates a look very much of the moment.

■ Objects, including utilitarian ones, arranged as still-lifes become decorative tableaux.

A LINK WITH **THE PAST**

This kitchen/dining area in Islington was converted from a run-down workshop which had been tacked on behind a Georgian house when the latter served time as offices. When designer Carol Thomas of Ruffle & Hook first saw the house, it was in a truly sorry state. Her immediate thought was to demolish the workshop and reinstate the garden, but the potential of the interior space was too good to let go; so, instead, she decided it should be made into a family room. Not wanting this room to be 'just a big space', she devised a scheme which would break up the volume and give it

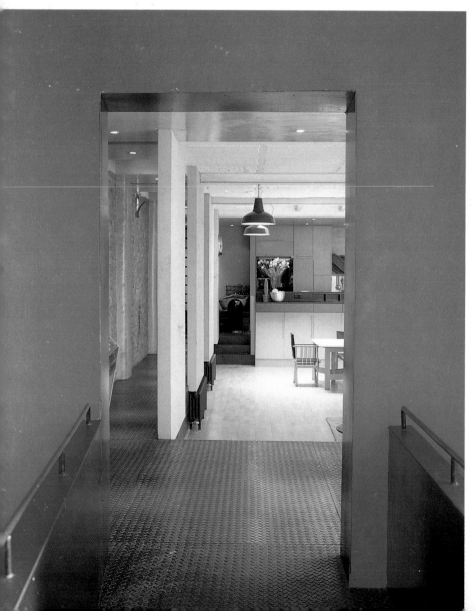

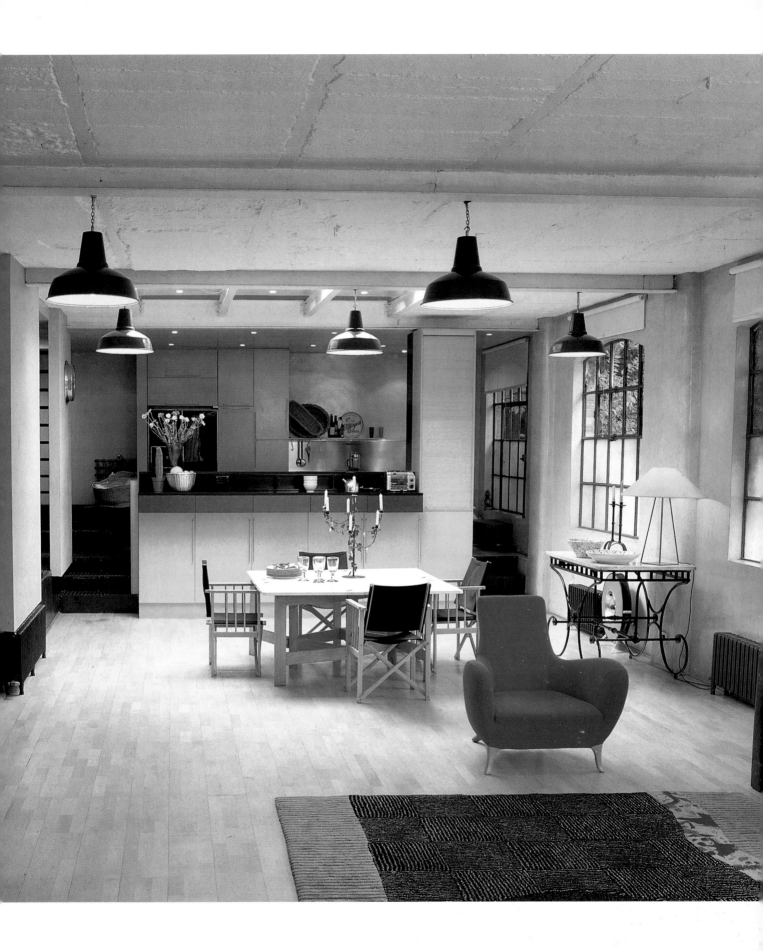

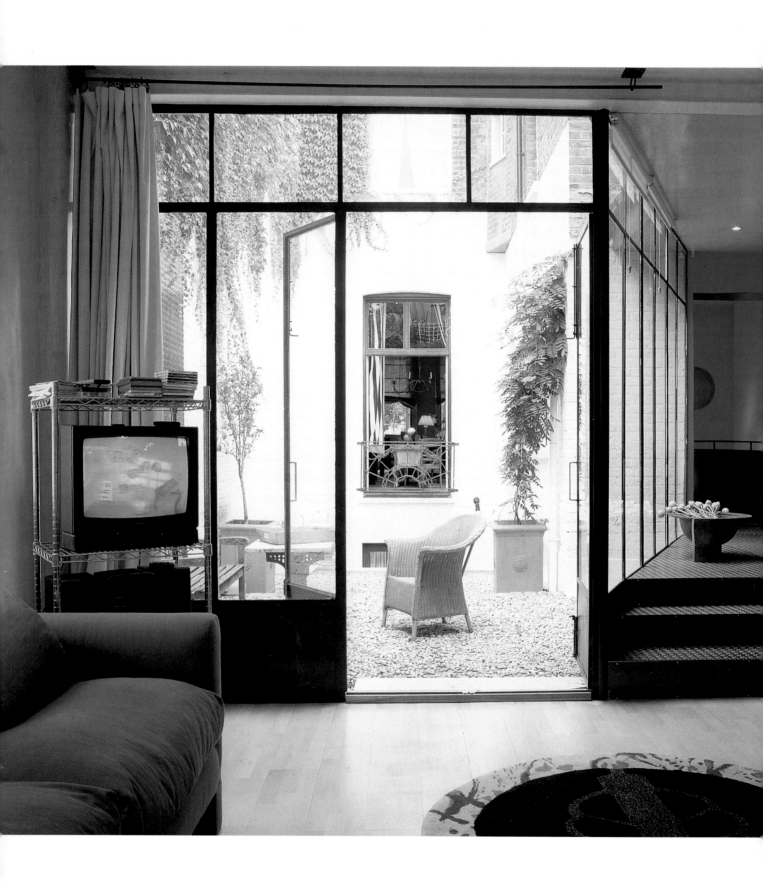

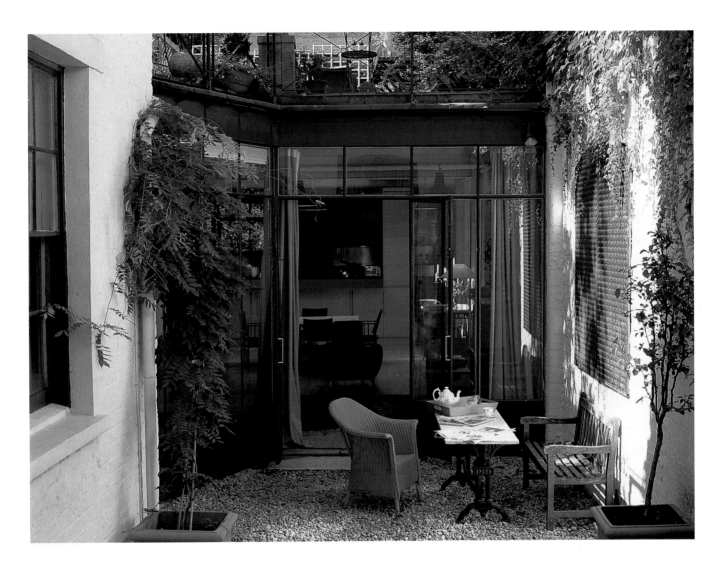

greater personality. She connected the former work-shop to the main house by a corridor, using deck-plating for the floor and glass for the walls. The corridor is extended down the side of the kitchen, which improves the room's proportions and also solves the problem of a change in floor level between the workshop and the house. The corridor remains at the higher level of the house so that when, for instance, heavy shopping is being carried to the kitchen, it is possible to walk straight through without having to negotiate a step. The kitchen itself is also sited on the higher level. In this heightened position, the person cooking can talk to family and friends seated in the dining area and be confident

that the practicalities of food preparation are unseen. The kitchen units are made from baked MDF, which has an attractive sheen. The glazed corridor linking the family room to the house has an angled wall with doors leading out to an attractive, pebbled courtyard which can be used for outdoor dining.

■ The raised floor level in the kitchen makes the basic activities of cooking less visible from the eating area.

■ Low, traditional-style radiators look appropriate in this type of interior.

■ Bright colours in bold planes have dramatic impact.

BLUE AS A BASE

Cobalt blue is an unusual choice for painted floorboards, especially in a Victorian interior, but here it is startlingly successful. This room was designed by William Nickerson for Lily Zimmermann, an American living in London. Her first house in England 'wasn't chintzy, but it was busy,' says Lily Zimmermann. 'It was very cluttered, full of pattern. Then I realized the things I really liked were the simple ones. This house is much more me.' Her home is a typical town house, built on several floors, including a semi-basement. Unusually for this type of house, Lily Zimmermann chose not to put the kitchen in the basement; instead she converted the largest of the raised-ground-floor rooms into a cooking and eating area, which suits a family lifestyle. There are two tables in the room: an extendable 'kitchen' one with Provençal-style chairs and, in the bay, a more formal design partnered by splat-back chairs. Between is a calico-covered sofa facing a limestone chimneypiece designed by William Nickerson. The 'Stars and Stripes' on the wall heralds Lily Zimmermann's transatlantic roots.

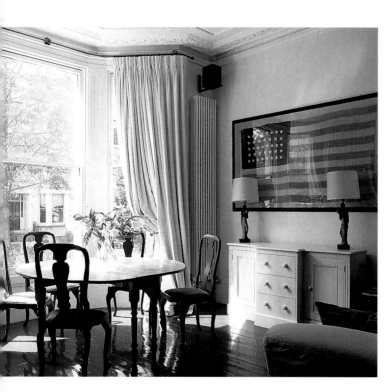

■ Details include the nickel-plating of the finials on the grate, the knobs on the cupboards and even of the fittings (originally brass) on the stove.

■ Tall, chimney-like housing for the cooker hood gives an essentially practical piece of equipment a sculptural rather than mundane presence.

■ A brightly painted floor is unusual and cheerful.

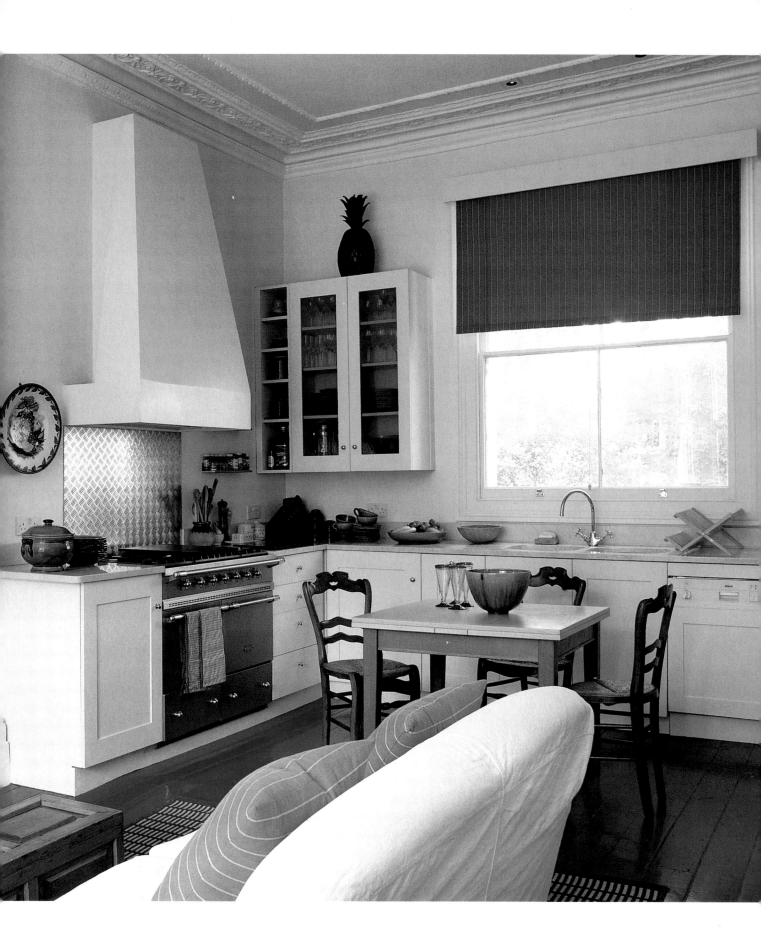

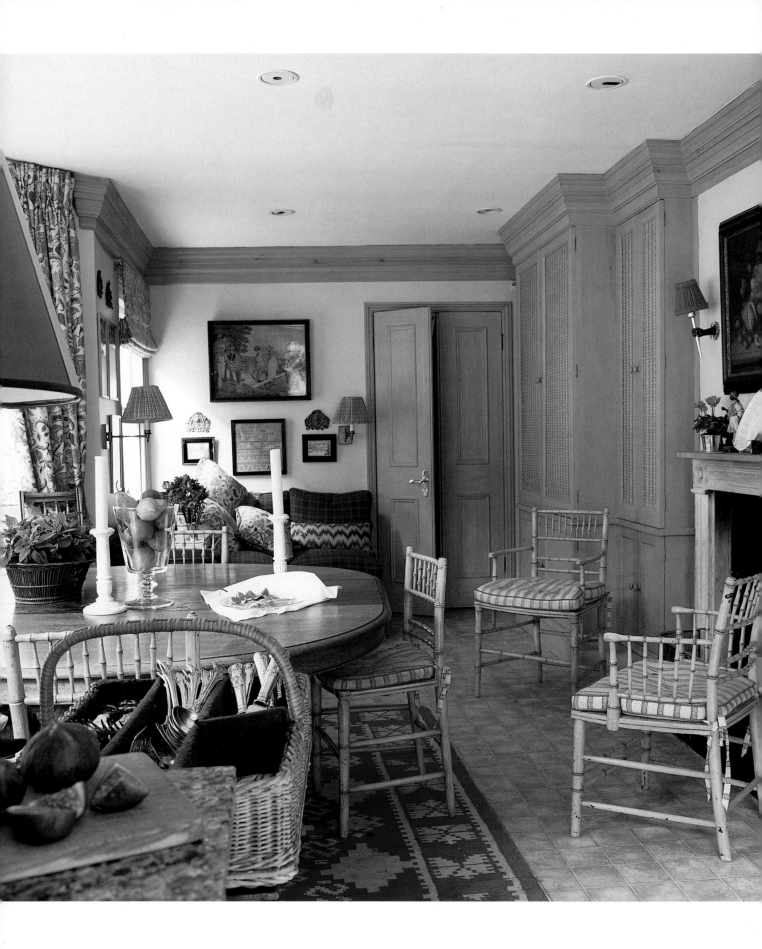

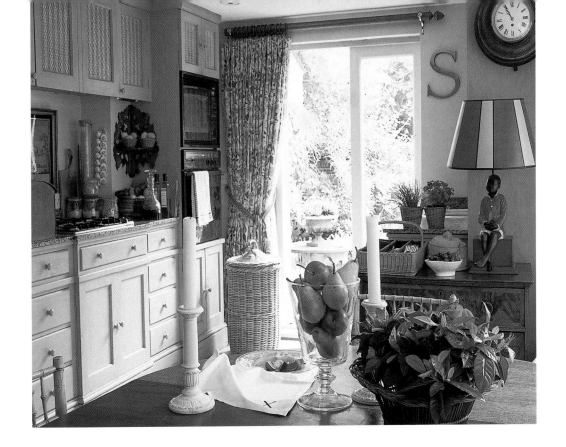

LOGICAL AND INVITING

For family life, an all-in-one room combining a kitchen, dining area and sitting area makes total sense. Interior decorator Sue de Zulueta of DZ Designs decided that this would be the most logical arrangement in the house she redesigned for herself, her husband and two young children. She kept a separate drawing room, but no formal dining room. Eating, whether *en famille* or with guests, takes place in the cosy room seen here. This is the quintessential 'heart of the home': warm and welcoming, with an open fire, but also outgoing, with French doors onto the garden. As a professional decorator, Sue de Zulueta admits that 'it's much more difficult to do your own place than someone else's. You tend to be far less decisive.' The slight lack of objective discipline play a large role in the appeal of this room. It is

an extremely personal place – a far cry from some of the more minimalist commissions Sue has recently carried out for clients – and has an exceptional feeling of cosiness. To either side of the limestone chimney-piece are floor-to-ceiling cupboards made of colour-washed, pine-veneered MDF with fabric-lined, chicken-wired door panels. The cream-coloured walls are hung with a medley of needlework and bird pictures; above the fire is a still-life of fruit flanked by 'fist' wall lights.

■ Wall lights are atmospheric supplements to the spotlights recessed in the ceiling.

■ The kitchen units are colour-washed to give a less intense finish than opaque paint.

LIFE IN A **NEUTRAL** ZONE

It takes courage to abandon, totally, a traditional style of interior decoration and go minimalist, yet here is a highly successful example of just such a volte-face. The owners, a professional couple, simplified their entire way of life by doing away with unnecessary clutter and opening up one whole floor of their home to make a tripartite space, divided up only by func-

tion. Before, there were lots of small rooms, all very dark and complicated. Now, with walls, cornices and mouldings removed, it offers a completely new lifestyle. Their architect, Nico Rensch, prefers to call this approach 'maximalism', rather than 'minimalism', as he contends that 'the more you take away, the more spacious it appears.' The most important thing

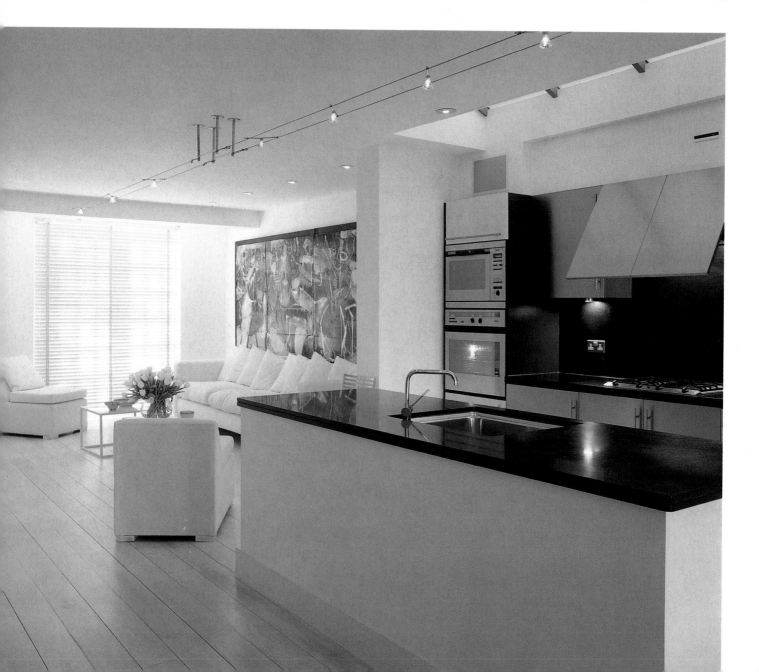

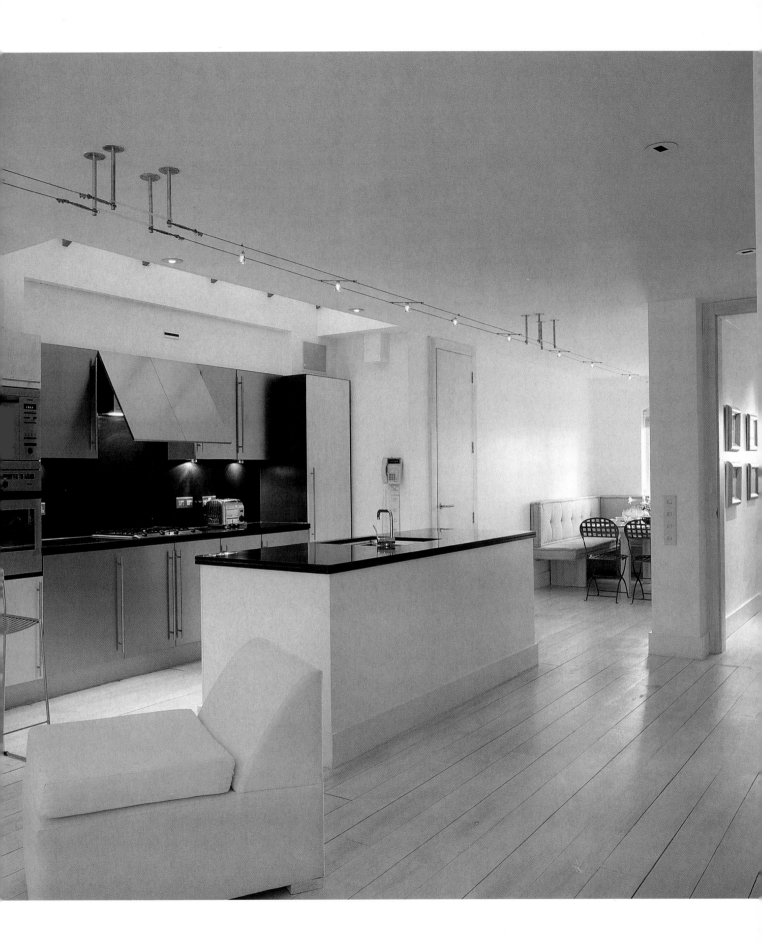

is to get the layout right. The kitchen is placed between the sitting area and the dining alcove, the three parts being linked by the same bleached-wood floor, low-voltage track lighting and white paintwork. Originally, the architect's idea was to have a four- or five-metre-long dining table, which would certainly have looked dramatic, but the owners wanted a cosier place for eating – hence the alcove with buttoned, banquette seating, which can seat up to ten people and works as well for a dinner party as for a goup of children playing with toys. At this end of the room, there is virtually no colour; at the other end, however, there is a sizeable painting by French artist Hugues d'Angosse, providing a bold splash in an otherwise neutral zone. The centrally-placed kitchen is also neutral-toned, though in a different way: the appliances are stainless steel and the worktop is black Italian granite.

■ Eliminating cornices and other mouldings increases the impression of space.

■ A pale-wood floor is in keeping with a light, modern, neutral palette but unobtrusively warms it up.

■ Underfloor heating eliminates the need for radiators, thus giving a cleaner look and allowing greater flexibility in placing furniture.

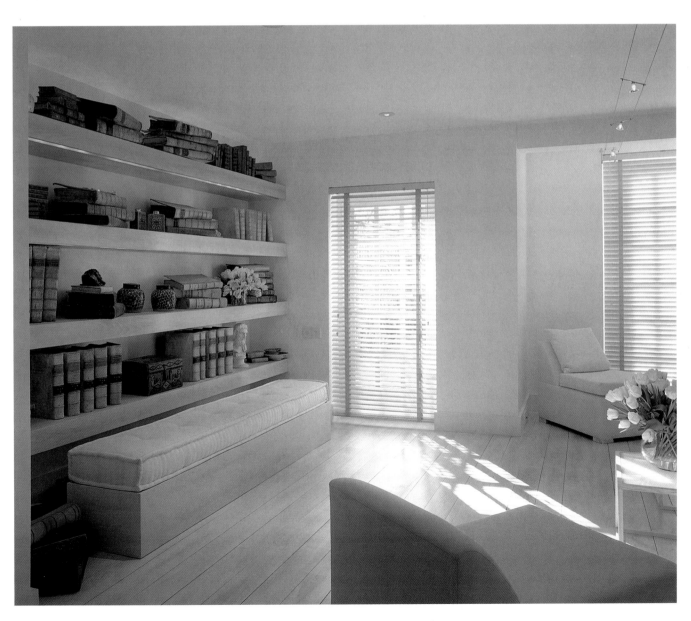

DYNAMIC TECHNIQUES AND SHAPES

Architect Julian Marsh is not a conventional person, and the house he designed for himself in a leafy suburb of Nottingham is not a conventional home. For instance, on the 'bridge' overlooking the main living area, the balustrading is made inventively – and economically – of bicycle chain. Leading off the living area, and quite open to it, are the kitchen and dining areas where there is another unexpected device: a cantilever table that can be adjusted to seat different numbers of people by sliding it in and out through the exterior wall. The table slips into a hollow table-top outside, which – yet another cantilever

construction – is used for alfresco eating in summer. The cantilever technique is popular with Julian Marsh: he has also used if for a counter between the cooking and eating area.

■ With a cantilever table, there are no legs to get in the way of diners.

■ The 'pillar' and counter between the kitchen and dining areas are set at an angle, giving a dynamic interplay.

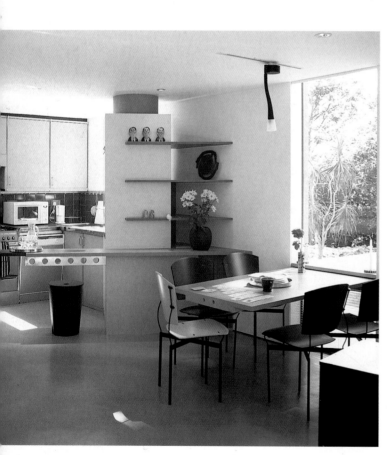

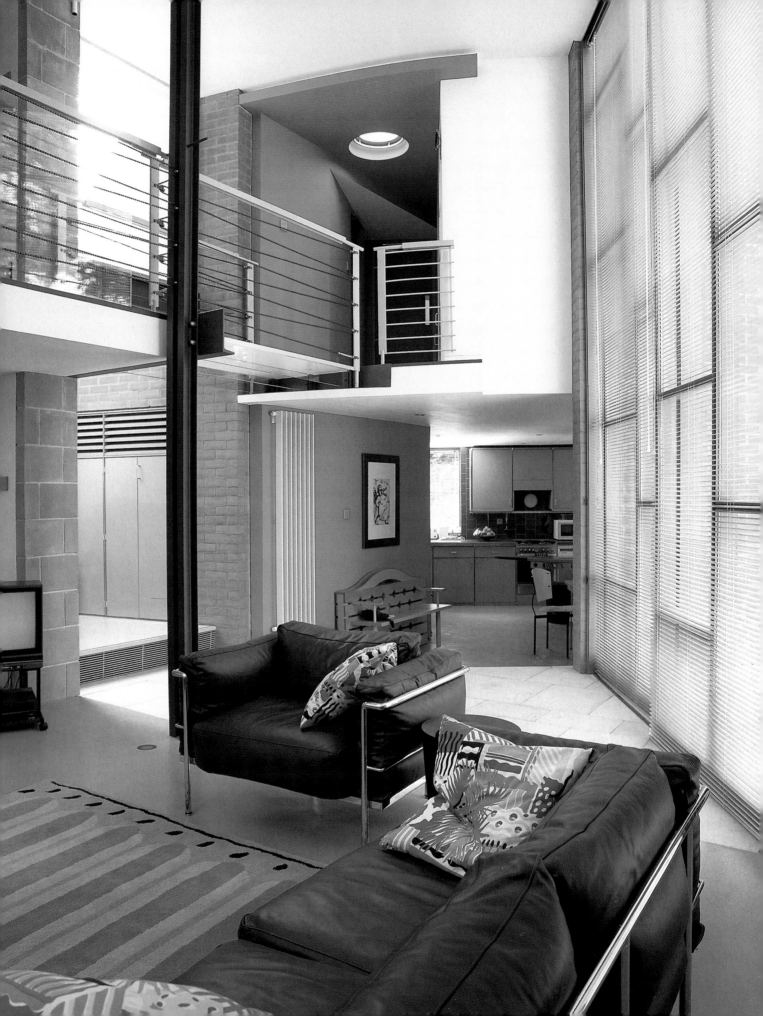

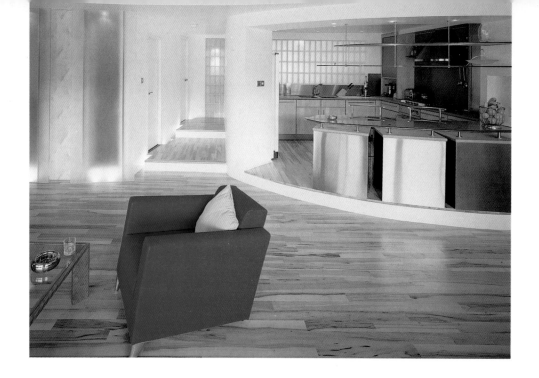

DEALING WITH **BIG SPACES**

These two kitchens are in the same location, a former industrial building now converted into apartments. Their design by Wisam Kamleh was overseen by Circus Architects partner Nigel Reynolds and shows alternative solutions in open-plan, loft settings. For the one at right, the clients wanted a scheme that was modern, not too expensive and childproof. One material that fits those criteria especially well but is an unusual choice is concrete. Its virtues include low cost, suitability for moulding on site into whatever shape is wanted, durability and receptiveness to pigments and different surface effects. Here it has been used to form a curved work surface that has been sanded, polished and sealed to produce a smooth, slightly shiny finish. The outside of this unit – one end of which is used as a breakfast bar – is plastered between the concrete supports. The concrete worktop was designed to allow for inset hotplates, hobs and maple chopping boards. Against the far wall, the concrete worktop was formed to take the sink and draining board. The cupboards to either side are made of painted MDF. In the kitchen shown above, the carcasses of the freestanding units are made of chipboard, faced with stainless steel. Steel is also used for the splashback above the birch-fronted units against the wall. A worktop made of two layers of laminated glass is suported on metal rods, echoed in the construction of the suspended shelving directly above. A glass-brick wall separating the kitchen from a bedroom maximizes light.

■ Given an imaginative treatment, inexpensive materials such as chipboard, MDF and concrete are practical and can often be used to much greater effect than many more costly, ready-made fittings.

■ Where there are changes in floor level, the risers are defined in white to prevent tripping.

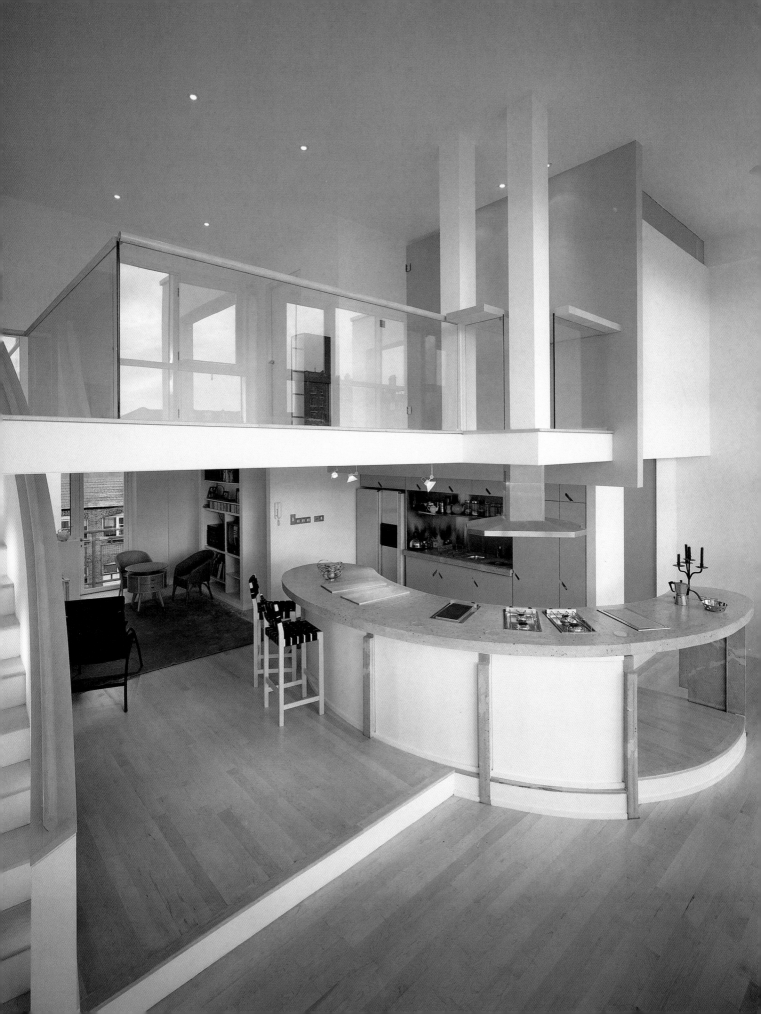

BACK TO **SCHOOLDAYS**

A huge, light, living space is an enviable rarity in a city, but transforming it into a friendly, family home is not the easiest of tasks. This room, once part of a Victorian schoolhouse in Battersea, measures an astonishing 24 metres long by 7.5 metres wide and has a 4.3-metre ceiling height. With proportionately large windows on three sides, it is flooded with natural light which emphasizes the room's magnificent scale. When Julian and Melanie Metcalfe bought their schoolhouse home, they made the top two floors into bedrooms and bathrooms, and this floor – the ground floor – into an all-in-one kitchen/dining/living room. Although the sheer impact of the space might have tempted some people to follow a

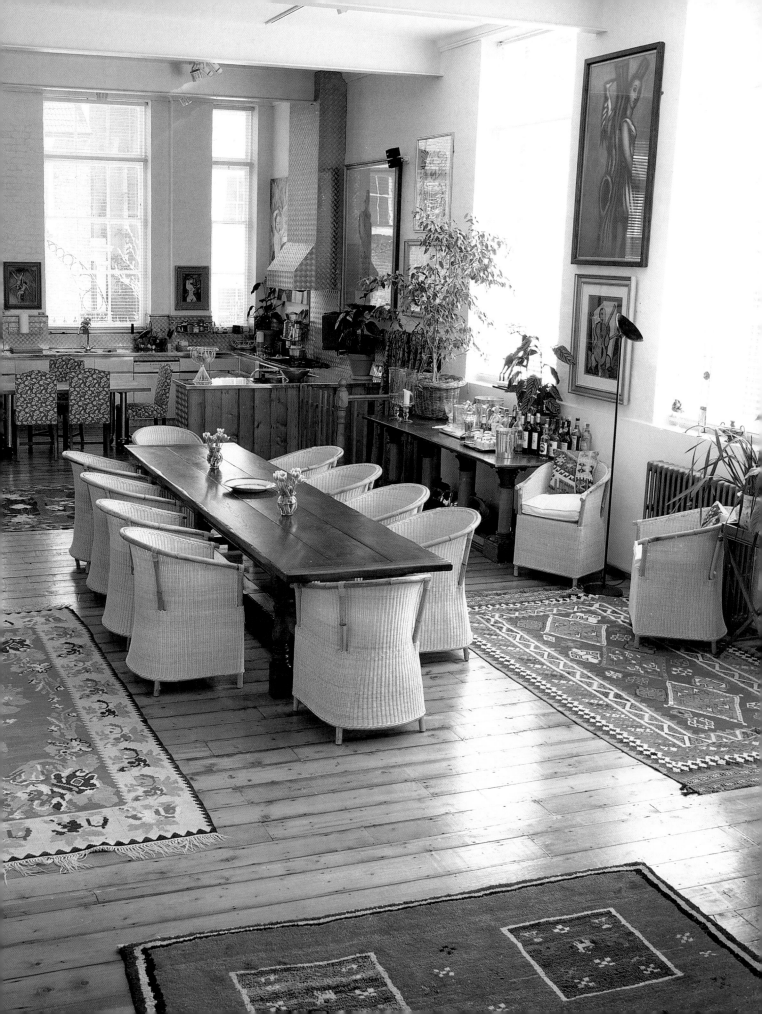

minimalist line, Julian Metcalfe takes the view that minimalism is incredibly expensive: it may look as though nothing is going on but, as no detail is too small to be disguised, it demands total perfectionism. In any case, the Metcalfes wanted an easy-going, usable home and, as they aleady owned a lot of comfortable furniture and good pictures, it was more a question of incorporating what they had and, where necessary, adding to it. They bought rugs and upholstery at auction, while some of the more basic things were found at Habitat. 'I'd rather spend the money getting the space right,' says Julian. 'It's staggering how many people buy really expensive houses that are impractical. Often, most of the rooms are shut off from one another. If you don't have a dinner party every night, what's the point of having half your living space given over to a dining room?' True to his philosophy, Julian has made quite sure that the dining

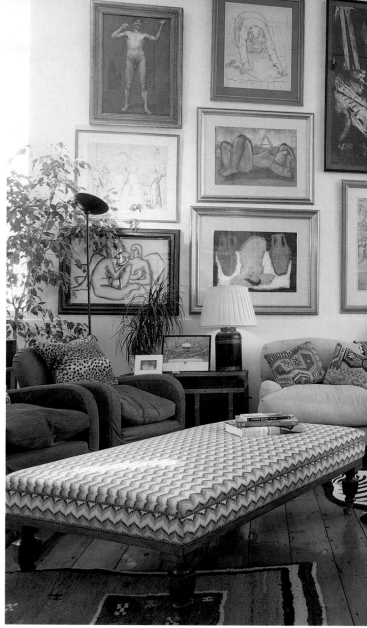

room is not a shut-away waste of space. Sited between the sitting area and kitchen, the dining area is the room's epicentre, but the low height of the chairs ensures that there is no interruption in the view from one end of the room to the other. Dining is central but not dominant. There is another eating area in the kitchen, which is semi-divided from the rest of the room by projecting banks of low units made of MDF, faced – on the kitchen side – with polished steel. The splashback in the kitchen is made of aluminium floorspaceplate – a signature finish in the

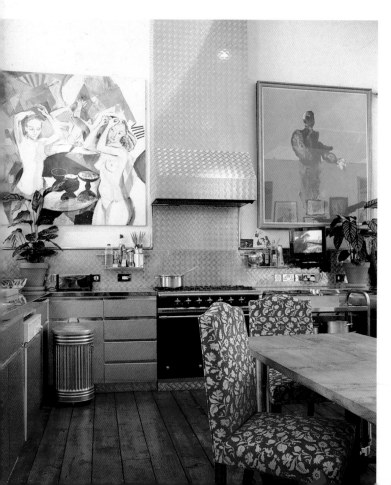

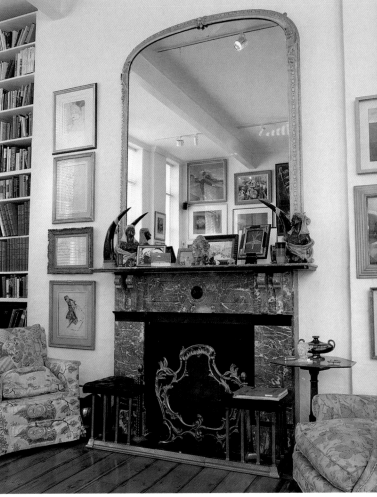

Prêt à Manger fast-food empire founded by Julian. The paintings in the kitchen are big and colourful – in fact, colour and pictures are keynotes throughout the whole interior. Julian Metcalfe – who says he could not have done the room without the help of his interior-designer friend William Nickerson and his stepmother, decorator Sally Metcalfe – has taken full advantage of the height of the room and hung his extensive art collection right to the top. As most of the pictures are bold and fairly large in scale, they can be placed well above eye-level and still be appreciated.

■ Apart from the exorbitant cost of curtaining so many large windows, the enormous amount of fabric involved would have looked overblown and out of character in this type of interior. Blinds are a better chioice.

■ Keeping the furniture low maintains an open vista across the room. Hanging the pictures right up to the ceiling prevents any feeling of emptiness overhead.

■ 'Clubby' furniture, bright colours and vivacious patterns look friendly and have the space to breathe in a big room.

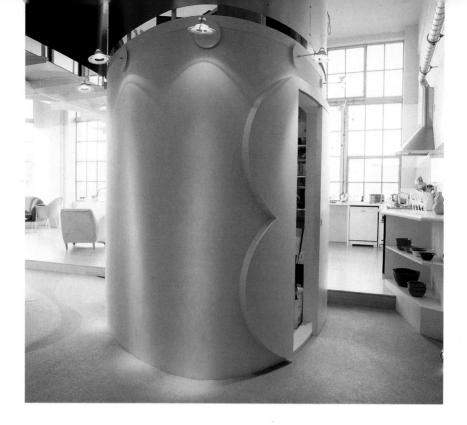

HIGH **IDEALS**

Where and how to include essential cupboards in a big, open loft so that they are easily accessible but do not appear stranded in the middle of nowhere is a conundrum. Having lived abroad in rented accommodation for several years, the Vaights had been subjected to other people's design mistakes and knew just what they wanted when they bought their own home back in London. With the help of Circus Architects, they devised an imaginative plan with a brilliant solution to the storage question. This is in the form of a 'utility pod', which separates the kitchen from the seating area and provides housing for the vacuum cleaner, ironing board, wine and so on. When you enter the apartment, you see the pod's voluptuously curved wall; on the other side of the pod, next to the kitchen, is a bank of cupboards. The kitchen workbench has doors and drawers with orig-

inal 1950s facings; the work surface and splashback are made of pre-moulded Corian. Above the splashback run panels of aqueous-green sandblasted glass. Overhead lighting, designed by Circus and Box Products, creates an open web that can be appreciated when looked down on from the gallery/study and does not obscure the view.

■ Siting the oven adjacent to, rather than below, the hob allows for a heat-resistant 'trivet' to be incorporated neatly in the surface directly above it – a practical feature when lifting up heavy pans. Here, stainless-steel rods are partially recessed in grooves.

■ Overhead lighting on wires gives good overall illumination and creates the effect of a ceiling in a high space without diminishing the sense of airiness.

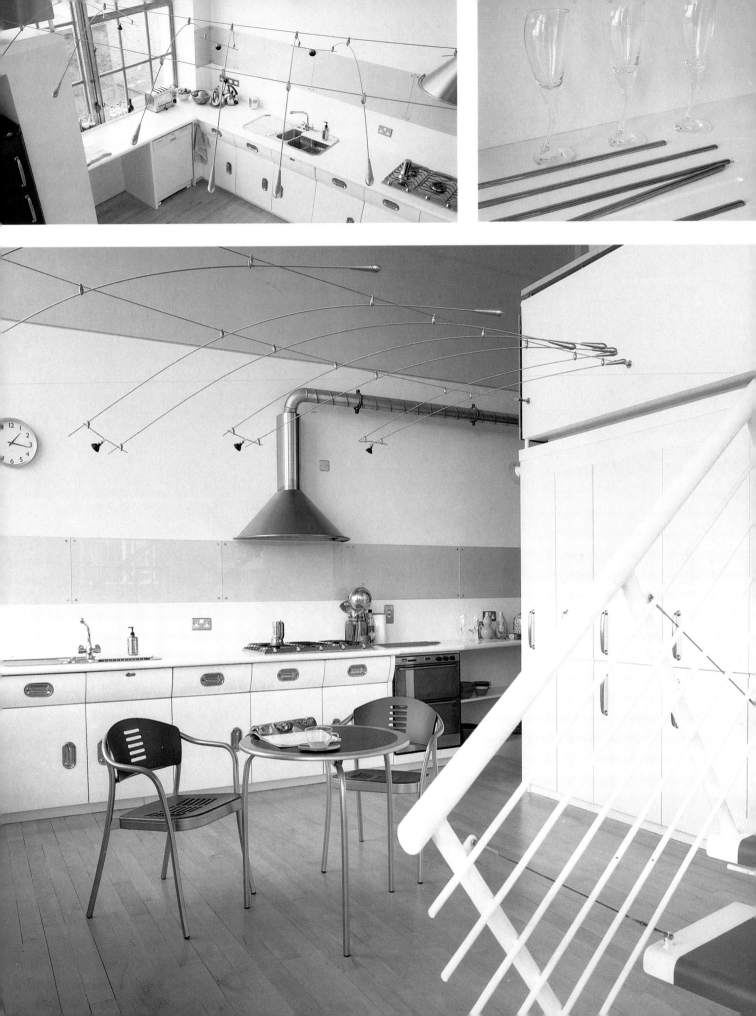

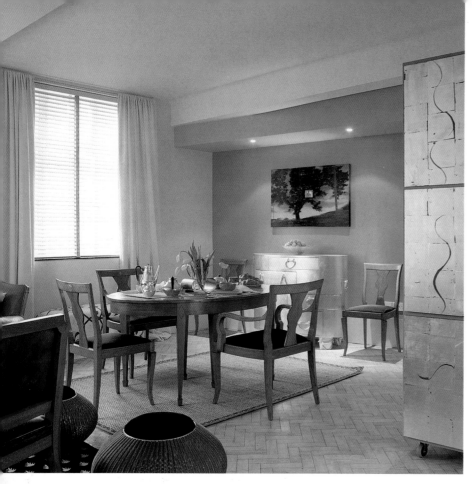

A FLEXIBLE
ARRANGEMENT

Jenny Armit is one of Britain's most original interior designers, both in her use of space and in her style of decoration. This open-plan interior in a converted telephone exchange reflects these talents. The structure offered generous floor area but its former existence as an industrial building imposed certain difficulties for conversion. These included a massive support-beam cutting across the main space, a lopped-off corner and some major ducting. Working with architect Mya Manakedes, she chose to keep the interior as unconstricted as possible and, rather than introduce too many internal walls dividing up the drawing room, eating and cooking areas, she has used mobile 'furniture' and planes of vivid colour to differentiate functions. For instance, the fridge and oven

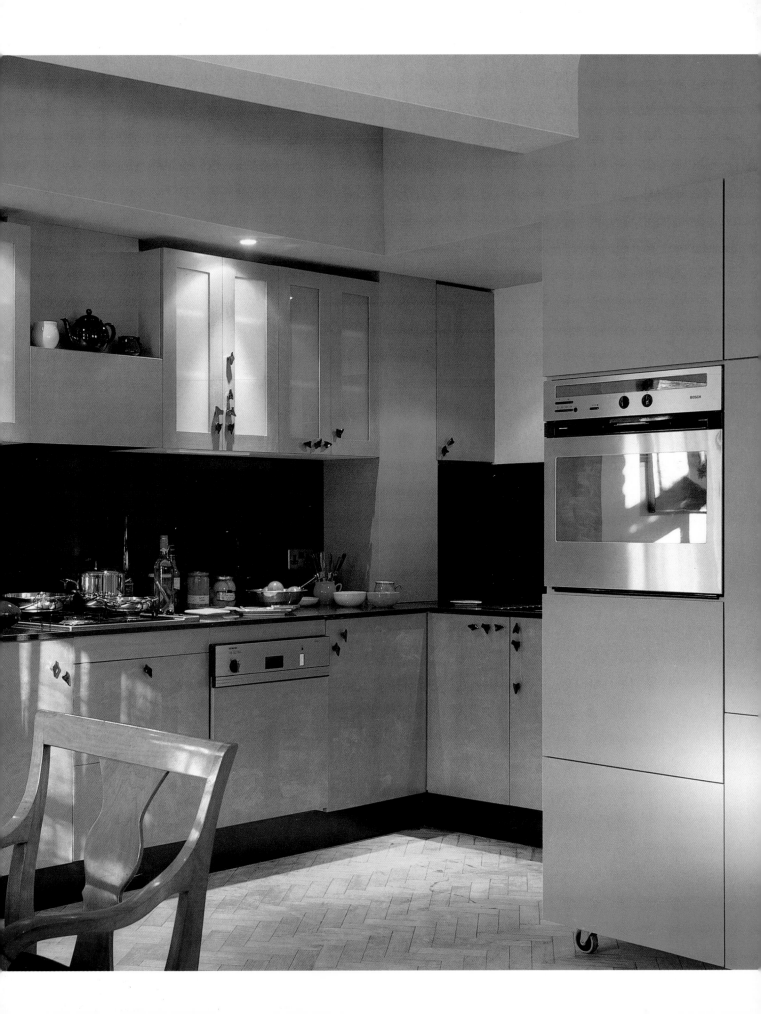

are housed in a unit on wheels, which is connected to the electricity supply in the ceiling and can be moved around to form a wall to conceal from diners unsightly clutter in the kitchen. The unit is finished in lime green – to match the far wall in the dining area – and, on one side, has a 'screen' of silver-leaf applied in a grid pattern by artist Baby de Sellier. Although the unit is primarily a functional work station, the treatment of the screen turns it into something of a sculpture. 'We wanted it to be an "object", not just a gilded panel,' explains Jenny, 'and we achieved this effect with silver leaf scored in different layers.' The kitchen cupboards are another illustration of how something relatively ordinary can, with ingenuity, be made special and individual. Their doors are MDF that has been given an Adembrite copper glaze, then dressed up with organically shaped knobs. The worktop and splashback are in dark siliceous quartz. The sheen generated by these finishes, plus the rich tones of the floor and satinwood dining table, generate a visual warmth. 'In such a hard, industrial space I wanted to soften and lighten. It was that glow I was after – burnished wood, waxed maple floors, a silvered patina on the mobile unit and chest in the dining area...they all make their contribution.'

■ The oven and fridge are housed in a movable unit which can be wheeled into different positions to conceal from view the kitchen clutter.

■ The unfussy window treatment combines blinds and full-length curtains hung simply from a rod.

■ The herringbone design used for the wood-block floor introduces a discreet element of pattern.

■ Well-placed lighting gives definition to specific areas and points up design features.

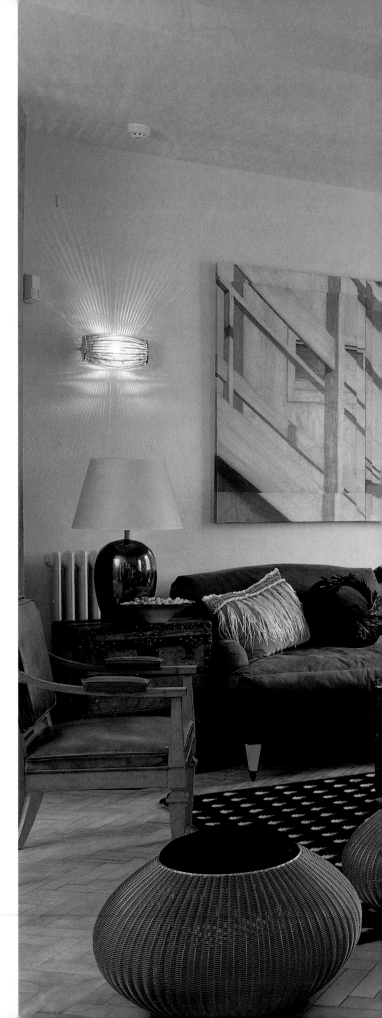

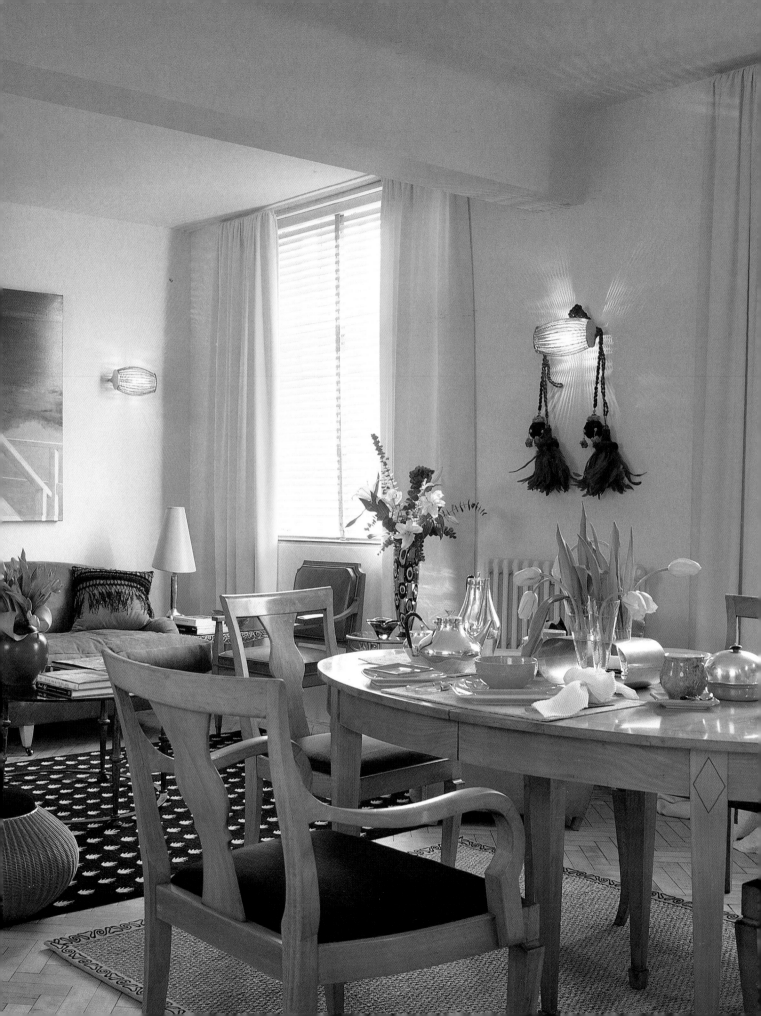

FAMILY MATTERS

Having experienced a kitchen with a 'wonderful walk-in larder', art consultant Sue Williams made the provision of adequate space for food storage a top priority when she moved to a large – but larderless – flat in South Kensington. The units by The Newcastle Furniture Co were selected because Sue felt that the elegant period room would be best suited by simplified, traditional detailing and clean lines. An extra-large fridge and a tall cupboard together provide the vital larder substitute. The kitchen's worktops are in different finishes chosen according to their function: next to the cooker is stainless steel to

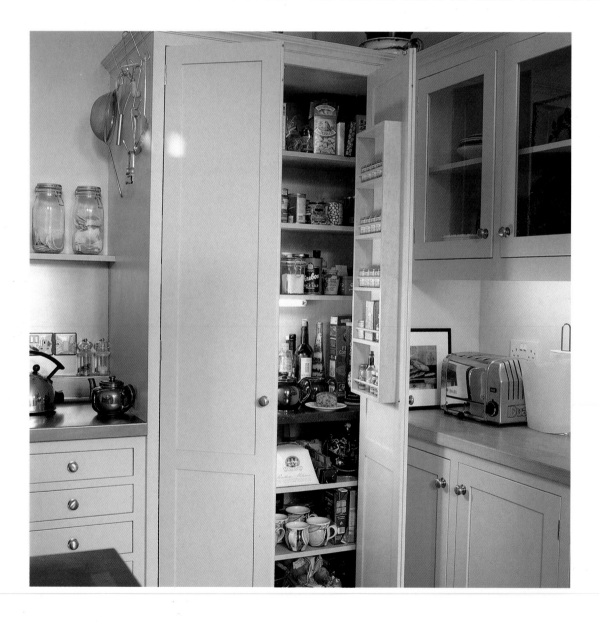

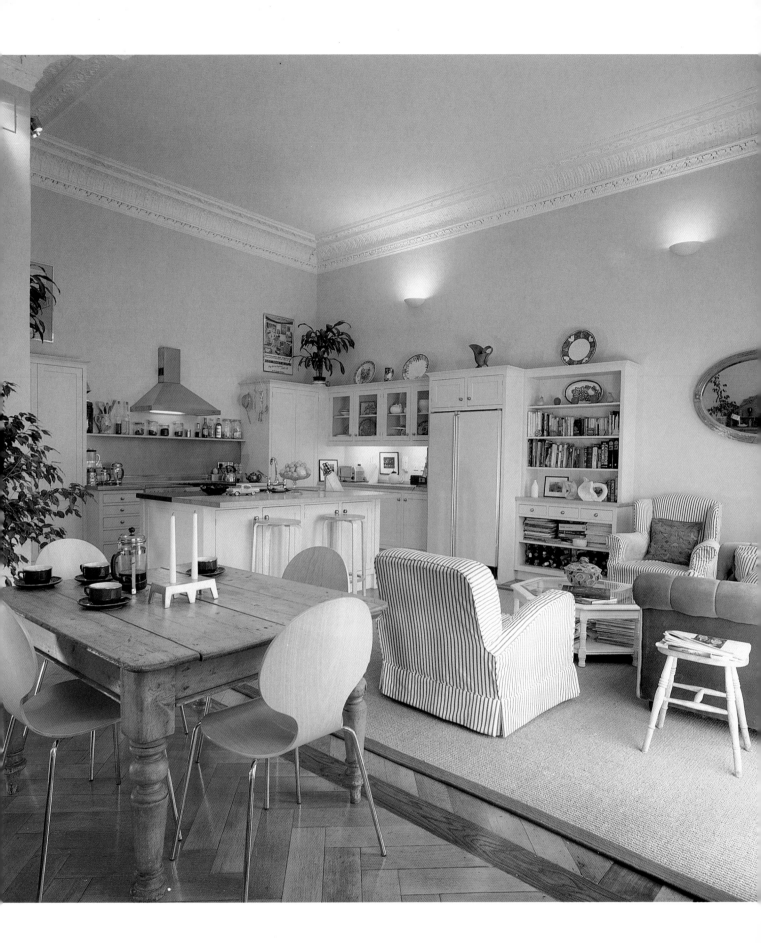

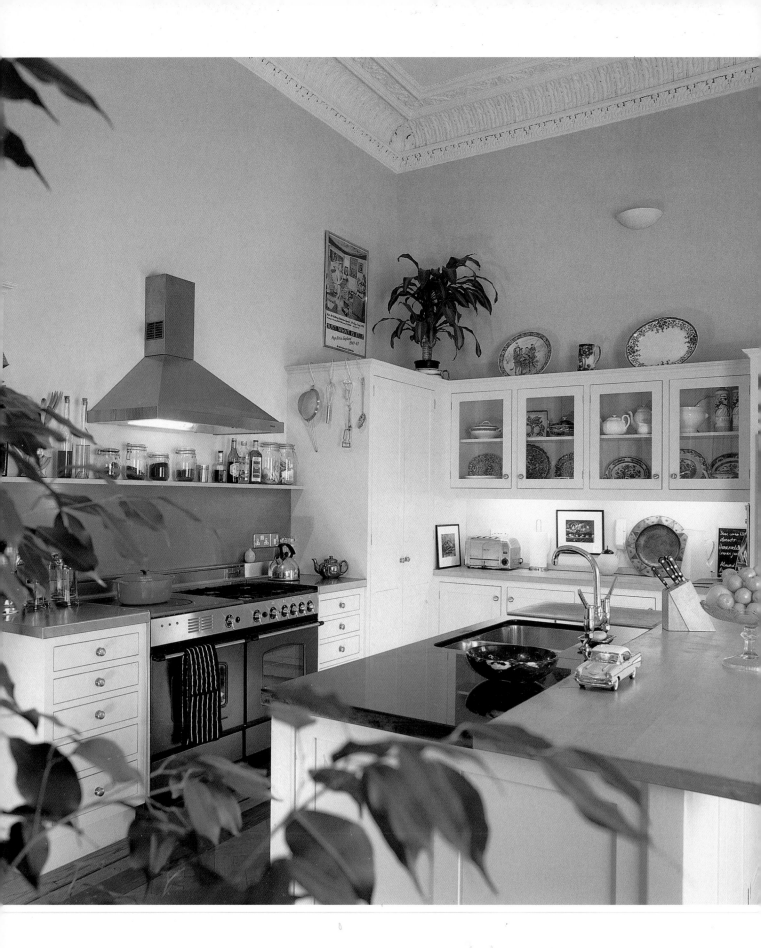

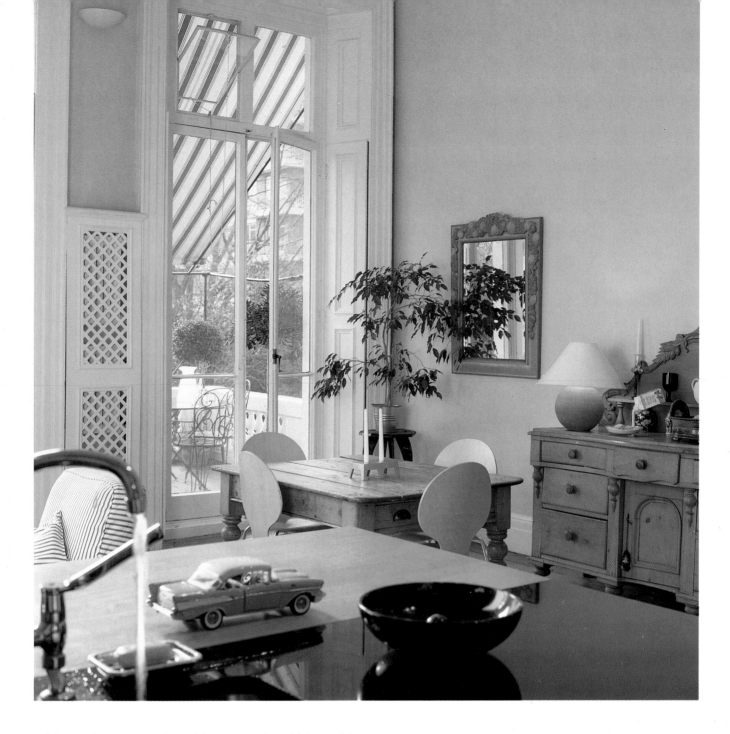

withstand the heat of cooking pots; the sideboard is topped with wood, while the island unit has black granite. The kitchen occupies one corner of what is an agreeably casual room, where a child can do homework, newspapers can be read, food cooked and meals eaten. It is the ideal, all-accomodating 'home' – 'so much so,' says Sue, that 'no one ever wants to leave this room and go to the sitting room next door.'

■ A casual mix of old and new furniture, plus comfortable seating, all looking as though it has come together through evolution rather than contrivance, is the best way to perpetrate an attractive homeliness.

■ If you do not have a larder, buy a fridge which, if anything, is bigger than you think you need. You will almost certainly find you use the extra capacity.

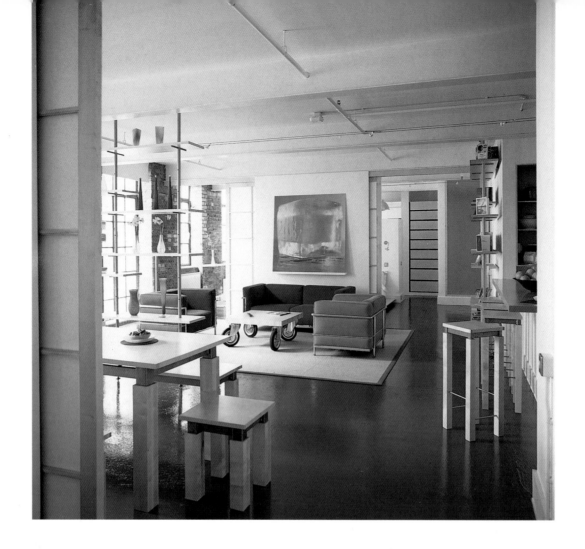

CONVERTING AN **EMPTY SHELL**

'Somewhere calm in the storm' is how Ian Tarr describes his apartment in the heart of Soho. Having lived for seventeen years in a converted Georgian house in the suburbs, he decided on a total change and took on an urban loft which was just an empty shell. He commissioned architectural designer Nico Rensch and his practice Architeam to interpret his brief for uncluttered simplicity, plus three practical requirements: a combined kitchen/dining/living area, a main bedroom with bathroom, and a study-cum-guest room. The challenge for the architectural team was how to achieve a layout which would not spoil the very thing that had attracted Ian Tarr to the building in the first place: the opennness of the interior. The solution has been achieved with a nod to Japanese domestic planning, in which paper screens are used to divide up space visually rather than structurally. Here, the screens are made of fibre-patterned polycarbonate, not paper, but their purpose is the same as in the East. A pair of screens slides into a cavity wall 'pillar' to separate the bedroom from the living area. Between the seating and dining areas, an open shelving unit acts as a minimal division – more symbolic than obvious. As a keen cook who likes

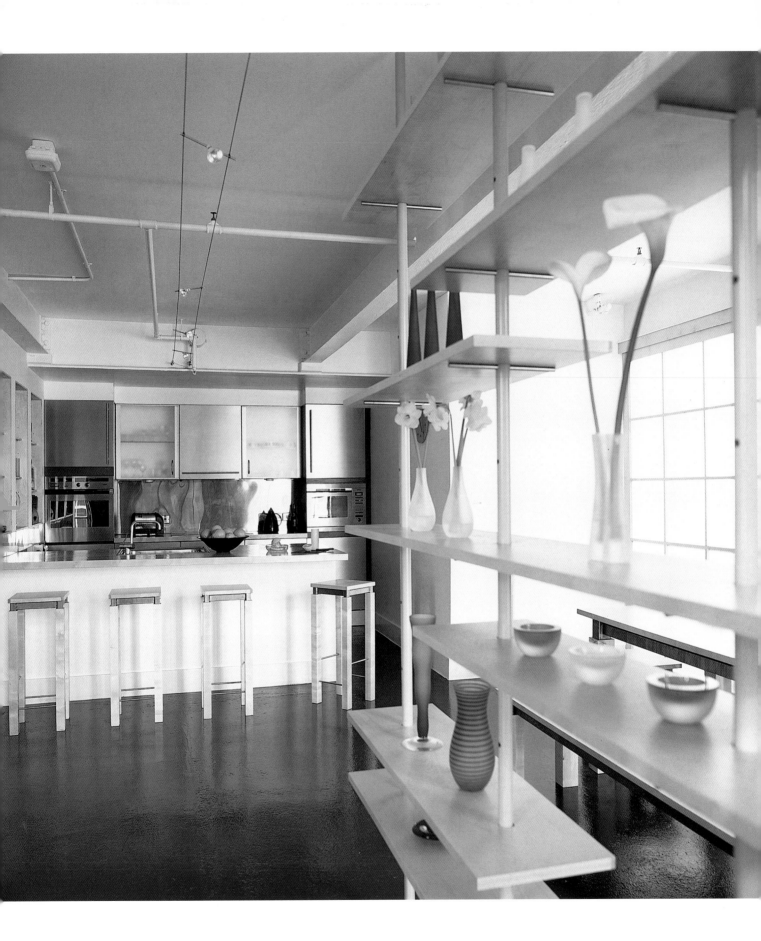

entertaining, Ian Tarr enjoys being able to talk to his guests whilst preparing the food. The furniture throughout is modern and angular, and the vivid-blue colour scheme is underpinned by the painted floor. The external walls have been left unplastered as a reminder of the building's industrial past. In fact, the industrial origins of the loft have been exploited to play an integral part in the new scheme: the criss-cross effect of the steel girders and fine pipes of the sprinkler system has been perpetuated by the cables carrying the lighting system. Even the catering-style, stainless-steel finish of the kitchen units reflects the building's urban heritage. In spite of this, however, the general ambience of the interior is calm and ordered, a true haven from the city bustle it overlooks outside.

■ Sliding screens give flexibility in dividing different areas without destroying the sense of space.

■ Open shelving – fixed to extendable, metal poles which reflect the building's industrial origins – creates a sense of separation between areas but reduces light only minimally. It also allows the display of glass objects to be seen from both sides.

■ Bench-style seating at the dining table is more streamlined than chairs for a modern interior.

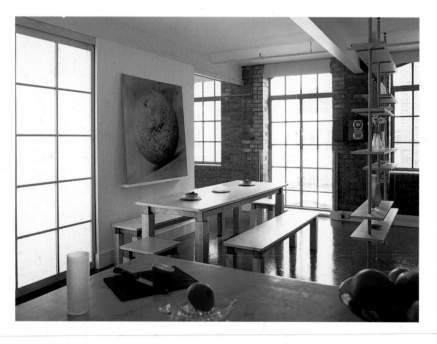

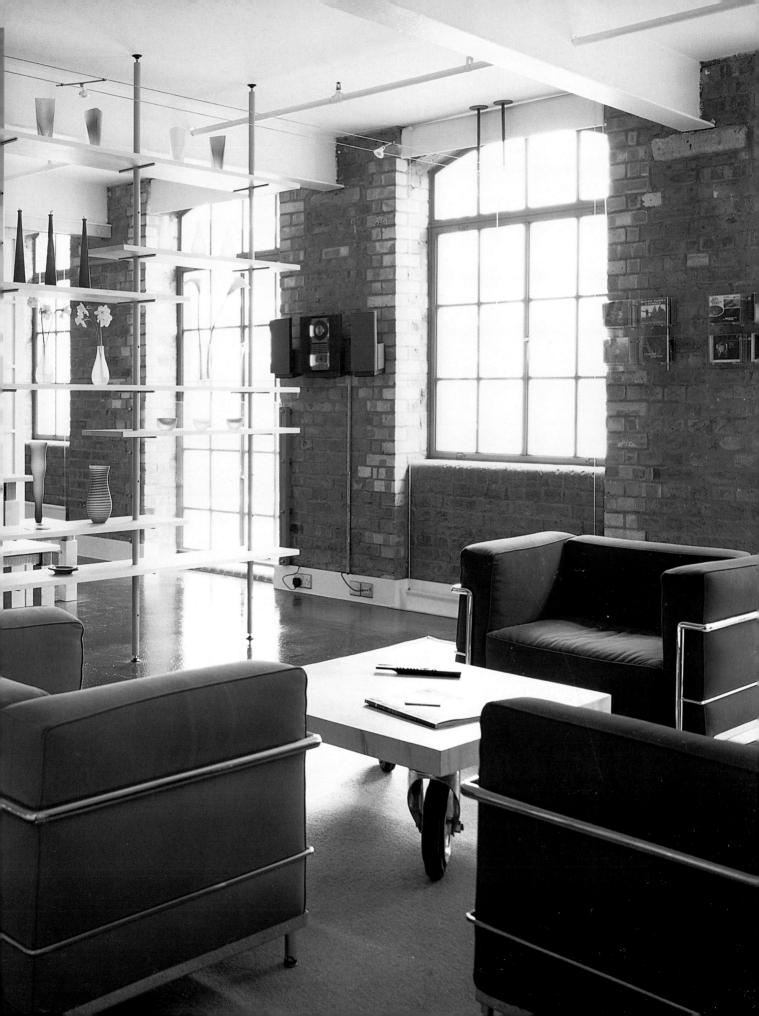

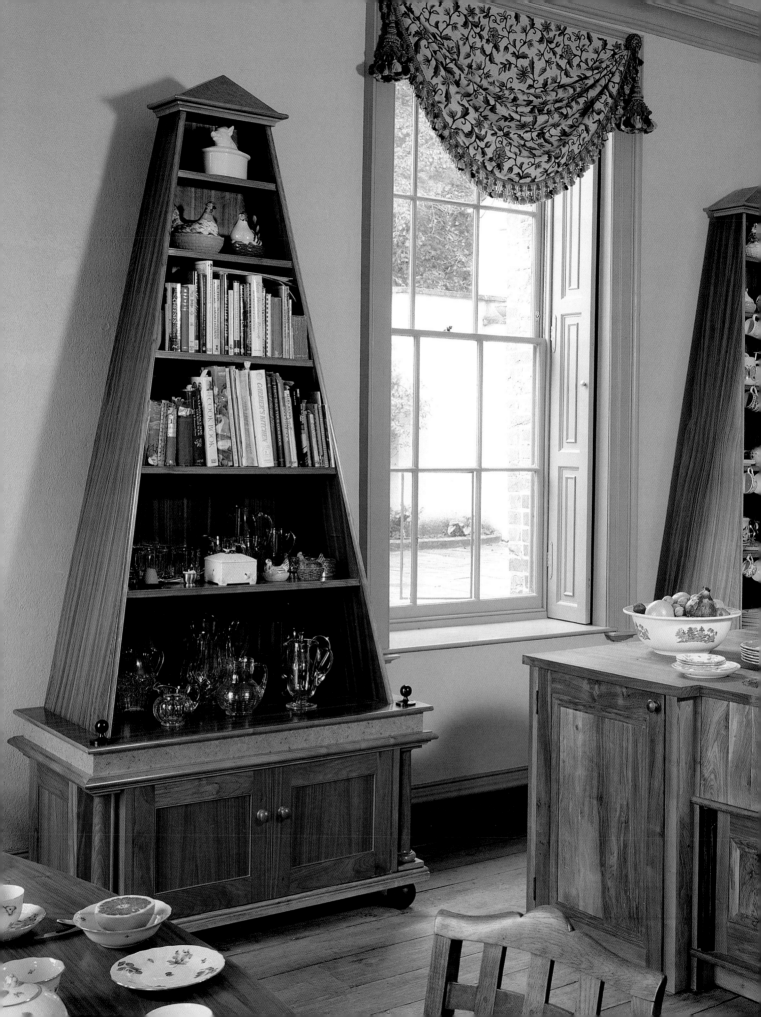

INSPIRATION FROM THE PAST

As the kitchen plays such an important part in all our lives, many people have an understandable wish to reflect a reassuring feeling of home in its decoration. They also feel that an interpretation of a historical style may be more sympathetic than an all-out modern one in a period house. A skilful designer can incorporate elements that bridge the disparity between present-day functionalism and traditional design motifs: in the kitchen shown on pages 130-133, for example, the Arts and Crafts character of the house inspired the detailing of the wooden units, while Mimmi O' Connell found inspiration in an eighteenth-century library in Stockholm, which led to her numbering the battened doors of her cupboards (pages 124-125). The numbers were included more for fun than for indexing but, like the little Chinese figures painted on the wall, they are highly decorative. The graphic, rather severe forms associated with the Biedermeier style are well suited to functional cabinetry, as can be seen in the room on pages 126-127, designed by David Wright. The painted illusions on pages 128-129 are decidedly more whimsical but have a practical spin-off: one creates a 'view'; the other hides kitchen appliances.

One of the most striking features about this kitchen is the pair of obelisk cabinets. Totally unlike typical kitchen storage units, they provide an appropriately classical, architectural note in an elegant, eighteenth-century interior. The cabinets were designed by Alexander Brydon, using walnut, the same wood being chosen for the preparation / sink-housing island which is topped with teak and green Cumberland slate. The scheme gives an un-kitcheny feel to the room – which was an important consideration in the brief from the client – but is nevertheless practical.

GOTHICK DETAIL

Rather than opt for a kitchen that is one-hundred-per-cent 'today', using contemporary styling and materials for all the surfaces and storage units, Gill Hornby, whose room is seen here, took a different direction in deciding to go for a traditional look and match the detailing of the kitchen cupboards to the style of her Gothick rectory. The cupboard doors and dresser with pointed-arch detail reflect the building's architectural idiom.

Originally, this room was a mere galley of a kitchen and had a staircase leading up to the back of the house. In order to gain a pleasant, well proportioned new kitchen, the space was totally reorganized, the ceiling lowered, a new doorway created to give access to the adjoining family room, and stone-mullioned windows installed to bring in extra light whilst being in keeping with existing ones. The scale and layout of the room were also determined by Gill Hornby's wish to incorporate a large table, measuring 3 metres long by nearly 2 metres wide, and eight chairs. Christine Scott Interiors helped with the room's design; Peter Thompson of York made the units and dresser.

■ The joinery details reflect the Gothick style of the house.

■ Maple is used for the worktops.

■ A ceiling rack provides practical, decorative storage for cooking implements.

■ Curtains are drawn back only to one side of the windows, in order not to block out too much daylight.

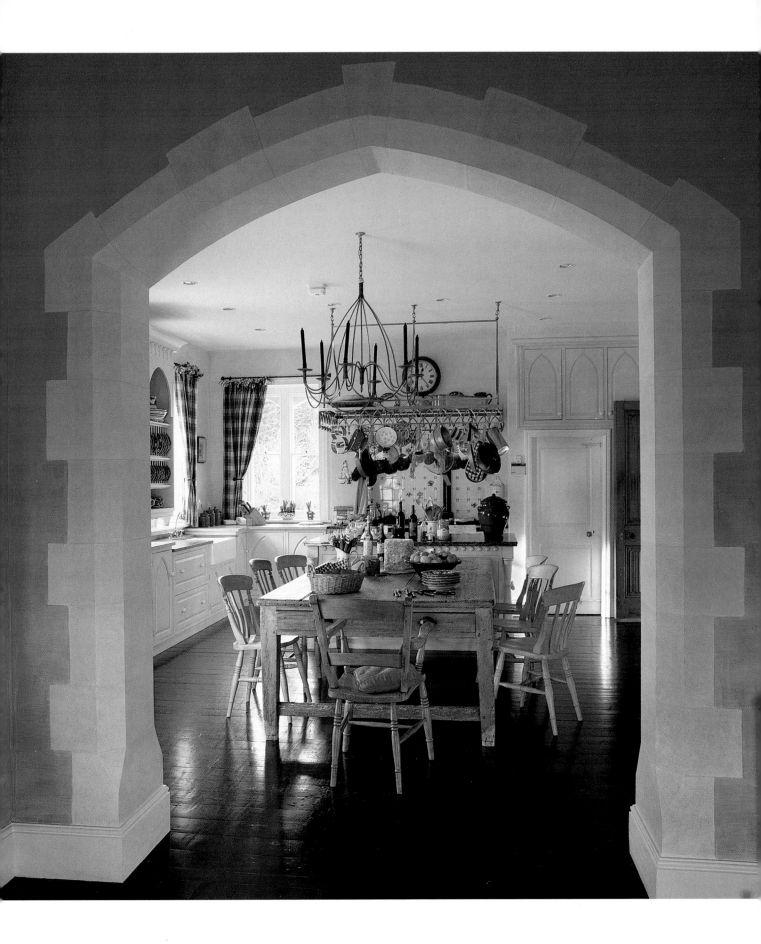

GUIDED BY THE PAST

Whilst respecting the integrity of old houses with architectural merit, Anthony Paine does not believe that a designer should be totally hamstrung by it. His talent lies in understanding historical styles, allowing himself to be guided by the original details and then interpreting them for modern living. The room shown here is in a house in Hampstead, designed in 1913 by the accomplished architect, Cyril Fairey. The owners, Alan and Joan Smith, were anxious that their new kitchen should be in keeping with the Arts and Crafts character of the house but they had a number of more functional requirements, including provision for the family to make snacks whenever they wanted without encroaching on the main preparation area. Anthony Paine began by creating a wide opening in the wall between the under-used dining room and the intended kitchen. Double doors

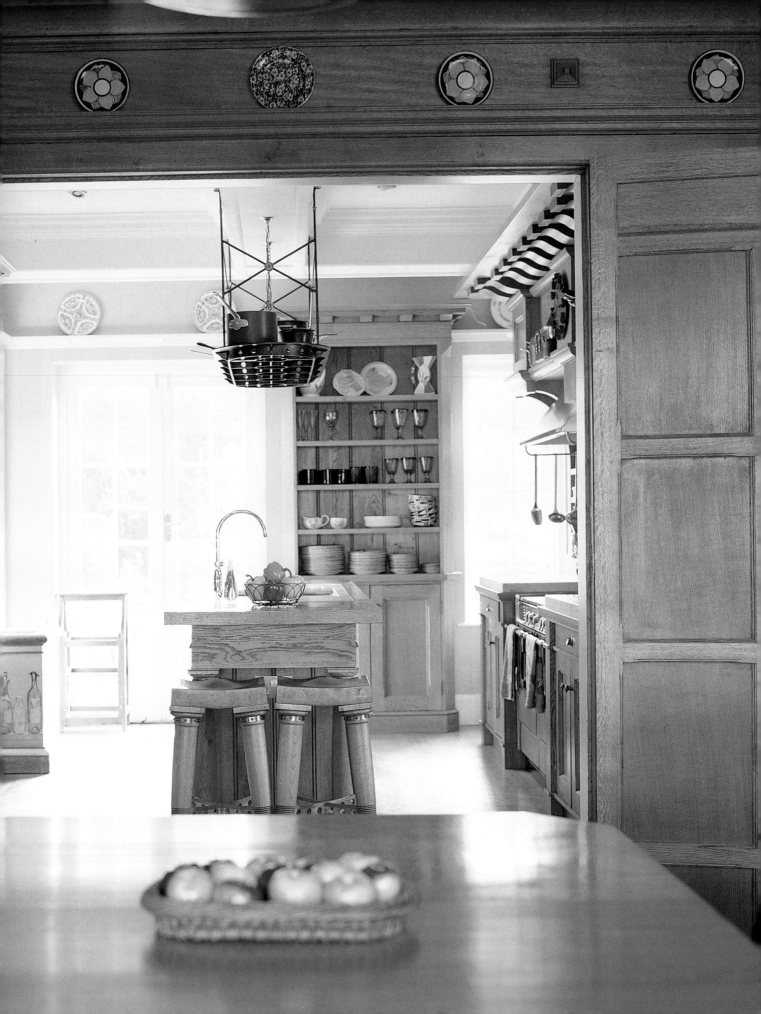

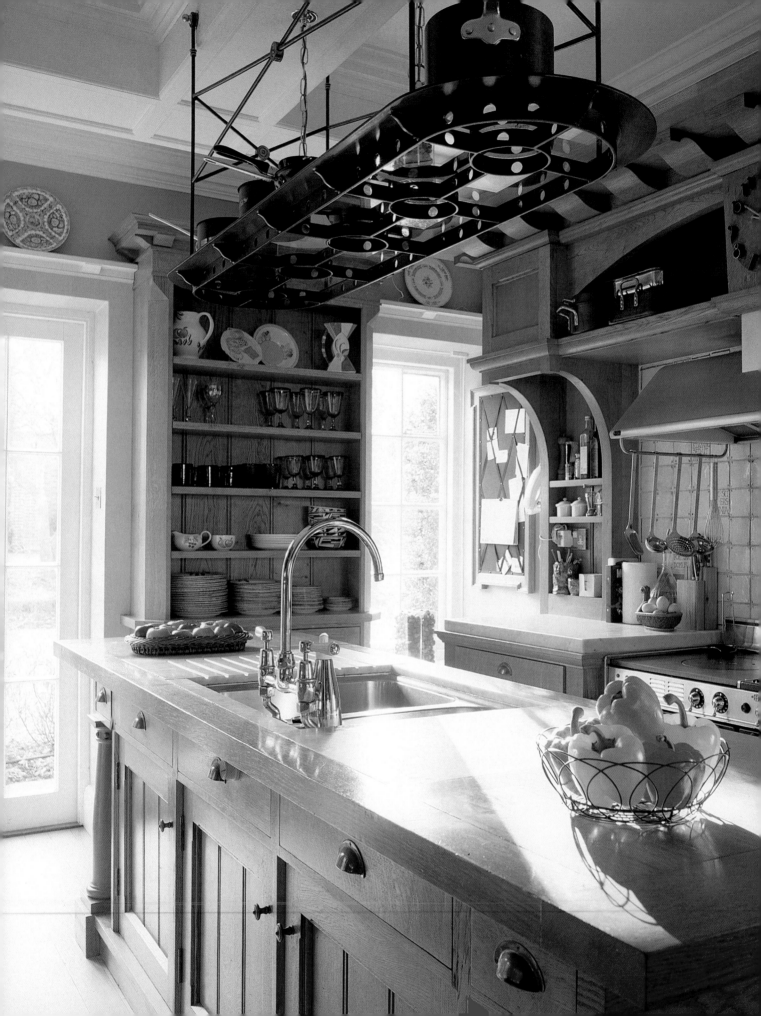

were made, re-using the original panelling. The kitchen appliances – chosen for their efficiency, of course, but also for their good, contemporary looks – are integrated with units made entirely of quarter-sawn English oak. Details, such as the brackets to the shelving above the cooker, reflect those in the dining room, particularly of the chimneypiece. The industrial-sized sink in the island unit was specified because it is big enough to take a roasting tin laid flat for soaking and cleaning. The design of the kitchen stools is a further interpretation of the Arts and Crafts style.

■ New beams replicate the original ceiling; one of them ingeniously conceals the duct from the extractor fan.

■ An industrial-sized sink is practical for cleaning large pots and dishes.

■ Creating a wide opening between the kitchen and dining room makes the latter more inviting to use on a regular basis.

■ Hand-painted tiles, incorporating the names of the maker, kitchen designer and owners, lend a personal touch.

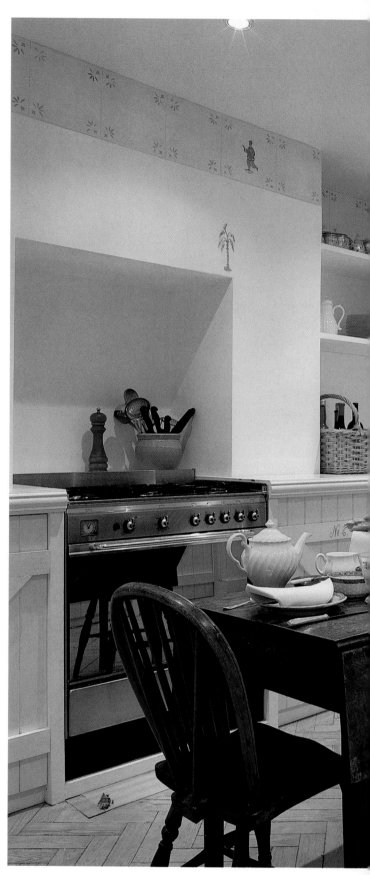

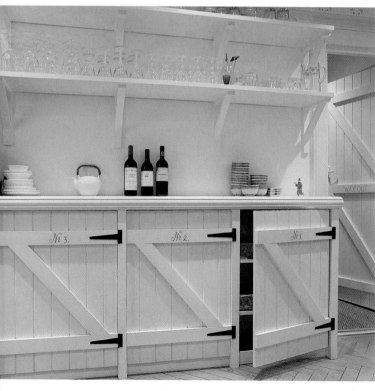

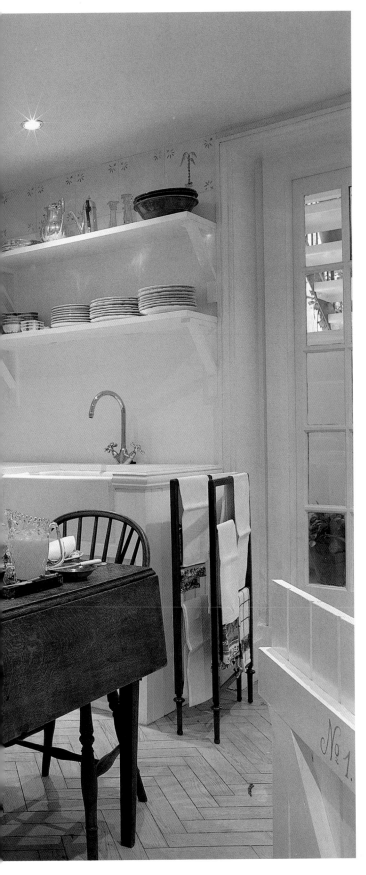

FROM **STOCKHOLM** TO LONDON

In whatever style Mimmi O'Connell decorates, she always carries it out with ebullience. Unlike her previous, heavily decorated home, this one is light and, in the kitchen, has what she calls a late-eighteenth-century 'Gustavian mood', prompted by a trip to Sweden. The cupboards are all numbered. 'I took the numbering idea from a very grand library in Stockholm,' she says. 'I use it here, in a modest way, for fun. Indexing is a feature more usually associated with books which are often on numbered or lettered shelves.' A reference to Mimmi O'Connell's Chinese interests is seen in the frieze incorporating charming little Chinese figures painted in blue. Her library/dining room is shown on pages 194-195.

■ Cupboard doors resemble stable doors and, index-like, are numbered – 'for fun'.

■ A frieze with lively-looking Chinese figures adds a further note of humour and vitality.

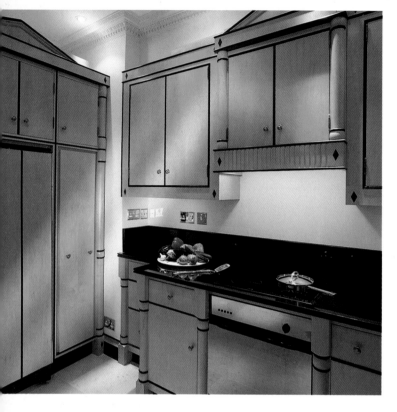
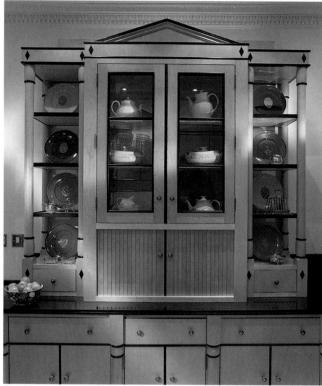

BACK TO **BIEDERMEIER**

The handsomely austere lines of the Biedermeier style, which developed on the Continent from about the 1820s, lend themselves to modern cabinetry, as can be seen in this adaptation of the genre in an Edwardian flat beside the Thames. Designer David Wright opted for the look because he felt it met the grandeur of the building and was the 'something stylish and different' requested by his client. The cabinets, made by Robinson and Cornish, are in the typical Biedermeier combination of pale wood – in this case, tinted maple – and black lacquer. Instead of looking like nothing other than functional storage units, they make the room seem 'furnished' whilst cleverly concealing appliances. The dresser, for instance, houses a washer/dryer and dishwasher, and an oven/microwave is hidden behind the shutters. A small eating area takes up the window bay where the woodwork is continued along the wall and across the seat, which also provides more storage.

■ The table is designed as part of the overall scheme, using the same materials and detailing to give a continuous appearance.

■ The check blind is edged with the identical fabric, cut on the diagonal to make an integrated, interesting border.

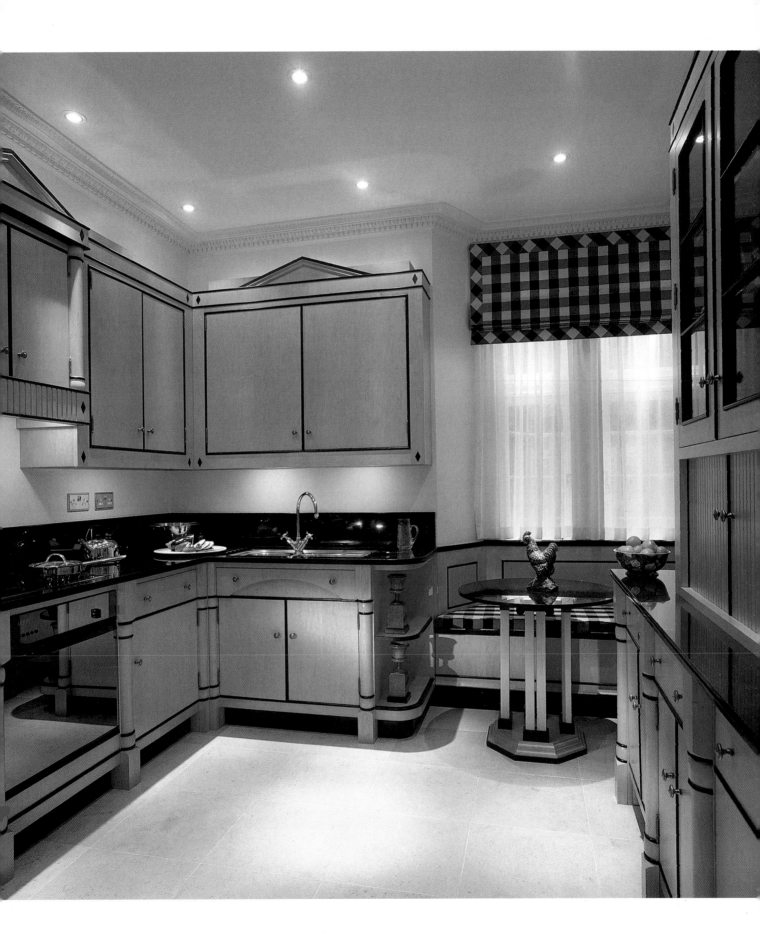

PLAYING **TRICKS** WITH PAINT

The long history of painting walls to fool the eye is maintained in these two kitchens. The one above is a tiny galley designed by Jonathan Hudson for his own flat; the other (seen at right) was devised by Fiona Allsopp. Jonathan's mural was painted by Emma Temple and depicts his pets and a house in the country where he once lived. The 'window' is framed in green to match the custom-made units with inset canework. Green is also Fiona Allsopp's choice, but here the *trompe l'oeil* painted by Chris McClure shows a clutter of books and objects intended to make the room feel like a library. Its real purpose, however, is to conceal the fridge and freezer.

■ Playing tricks with paint adds wit and can serve a practical purpose, too. For instance, a pair of doors, as seen at right, can be turned into make-believe bookshelves and hide major appliances; or a rural 'view' (above) can be opened up where none exists.

■ Doors with inset canework allow air to circulate in cupboards but offer some protection from dust.

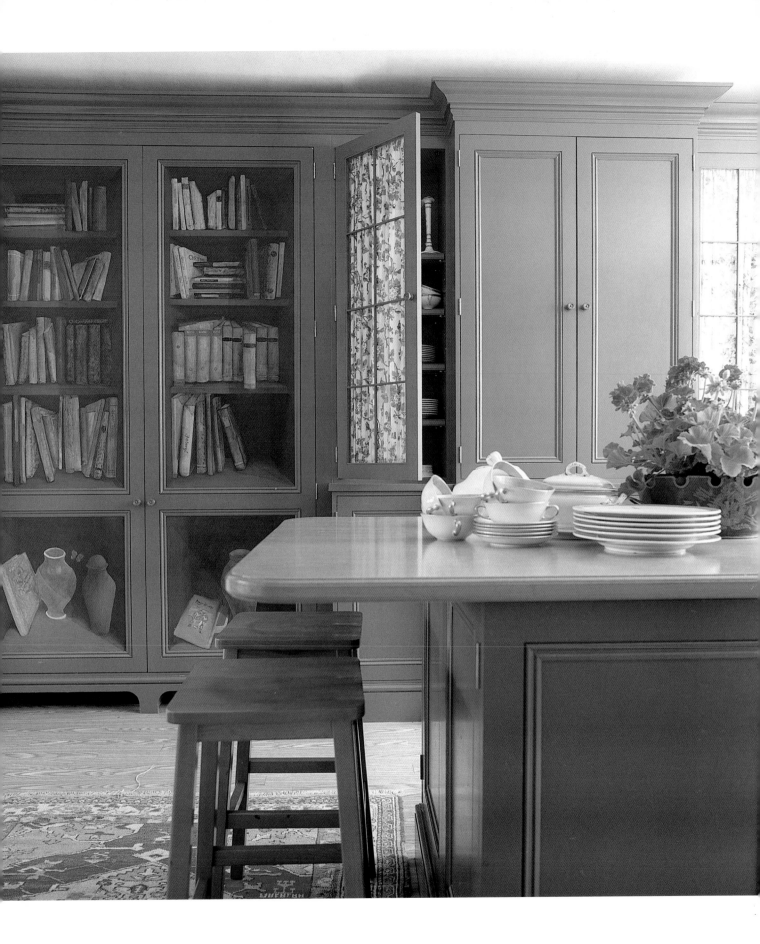

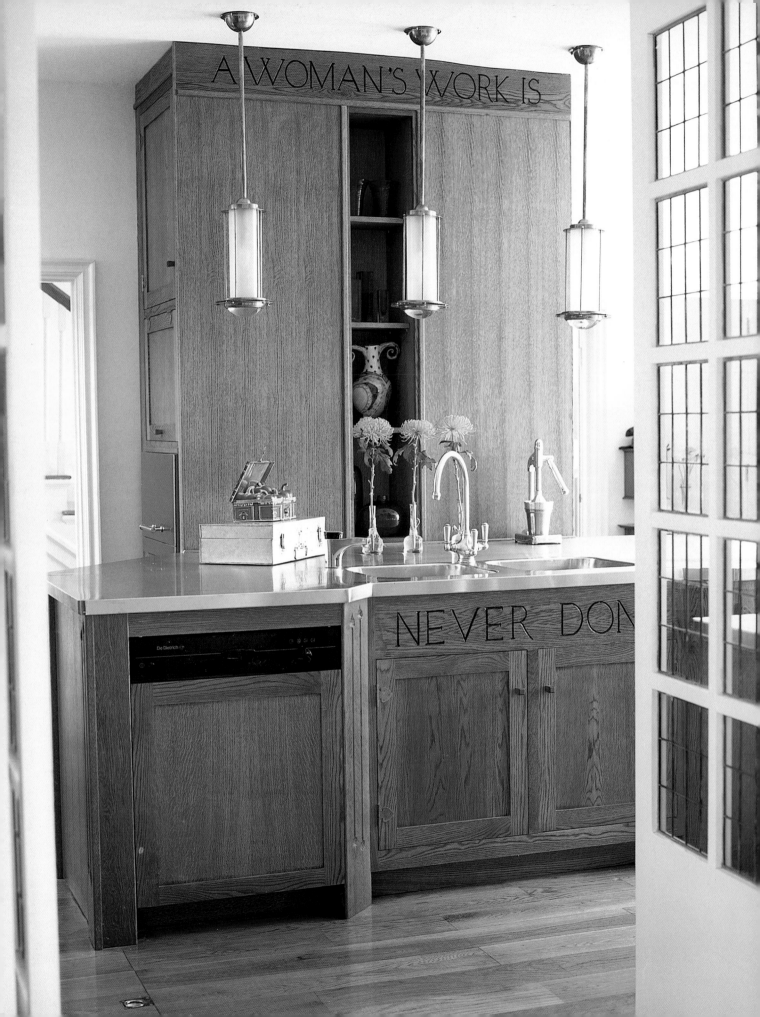

WELL CRAFTED FOR TODAY

After a switchback history of being much loved and sadly neglected, this house in Hampstead, built in the 1790s by the artist George Romney, has been given a new lease of life. Much work was needed to restore it and turn it into a practical, family home. Part of the refurbishment, which was caried out with architectural help from Geoff Reeve, included a new kitchen, a skilful mixture of sleek, modern elements in stainless steel and Arts-and-Crafts-inspired wooden cabinetry. The owner had always liked plain, neutral colours and finishes, and she felt that woodwork fash-ioned in the homely, craftsman style of the late nineteenth century would not only suit the house but would create an interesting contrast with the technological equipment which is essential for late-twentieth-century living. The kitchen incorporates some eye-catching design features, ranging from the aphorism carved out of the wooden units to the catering-style, stainless-steel table on wheels. The pendant lamps continue the Arts-and-Crafts theme, while the high stools are quirkily modern. The traditional and modern aspects of this room, though very

different from one another, share an unfussy character. This is emphasized by the plain floor and Venetian blinds. The thread is continued in the informal, family eating area, with its plain white walls and Arts-and-Crafts furniture, charmingly enlivened by the owner's collection of miniature New England chairs.

■ Visual contrasts are created by the naturalness of wood and the industrialness of stainless steel.

■ The 'craftsman' style suits an old house without being pastiche.

■ A table on wheels, as used in professional kitchens, provides an efficient, movable worktop.

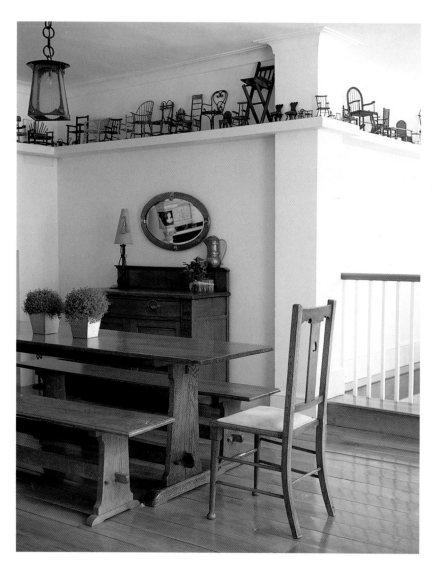

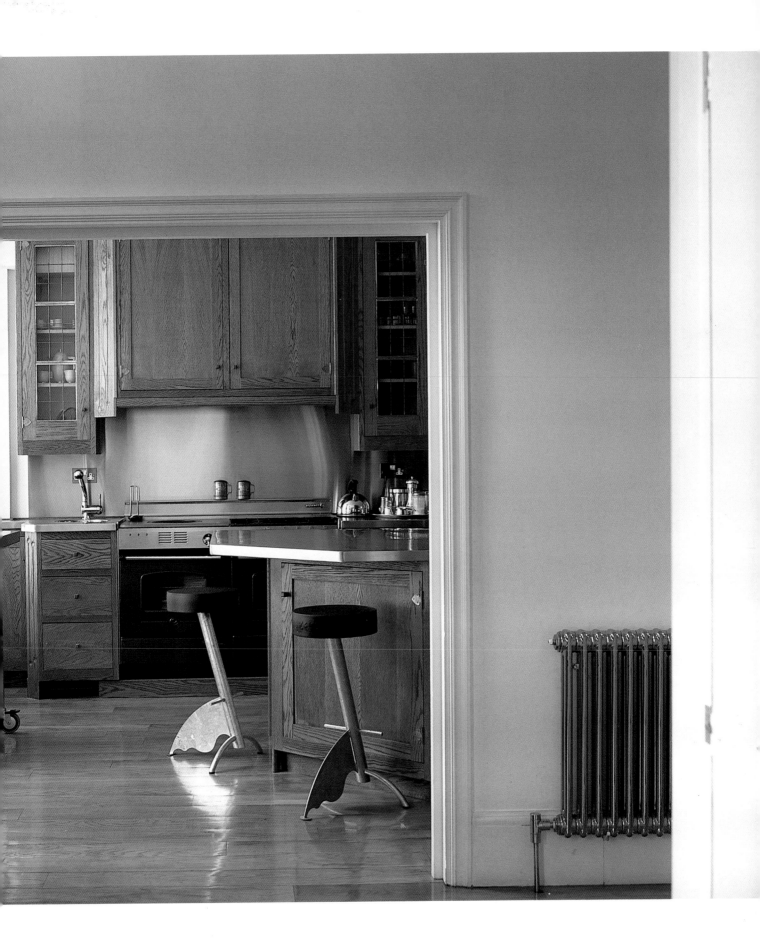

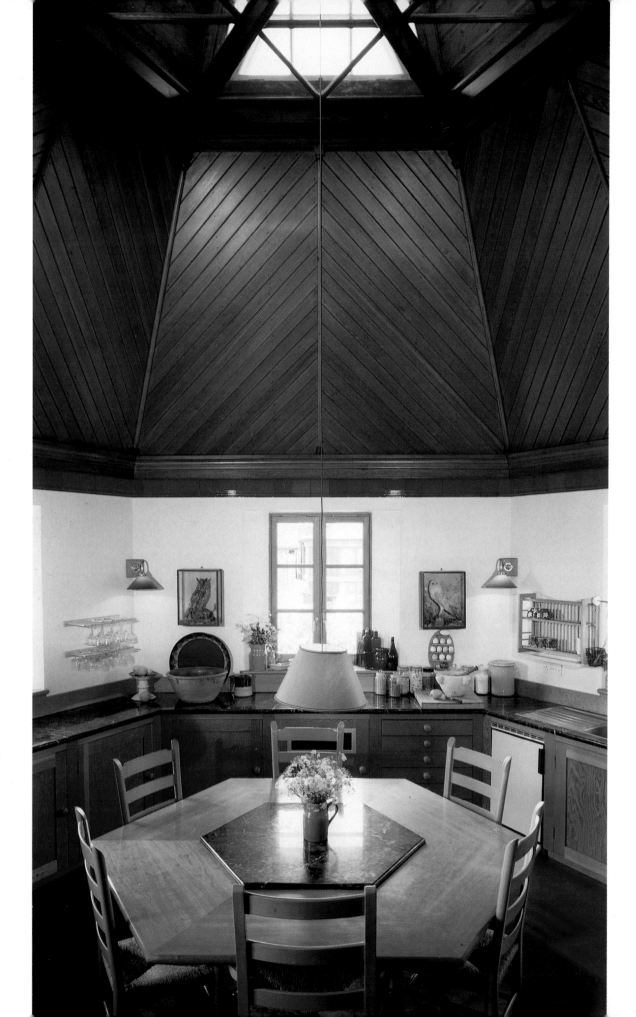

CONTINUING A **COUNTRY HERITAGE**

A nineteenth-century, hexagonal dairy, which initially adjoined two farm labourers' cottages, has been sympathetically converted into a family kitchen. The owner, who had already adapted the cottages to form a single house, asked architect John Wharton to produce a scheme which would enable her to enjoy views of her vegetable garden from her kitchen and would, as far as possible, maintain the building's unusual character. The beautifully laid hexagonal floor tiles have been retained, and the Ashburton-marble shelf, once used to support pottery milk crocks, was polished and re-instated. Originally, the only natural light came through the skylight at the apex of the room; now this is supplemented by four new windows. Natural wood is used extensively: it makes a warm facing to the roof space and is used for the units, specially fashioned to match the doors leading to the house. Six panels of cherrywood have been constructed to surround the dairy's original marble table and create a top large enough for family meals.

■ Natural materials suit a vernacular building in the country.

■ Original architectural fittings have been successfully incorporated in a workable scheme for present-day living.

■ Painting furniture a gentle, but solid, colour – such as grey-blue – avoids an over-emphasis on natural wood whilst keeping up the suggestion of natural finishes.

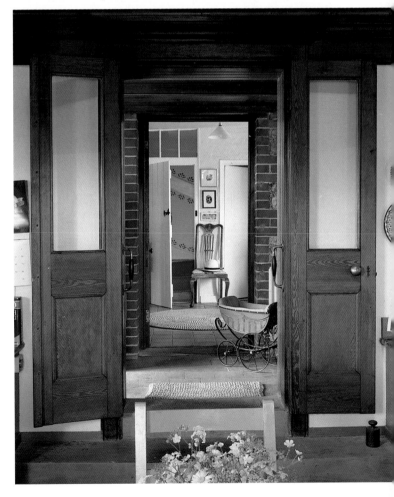

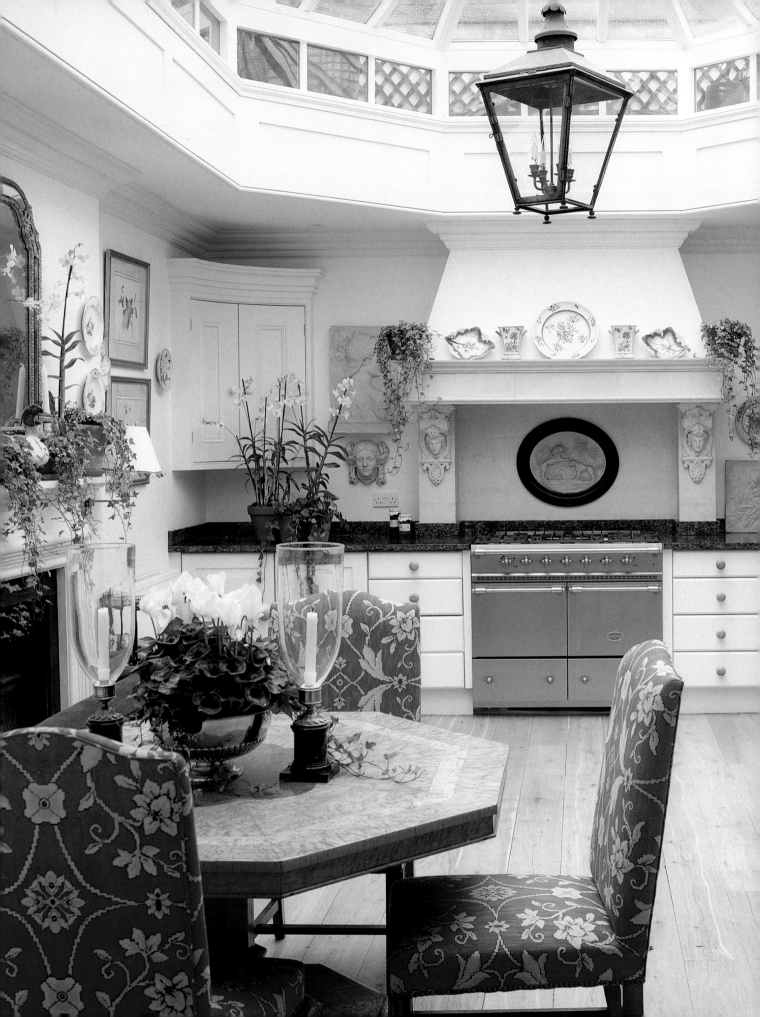

A CONSERVATORY AMBIENCE

Originally, conservatories were designed as winter-gardens filled with plants. If they contained any furniture at all, it was probably a stone or metal bench on which to sit and enjoy the spectacle of exotic blooms and leafy fronds. Now, the priorities are reversed: most conservatories are furnished to provide additional living space, and the plants are ancillary. The great thing about these spaces is the sense of light. Strictly speaking, the rooms shown in this chapter are not all conservatories – in that some do not have glass walls – but each has a significant area of glazing bringing masses of natural light into the interior. The room on this page, for instance, has a huge skylight, as does the dining room on pages 142-143, while the interiors on pages 147 and 148-151 do in fact have entire walls of glass. These two glass-walled rooms illustrate very different thinking: the traditional one has small panes and period-influenced decoration; the other is wholeheartedly contemporary, both in its architecture and furniture. The nearest to a conventional conservatory, perhaps, is Lee Wheeler's scheme overleaf, where plants growing up the wall create a link with the garden outside.

Designed by Fiona Hindlip of Hindlip & Prentice, this is an elegant and practical example of a room which has a conservatory mood yet displays all the comforts expected indoors, including an open fire. The conservatory impression derives from the huge, octagonal skylight, hanging from the centre of which is a handsome lantern. Bas-relief plaques and lots of plants carry through the gardenesque theme. Wall-hung corner cupboards use space practically and soften the room's outline. The table on wheels and comfortably upholstered chairs can be moved through to the adjoining, small study/sitting room which is sometimes used as an informal dining room. Beyond, is the main dining area, shown on pages 166-167.

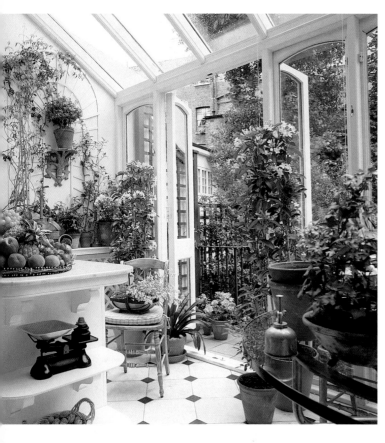

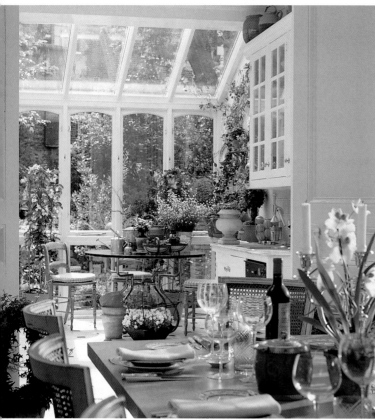

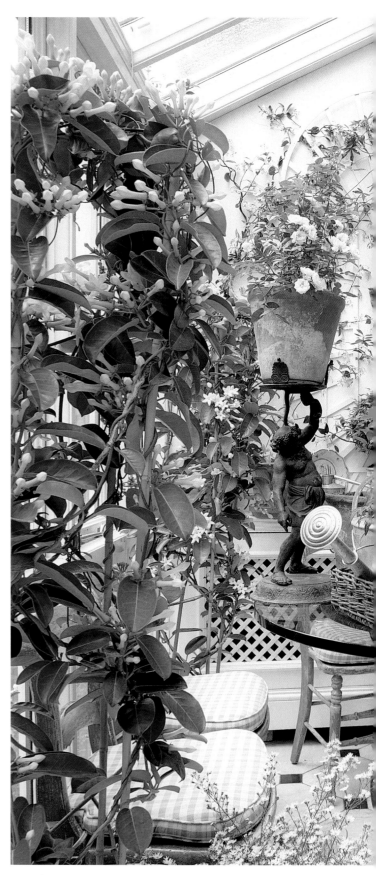

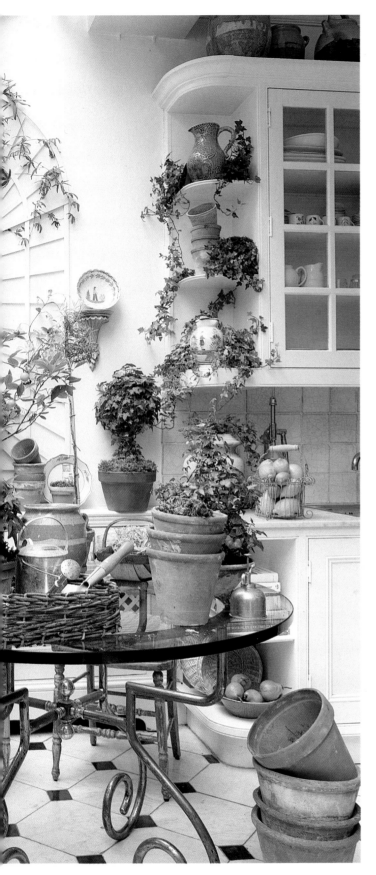

LET THERE BE **LIGHT**

Adding a room built of glass rather than of solid brick extends your living space without making the rest of the interior dark and gloomy. Here, American-born decorator Lee Wheeler gave her London house a conservatory which is big enough for use as a gloriously light and fresh kitchen with an informal eating area. Plants growing against the glazed wall fuse the boundary between indoors and outdoors, so the garden has become virtually part of the room. As a bonus, the wide opening between the kitchen and more formal dining room (below left and page 182) allows leafy, external vistas from the core of the house. For the style of her kitchen, Lee Wheeler chose what she describes as a 'butler's look', with white-painted cupboards, marble worktops and brass handles. The Genovese-pattern marble floor – octagonal, white tiles with black inserts – was salvaged from an older building. However, the tone of this kitchen is not pure nostalgia: it is updated by a modern, glass-topped table with a handsomely contoured base.

■ The all-white scheme for walls, units and tiles, plus a black-and-white chequered floor, increases the conservatory ambience.

■ Instead of pictures, plants grown on a trelllis and in pots on brackets provide wall decoration.

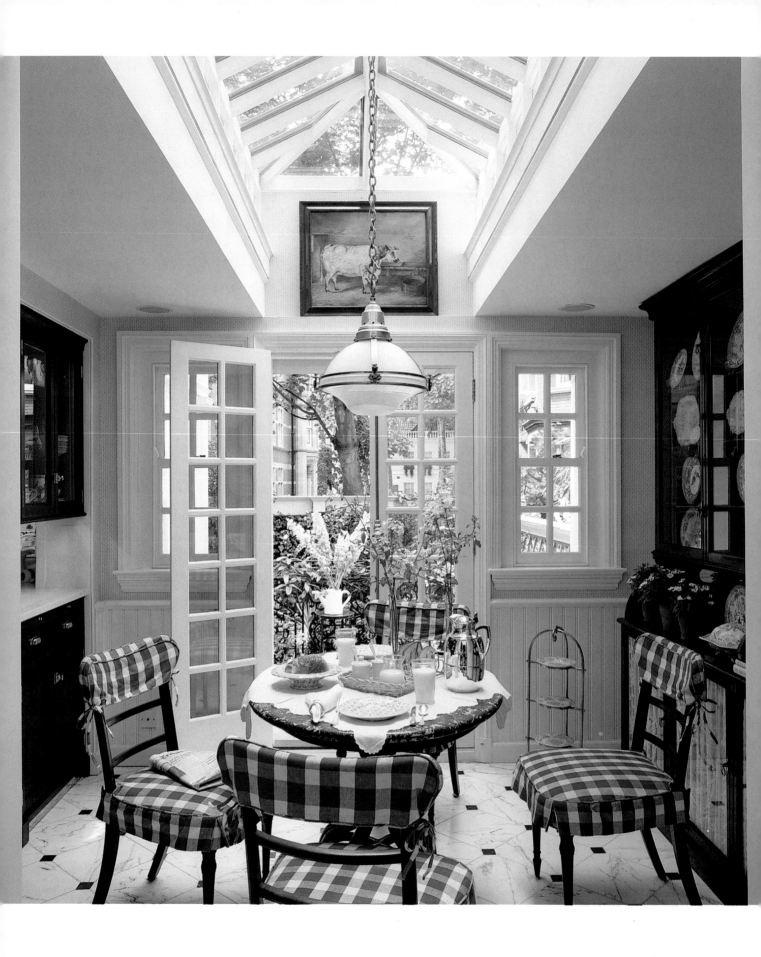

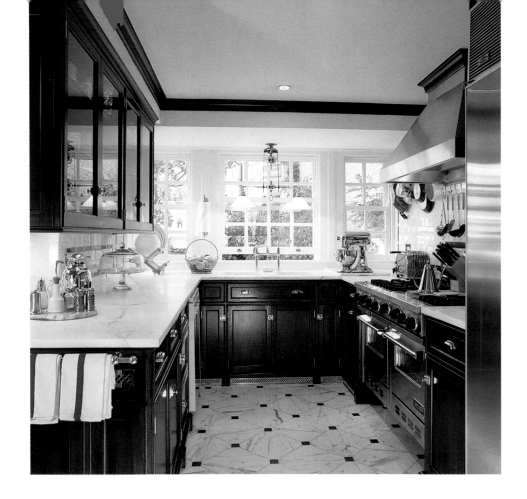

VIEWS TO THE OPEN

Jauntily-clad chairs, dark units and a marble floor give a slightly Continental feel to this airy interior. One part of the room concentrates on cooking and includes a professional-size hob/oven with a large stainless-steel extractor hood above. In another part there is a breakfast area with French doors opening onto a terrace. The flanking windows, with glazing bars to match the doors, bring in further daylight, but the main feeling of light and space comes from above, where there is a pyramidal roof light. The garden elevation has a matchboarded dado, which adds to the scheme's informality and period quality. The room was designed by New-York-based Joan Schindler, working with American architect Kim Doggett, for an American couple living in London. Many of the elements were brought specially from New York: these include the antique chairs and table as well as the 'subway' tiles on the walls.

■ Seat covers and 'hats' in a merry check give antique chairs a more relaxed look.

■ The painting hung at high level leads the eye up to a point of strong architectural character.

■ A freestanding antique mahogany jeweller's cabinet, adapted for kitchen storage and displaying china, adds interest in the conservatory-like breakfast area.

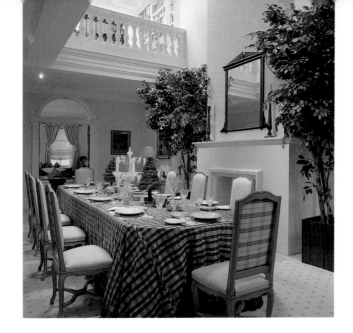

PLAYING TO THE **GALLERY**

Because of so much pressure on inner-city space and the high land values, most town houses are tall and narrow, with their rooms disposed in a vertical rather than horizontal plan. But this house, with its lateral emphasis, is an exception and, even more unusual, it has a galleried interior with decorative skylights, 'a splendid architectural bonus which brings natural light right into its heart,' says Simon Lowe, who reworked the earlier scheme to maximize this bonus and created a splendid dining room which opens through mahogany, double doors into the drawing room. Simon Lowe usually prefers to furnish a dining room with a pair of tables but, in this instance, he was hampered by the room's long, narrow proportions. 'Then I couldn't find a five-metre-long table, so I settled for a piece of blockboard cut to the right size, then covered it with a floor-length, silk tartan cloth with a heavy bullion fringe, and worked the decoration round it.' The walls are marbled in a warm off-white and the furniture is kept to a minimum. At one end of the room, a pair of still-life paintings and a carved seventeenth-century Dutch walnut linen-press form a symmetrical focal point.

■ The chair backs, upholstered in tartan, look attractive when seen from behind and link with the tablecloth.

■ Blockboard, covered with a full-length cloth, solves the problem of finding a table to fit a room with difficult proportions.

■ Well made artificial plants, such as the enormous silk *Ficus benjamina* trees seen here, provide stylish, evergreen decoration.

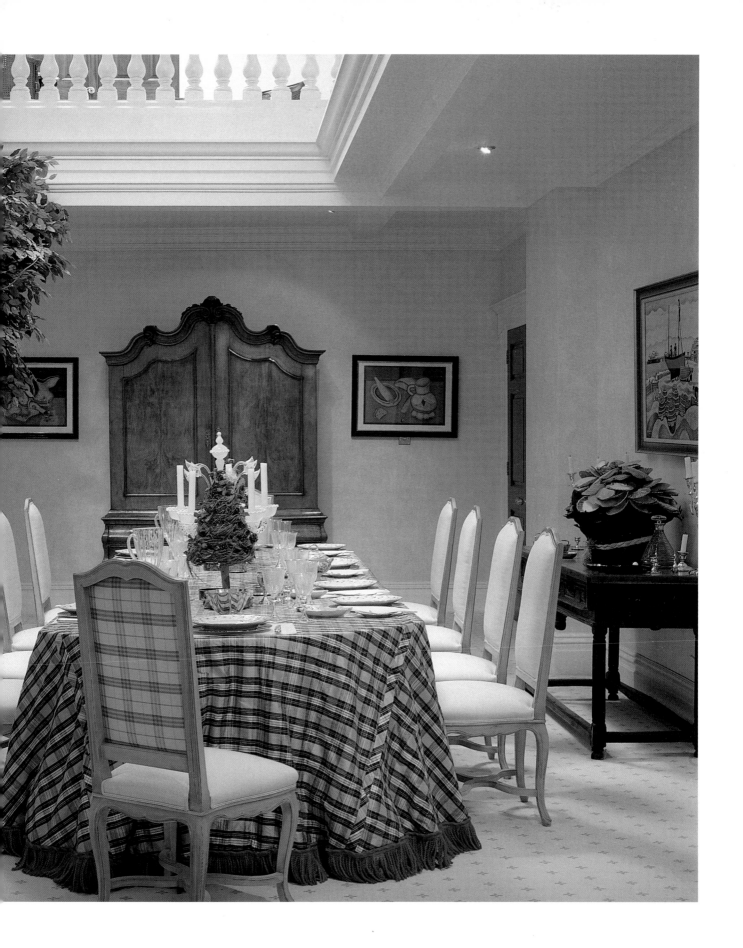

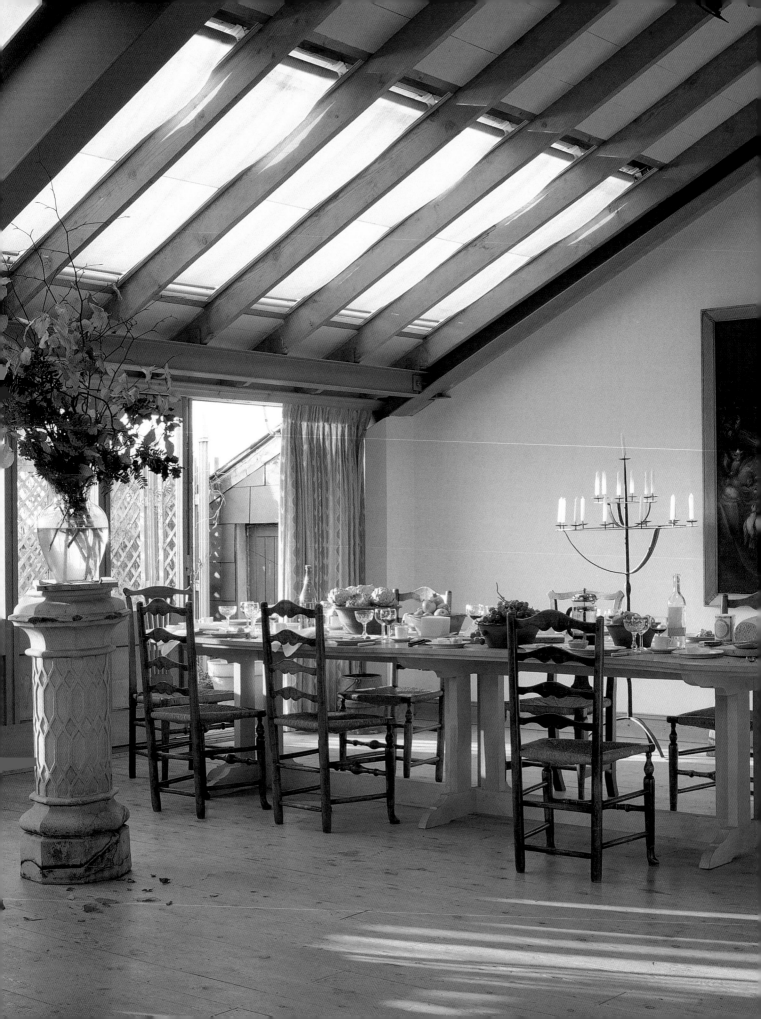

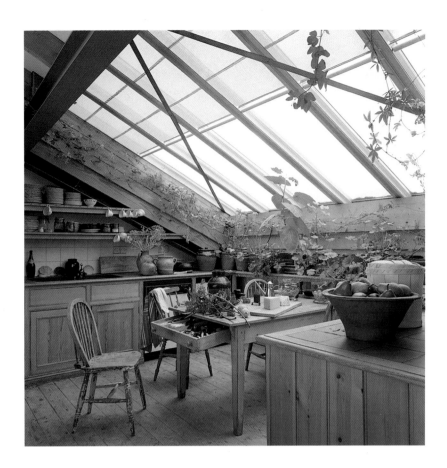

ABOVE THE **ROOFTOPS**

Designed by architect Francis Machin, this dramatic, open-plan dining area and kitchen were built on top of a derelict warehouse near the Thames in Battersea. Both areas have huge skylights; the one in the kitchen slides sideways, giving an astonishing sense of openness. The dining part of the room has glazed doors leading onto a roof terrace, enlarging the space still further. In such a big room, the furniture and accessories need to be of comparable scale, in order not to look dwarfed. Here, the elm table designed by Francis Machin fills the length of the dining area, while the rush-seated chairs have high backs in keeping with the tall ceiling. The painting is also of an appropriately imposing size.

■ Worktops of terracotta tiles complement the natural, country quality of the pine furniture in the kitchen.

■ A floor-standing candelabra and large-scale arrangement of twigs on a high pedestal provide the tall 'punctuation marks' necessary in a large, lofty space.

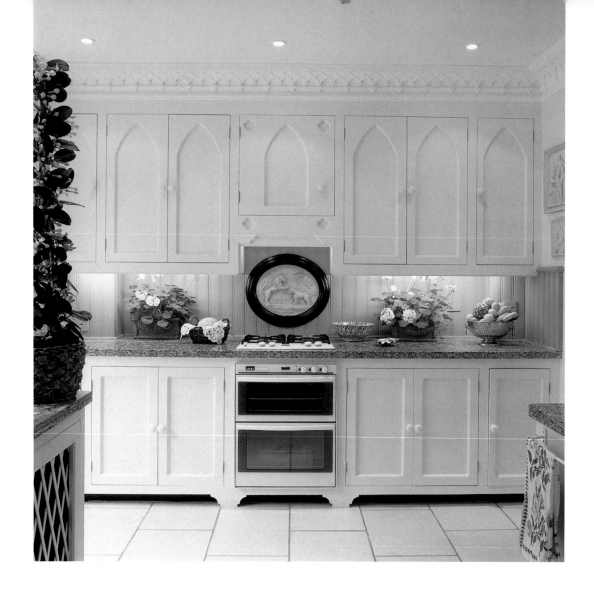

LIGHTHEARTED **MOTIFS**

The attenuated arches and pretty quatrefoils of the Gothick style – a lighthearted eighteenth-century variant of earlier Gothic – was the inspiration for this kitchen designed by Fiona Hindlip. Painted timber-fronted cupboards, juxtaposed with granite worktops, are set against painted matchboarding. The adjoining conservatory was designed as a year-round, casual alternative to a formal dining room and has a table with stone columns for a base. This looks particularly appropriate in an indoor/outdoor,

glasshouse setting – as does the Gothick lantern which harks back to the design motifs in the kitchen.

■ Wooden chairs are more comfortable with cushions – but, for an informal setting, the fabric and pattern should be unpretentious. Here, a check fits the bill admirably.

■ Matchboarding is less usual than tiles for a splashback but is well suited, visually, to a situation where there are timber-fronted cupboards with traditional design motifs.

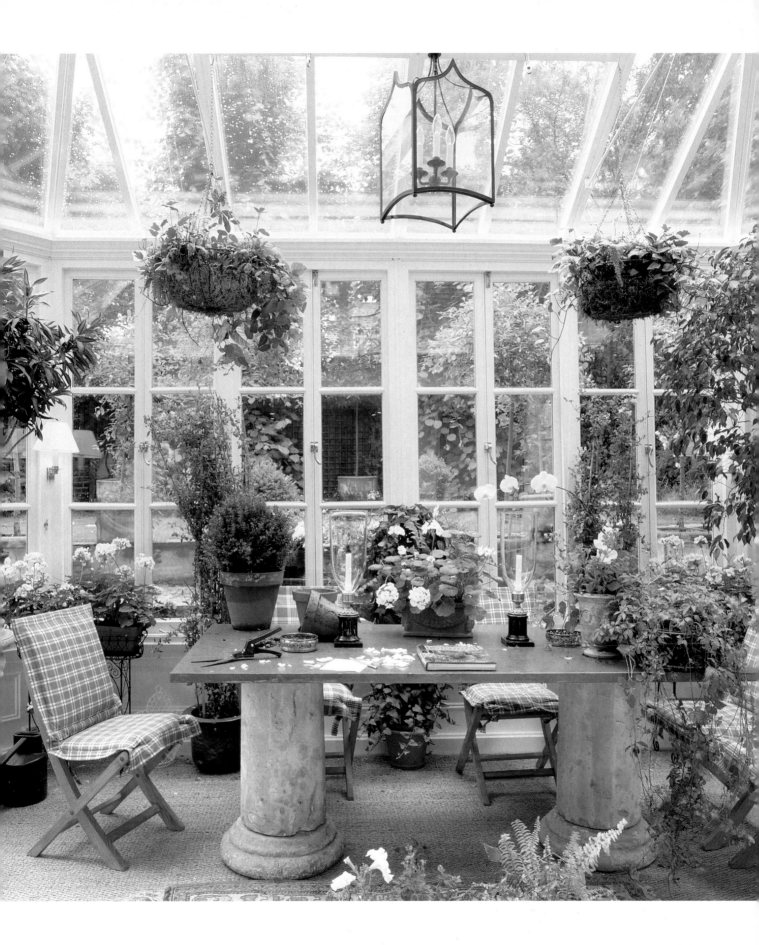

UNSCRAMBLED
SPACE

The radical remodelling of the back of a Georgian town house resulted in a façade built almost entirely of glass. This innovative arrangement was the brainchild of architect Rick Mather, an American who has lived and worked in England for thirty years. In his domestic schemes, he is particularly noted for his ability to unscramble the tangled layouts that have evolved over the decades in so many traditional terrace houses – a type of building which, incidentally, he generally approves of – and to transform them into a series of workable, elegant, pure spaces. Here, at raised-ground-floor level, there is a dining room

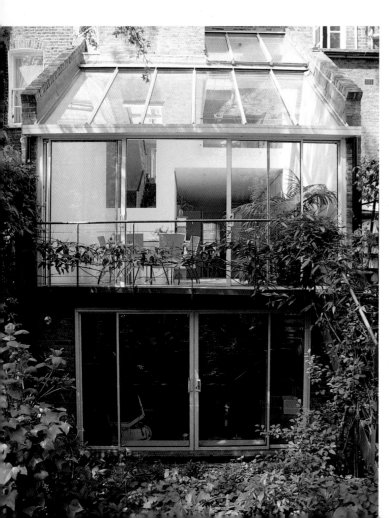

which overlooks the garden and has lush, indoor planting, giving the effect of being in a tree-house. The room leads via a wide opening, furnished on one side with Fifties open shelving, to a streamlined kitchen. Two further openings give vistas from above into the dining room: the drawing-room opening has a balcony constructed of tubular steel and floating glass, while, to its left, can be seen a narrower piercing that allows a view from the stairs right through to the garden. The dining room is furnished with minimum fuss: a circular, glass-topped table, leather-covered chairs and a glass sideboard are just about the sum total. A pale-wood floor integrates this

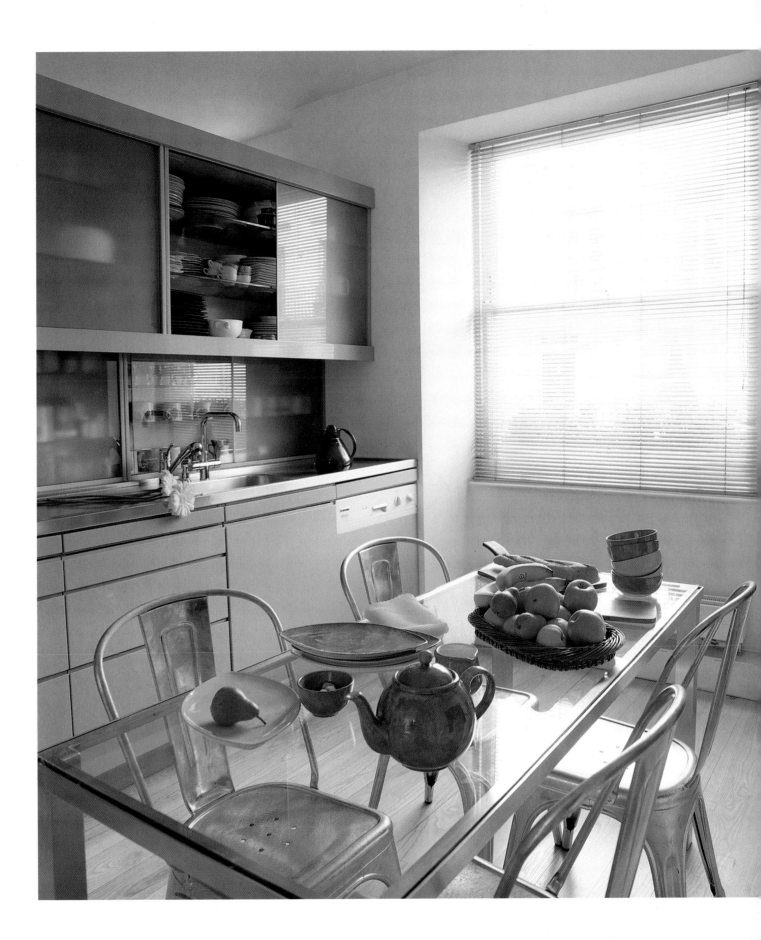

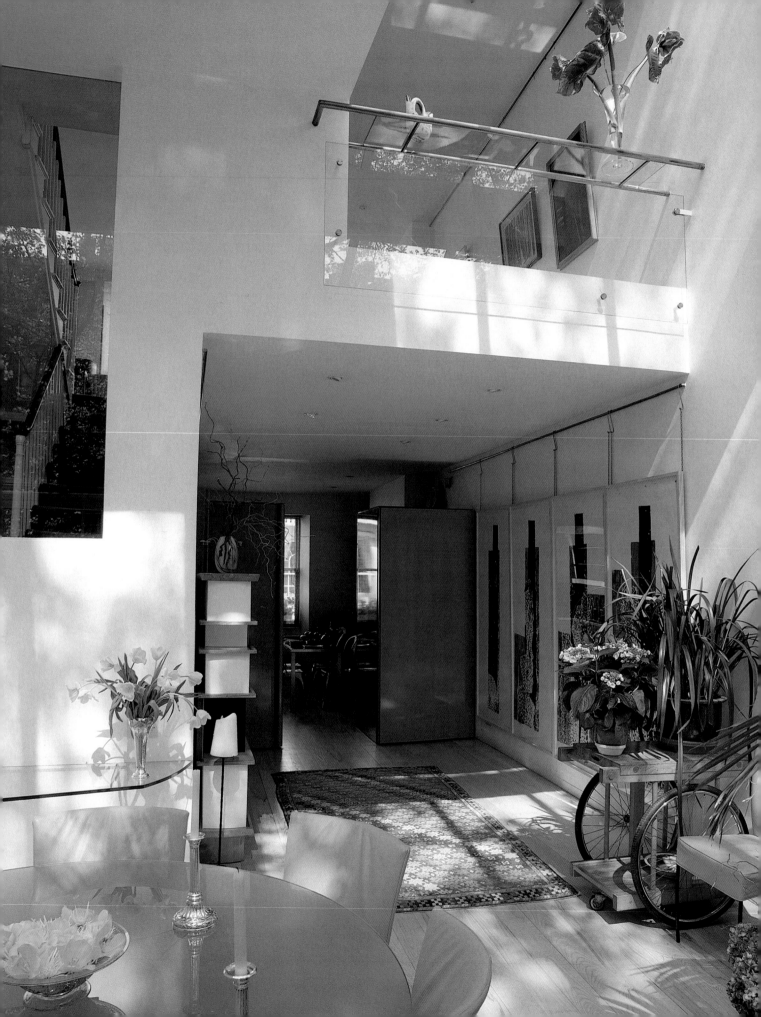

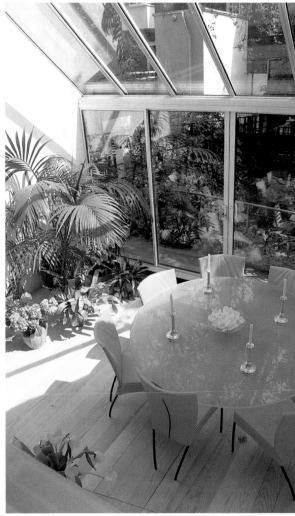

room with the kitchen, where ingeniously designed, projecting 'walls' conceal storage and there is a rectangular, glass-and-steel table with a lightness of style that complements the French café-style chairs. Throughout the house, walls are painted white, a non-colour chosen by Rick Mather to intensify what he defines as 'the sculptural interest' of the interior.

■ Less really can mean more if the architecture is so well considered that it forms its own patterns.

■ Light interiors often look best with light styles of furniture, such as those made of glass and fine metal.

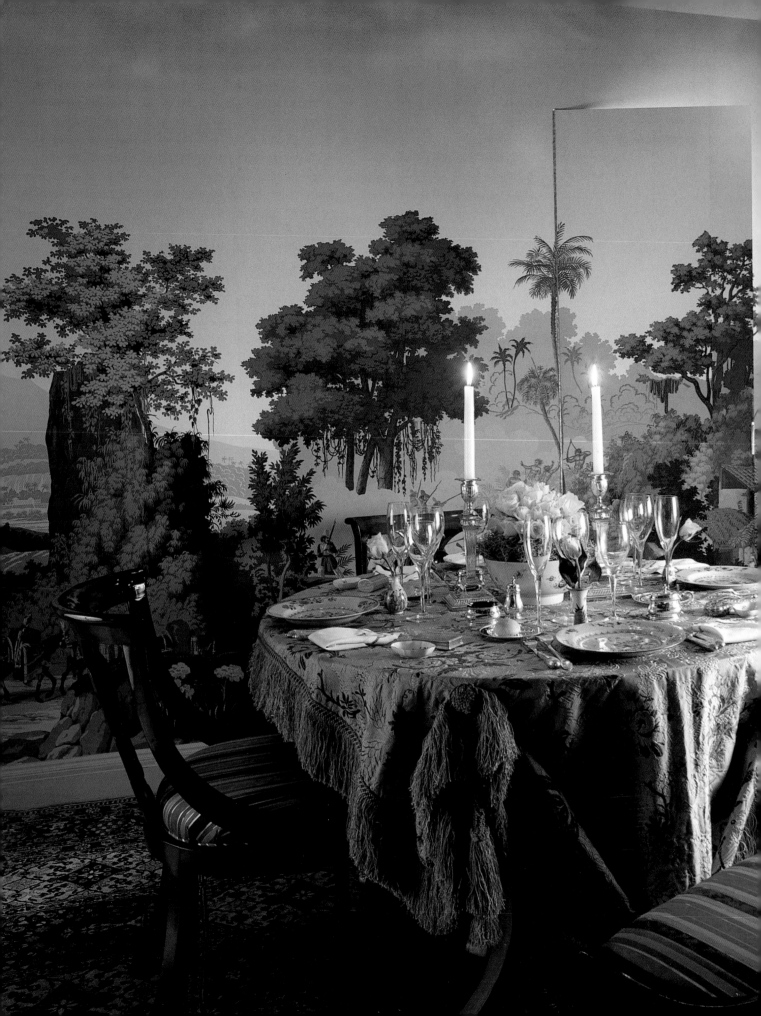

DESIGNED SPECIALLY FOR DINING

Every room should have 'atmosphere' but a dining room needs an extra fusion of it. In order to establish a mood which will enhance the whole experience of eating, particularly when you are giving a party, think of the space along the lines of a theatre-set. Guests appreciate the trouble you have taken and enjoy the feeling of being part of a special evening. For more formal occasions, the sheen of a silken cloth under candlelight, as seen on this page, is exquisitely beautiful. The colouring in the room shown overleaf is more restrained but here, too, the table-covering makes an elegant statement, while blossom-laden twigs in a tall glass vase provide a dramatic, soaring centrepiece. The overall effect is highly sophisticated and perfectly balanced, neither overtly traditional nor modern. The room by Federica Palacios (pages 174-177) also strikes this even note. Richard Nelson and James Michael, on the other hand, have made a point of following an historical line in their house illustrated on pages 178-179. Generally, people do seem to prefer a hint of traditionalism in their dining rooms, but the French decorator and design patron, Elizabeth Delacarte, is uncommitted to the past in her stylishly modern scheme on pages 184-185.

Lourdes Catao's decorating style has been described as 'opulent ease touched with fantasy', and this is well exemplified in the dining room she designed for her own apartment in New York. She is a great believer in murals to expand small spaces: here she has used a magnificent wallpaper showing a coastal view in Brazil painted by a French artist in the eighteenth century. Within this far-off fantasy sits a circular table covered with a fringed, silk damask cloth and surrounded by Regency chairs with striped silk upholstery picking up the colours of the wallpaper and nineteenth-century carpet.

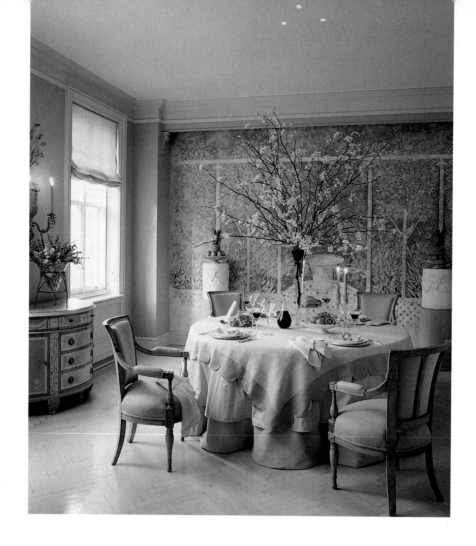

SHADES OF **POMPEII**

John Saladino is a true master of design. Everything he does is highly thought out and can be justified aesthetically or practically yet his views are not stultifyingly pedantic and his work always has terrific chic. He says he is 'not interested in decorating', preferring instead to create 'emotional experiences – moments of transcendence', and he likes the focus of a room to be objects and people, not bulky upholstery. The latter is therefore designed and coloured to recede by matching either the walls or the floor. When you enter the Manhattan apartment shown here, you step into a vestibule which leads into the

drawing room through a broad opening embellished with Tuscan columns. If you stop for a moment, and if the double doors separating the drawing room from the dining room at the far end are open, you will be 'rewarded', as John Saladino says, by a view of the mural of a ruined Pompeiian garden. In the mural you will see more columns, attenuated and rising above a lattice fence. The effect of the mural and the stripped frames of the dining chairs is one of gently decaying grandeur, evocative of an ancient Italian palazzo. Against the mural wall is a pair of marble cylinders topped, surprisingly simply in the context,

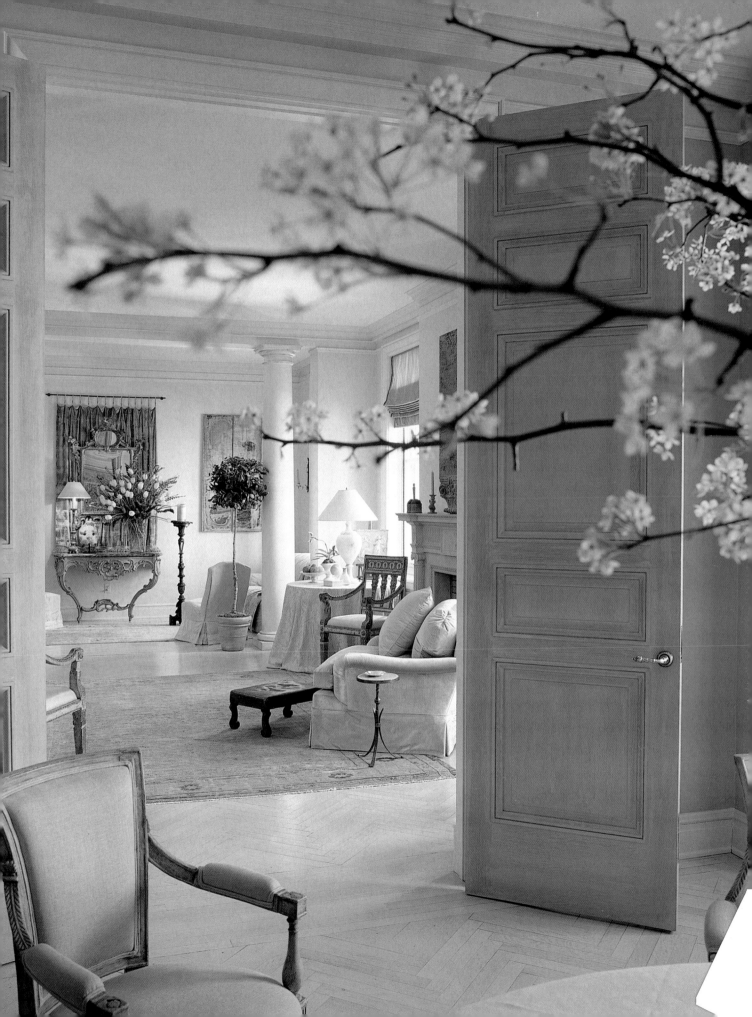

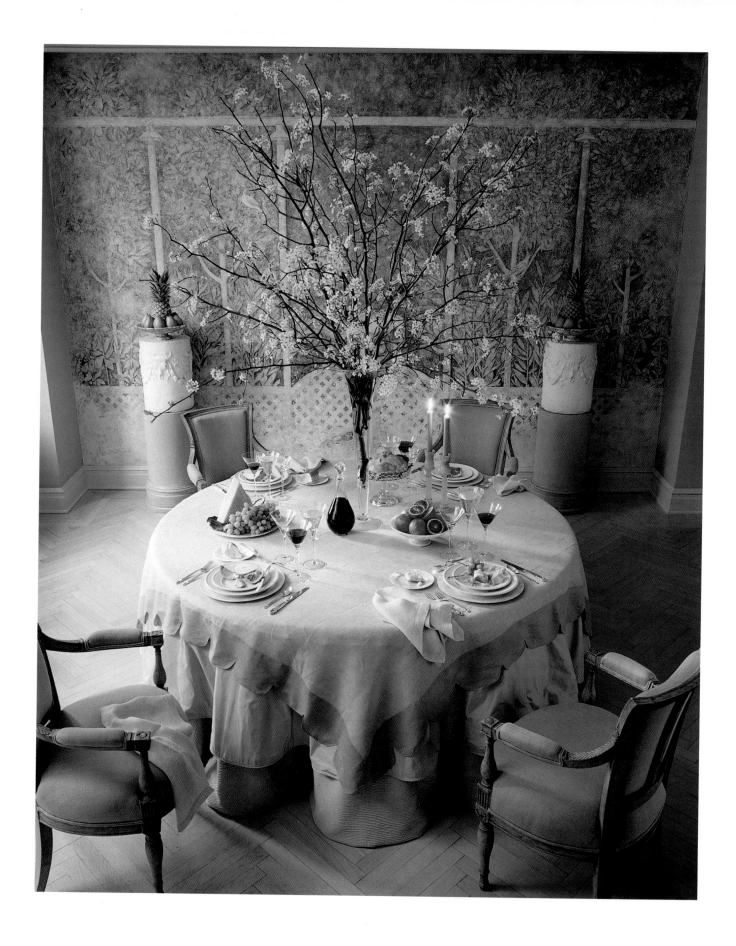

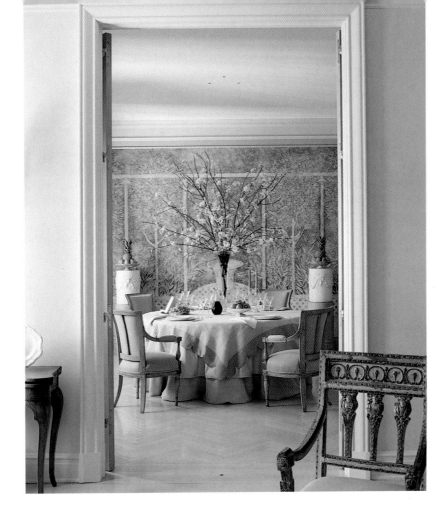

with piles of fruit. The other walls of the room are the colour of sable. Toning with this gentle background are the chair upholstery and the tablecloths. There are three cloths: the top one has a darker, scalloped border; the middle one is silk taffeta; and, beneath, is fine, tucked silk.

■ Using upholstery fabrics to tone with the colour of the walls or floor makes the furniture recede and thus gives greater emphasis to the room's decorative objects.

■ For a large table, layered cloths look less cumbersome than a single, floor-length cloth.

■ An expansive centrepiece on a dining table needs to be very narrow at the bottom half – as here – so that diners' sightlines are not obstructed.

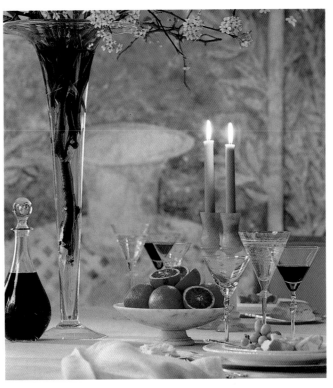

AN ECLECTIC
ELEGANCE

This supremely elegant interior in Geneva was designed by Françoise de Pfyffer, a true cosmopolitan not only in her family background – she is part Swedish, part French – but in where she lives, dividing her time between Geneva and London, in both of which cities she has an ultra-smart shop. 'I like an eclectic look,' she says, 'and I love contemporary art and mixing the old with the new.' All this is relevant in that the decoration scheme seen here reveals an international sophistication and eclecticism. Inspired

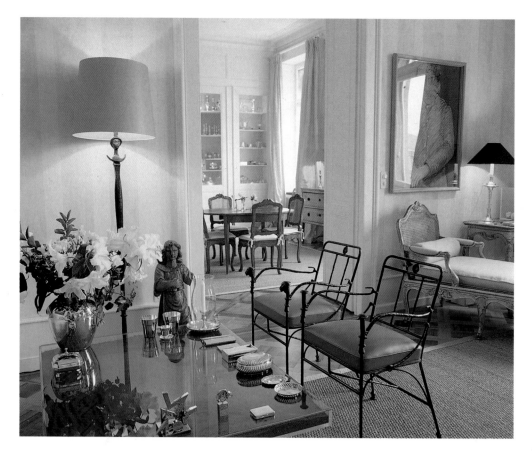

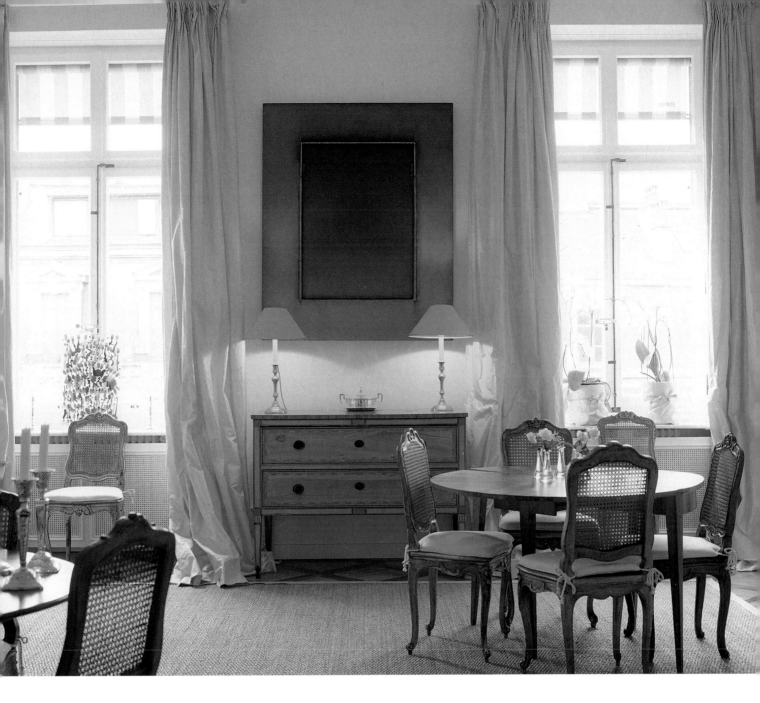

by the window treatment seen in many late-eighteenth-century Swedish Gustavian rooms, the silk taffeta curtains are very simple. The focal point of the room is a Swiss ceramic stove flanked by display cabinets with chickenwire panels. The furniture is antique but the modern mix comes with the artworks, which include a Seventies monochrome painting by American artist Paul Rotterdam and sculptures by Yves Klein in his signature blue.

■ Yellow curtains in silk taffeta enhance natural light.

■ Central heating is concealed behind canework panels, woven in a similar pattern to the chairs but painted to match the walls.

■ Chickenwire gives an interesting effect for a display cabinet – subtler than leaving the shelves open and less predictable than glass.

THE **ULTIMATE**
CHINA ROOM

This must be one of the prettiest dining rooms in London – and a great encouragement to anyone with a room which, in itself, has very little going for it. When June Ducas – a journalist who specializes in interior design and does the occasional decorating commission herself – bought the house, this room in an annexe was very depressing, the sort of space that is hard to envisage ever coming to life. However, June had the good fortune to find a Brunschwig *trompe l'oeil* wallpaper printed with exactly the same

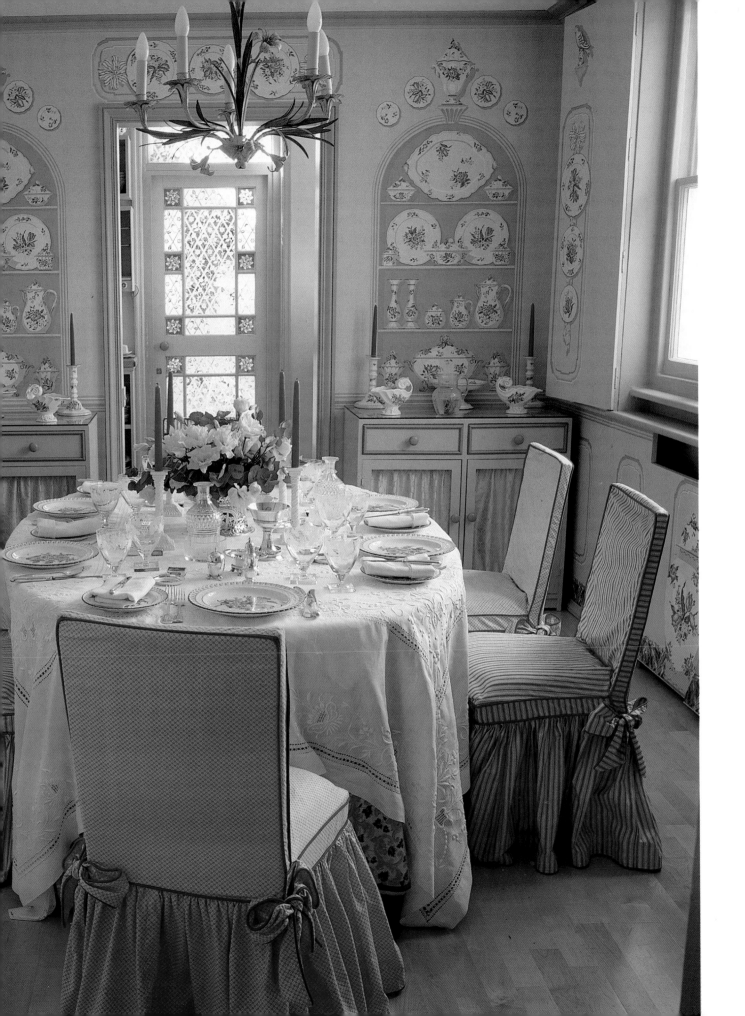

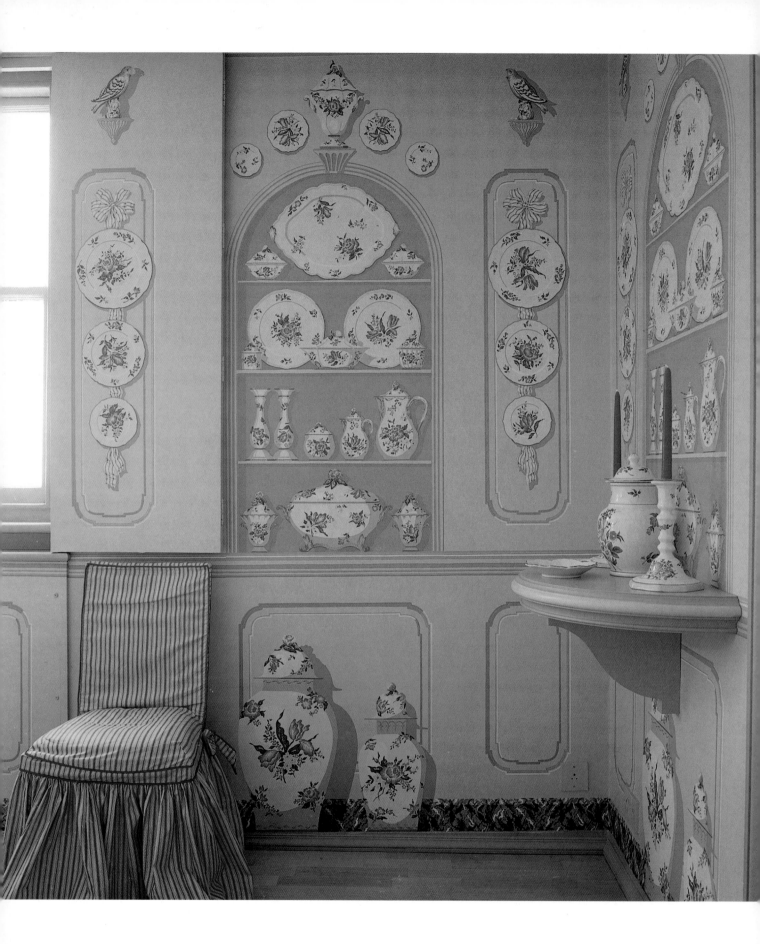

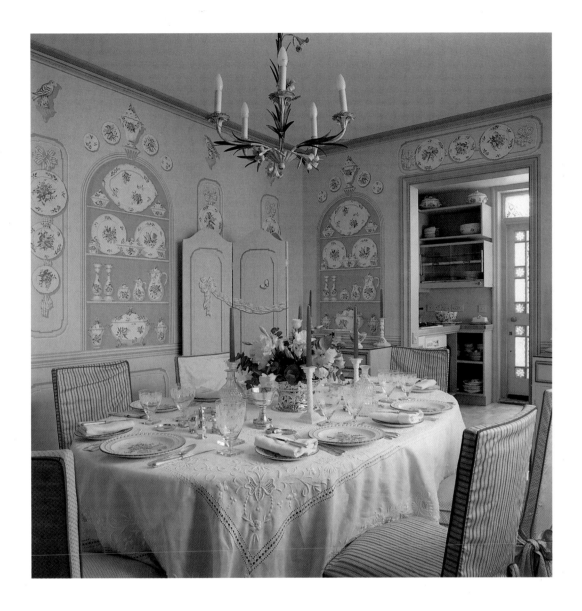

Luneville china as her own. It was too good an opportunity to miss, and with it she has made an exquisite 'china room', furnished with chairs sporting red-and-white slipcovers. A window and glazed door at the far end, leading to the garden, have been fitted out with colourful, toughened glass reproduced from an 1840s original. The three gradations of paint colour used for the architectural mouldings were picked out from the wallpaper.

■ Cupboards built to line up with the dado are painted in tones which tie in with the rest of the room. The doors have a suitably pretty treatment, comprising fabric gathered behind chickenwire.

■ A coordinating screen gives another dimension to the perimeter of the room without cutting too much into the space. More prosaically, it can be moved to separate the kitchen from the dining room for smart dinner parties.

OPENING **GAMBIT**

The dining room seen opposite started with an idea to build a fully glazed conservatory extension, but the plan was modified to include large areas of solid wall. However, it also has big expanses of floor-to-ceiling, glazed doors and a partly glazed roof at one end, which bring so much light to the interior that the effect could be compared at least with an orangery. In fact, building solid walls for part of the room was a deliberate manoeuvre as it was reckoned that they would make the area more usable all year round. It is part of Annie Stevens's revamp of a flat for clients who originally commissioned her simply to build on a conservatory but ended up having their entire apartment restructured, making it much more open and free-flowing. Removing most of the wall between the living area and hall meant that the stairs became an important feature within the enlarged space, so the previous wooden balustrade was replaced by a metal one more in keeping with the new surroundings. Individual pieces of furniture and artworks, all carefully placed, imbue a gallery-like ambience. The same consideration is seen in the dining room, but the look is more minimal: a marble-topped table with limed-wood base and a group of chairs covered in unbleached calico are the totality. Part of the reason for this restraint was that the dining room leads into the kitchen and the client, an enthusiastic cook, did not want 'decoration to dominate'. The large canvas is by Adrian Everitt.

■ The wide opening between the living and dining areas has full-width, full-height, clear-glass doors that can be closed to shut off the dining room (which opens into the kitchen) without obstructing the outlook to the garden.

■ Rugs of bound-edged coir matting are in the same colour range as the lime-washed oak floor, adding texture and warmth without breaking the visual flow.

NEOCLASSICAL NUANCES

The somewhat severe decoration of this dining room by Fiona Hindlip reflects the neoclassical style of the house, which was built in the first half of the nineteenth century. Stone-coursing painted by Paul MacDonell is hung with black-framed architectural engravings and a large bas-relief, while the window treatment consists of shutters and a festooned pel-

met. As the room was designed by Lady Hindlip for frequent entertaining, there are two tables, both recently made to an ingenious, antique design which allows the tops to be extended by the addition of curved sections slotted round the circumference. Chairs with brass-studded, animal-print upholstery round off the mellow colour scheme. The dining

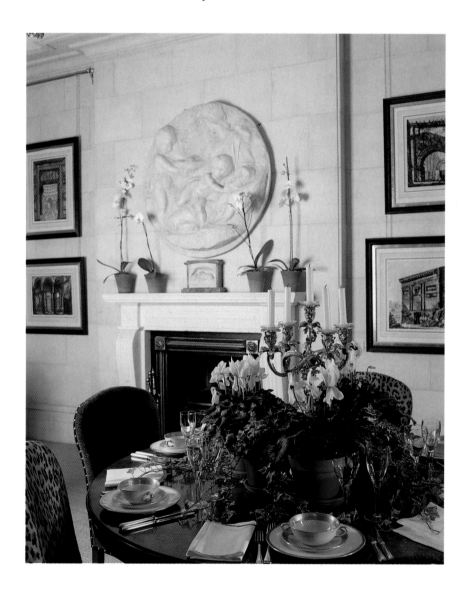

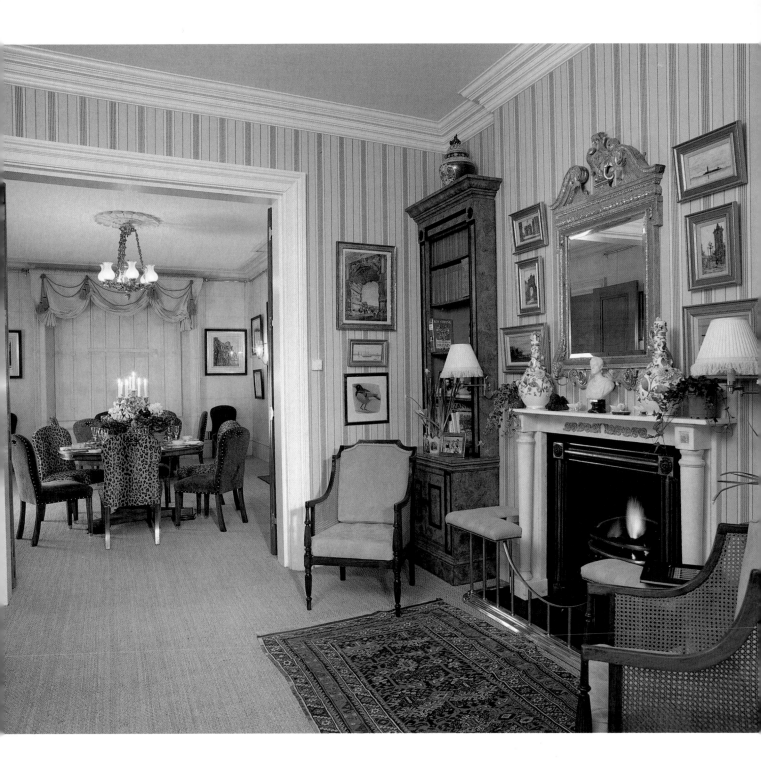

room is at one end of an enfilade, with the kitchen (see page 136) at the other and a small study-cum-sitting-room in between. The study (seen in the foreground, above) can be used as an extension to the dining room for big parties and, on its own, as a more intimate alternative.

■ Using brass rods and chains to hang pictures suits the neoclassical style of the dining room.

■ Black-and-white engravings have an identity strong enough to stand up to the dining room's architecturally-inspired decoration.

PARISIAN VITALITY

This dining room in Paris opens off a central hall which has five sets of double doors leading into the various reception rooms, and these rooms are in turn interconnecting. Tim Corrigan furnished it with antique elements but managed to keep the whole thing looking 'alive', a difficult trick to pull off but here it is superbly accomplished. Many rooms with elaborate mouldings and traditional furniture look fusty but this one, with its pale walls and contrasting rich-red curtains, plus large blue-and-white pots, has vitality. Portraits are hung in combination with landscapes from silk cords, a typical method in the eighteenth century, especially on the Continent. Another Continental attribute is the superimposition of a painting on a large mirror, relieving the sheer expanse of glass and giving the impression that it is floating in mid-air. The chandelier is a slightly quirky choice for the setting but, for any period room to have originality and be truly memorable, such an element of surprise is exactly what is needed. The neatest surprise of all, however, is the integrated door to the right of the chimneypiece: hung with a painting, it all but disappears into the elegant panelling.

■ The wrought-iron chandelier holds real candles but has been specially adapted to electricity.

■ Picture lights provide a secondary source of lighting.

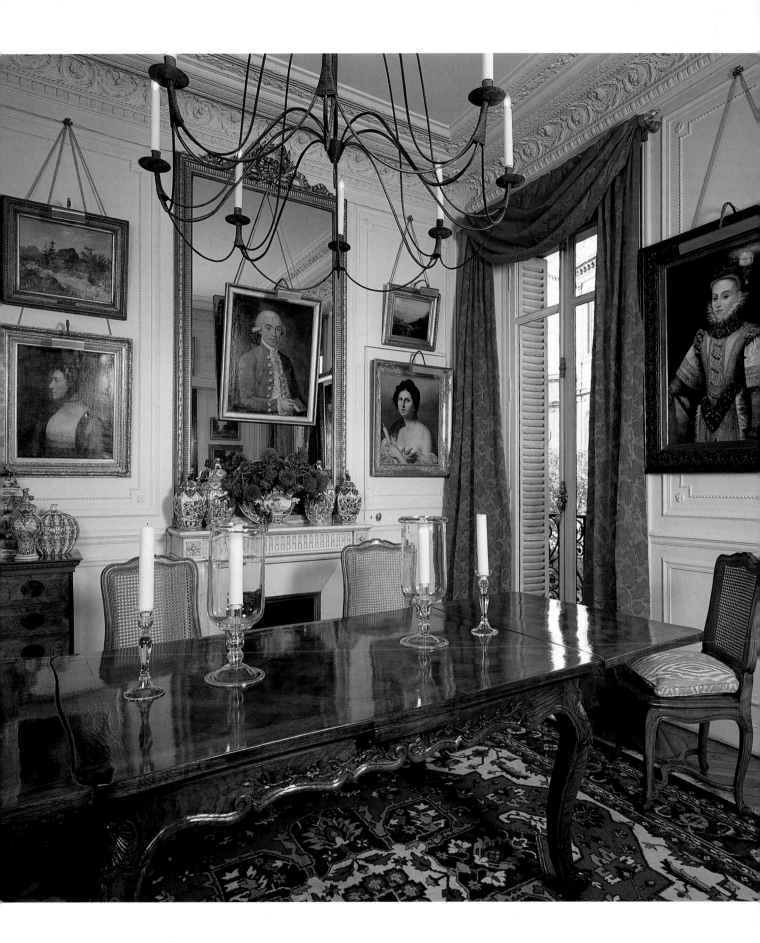

MORE **CONTEMPLATIVE**

Different cultures are represented in this room yet there is no hint of a clash: the various components come together in an atmosphere of stillness and poise, exactly as the owner, Isabel Bird, hoped they would when she asked decorator Prue Lane to help her achieve her wish for the calm simplicity associated with Eastern inte-

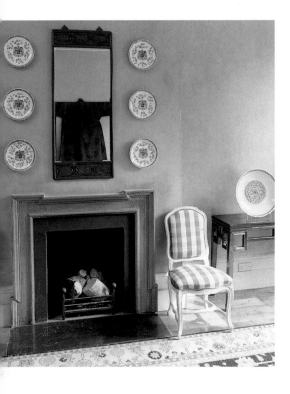

riors. When Isabel came from New York to live in London, her house was full of American artefacts but, one day, as she walked past Prue's shop, she spotted in the window a large Rajasthan wooden door and just knew she had to buy it. So began the change of direction which turned her interest towards a more contemplative style with oriental accents. Prue, an Australian, immediately understood what Isabel was after and helped her find objects and textiles around which each room could be decorated. In the dining room, the focus is a Tibetan ceremonial gown hung on the wall opposite the fireplace (seen, left, reflected in the mirror). This and the room's few other objects are displayed in a very clean, separated manner so that each piece can be appreciated individually. The background colour – a luminous, watery shade arrived at by applying navy-tinted lacquer over grey paint – is the perfect foil for the mix of furniture, which includes a pair of nineteenth-century Chinese temple tables (to either side of the chimneypiece) and French, Régence-style chairs.

■ The cotton blinds have heavy silk ties, contrasting in weight and colour.

■ Objects are few and far between, getting away from the cluttered look and allowing each piece to be enjoyed in its own right.

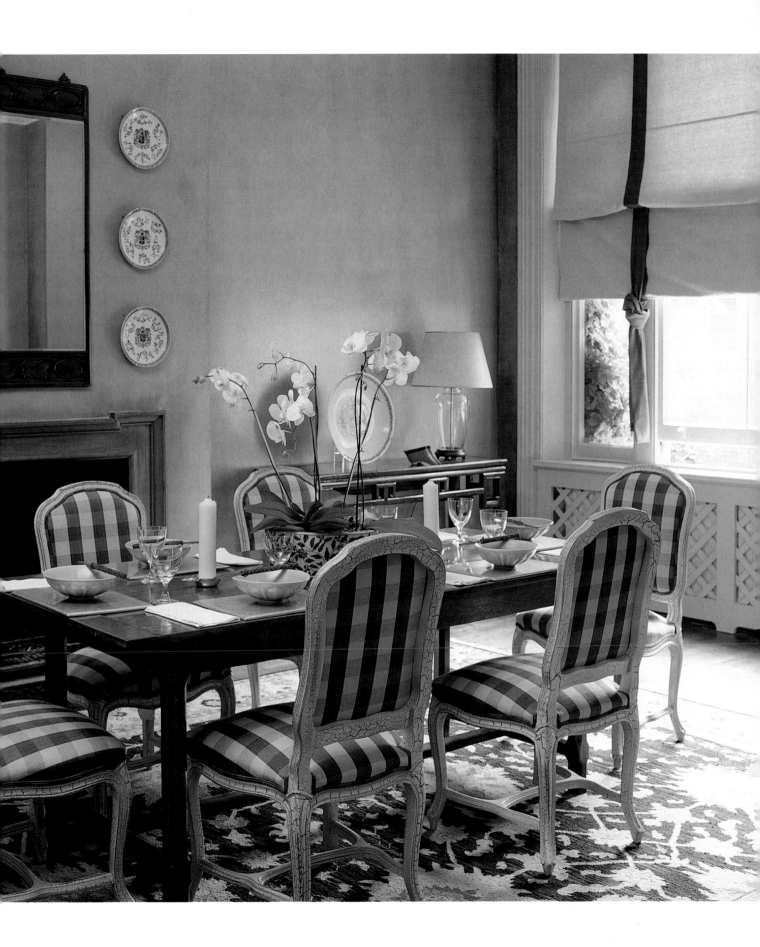

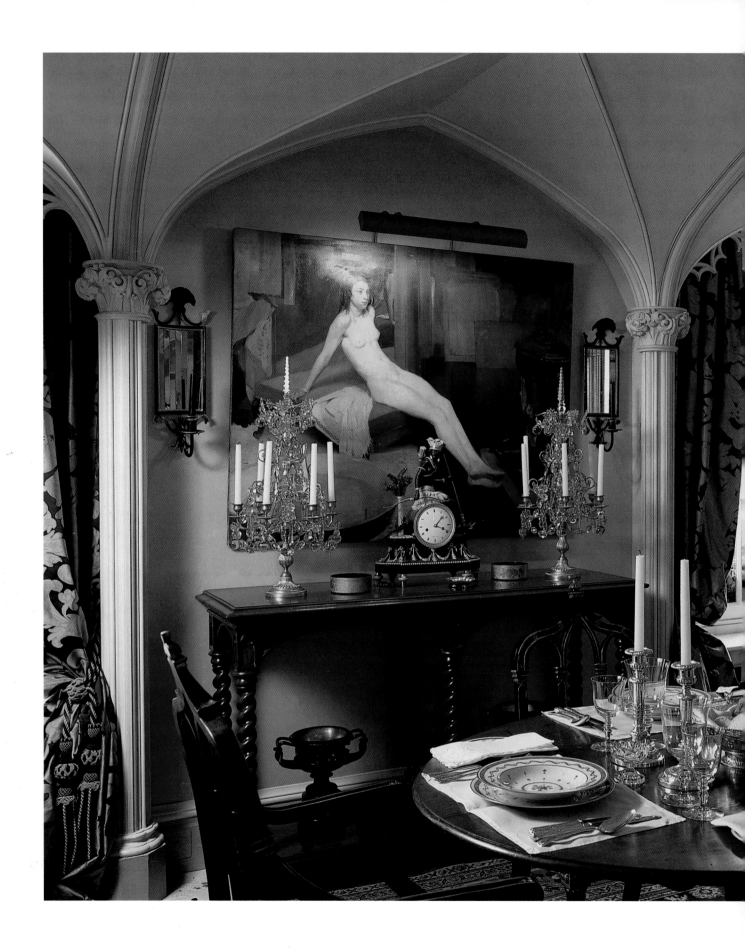

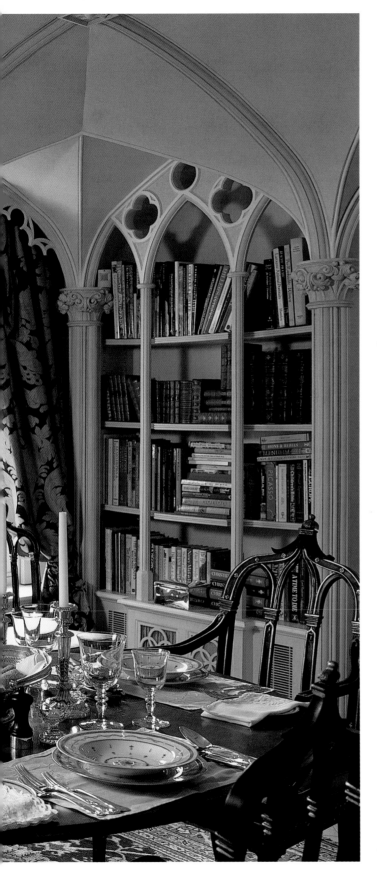

REINVENTING
HISTORY

The eighteenth-century aesthete Horace Walpole, whose house at Strawberry Hill set the fashion for the Gothick style, would feel quite at home here, even though this interior was confected in the 1990s rather than the 1740s. Having read as many books on Strawberry Hill as they could find, the owners knew just what they wanted and commissioned architects Peter Wood and Partners to interpret and adapt the style for today. It was a major challenge for the builders, but the result is a triumph. The vaulted ceiling had to be made in plaster in three sections, joined together on site, then suspended on wires. The columns and tracery are made of wood, and the whole is painted in shades of stone colour. The Gothick chairs were bought at auction, though at the time their appearance was very different from now. They had been covered in olive-green paint but, happily, the black-and-gilt finish came to light when they were restored. (The kitchen in the same house, shown on page 72, makes a streamlined contrast with the intricate patterns that characterize this room.)

■ Curtains are hung from behind the vaulting, avoiding the need for a visible pelmet or pole.

■ Heating and air-conditioning are concealed behind the pierced panels at the bottom of the bookcase.

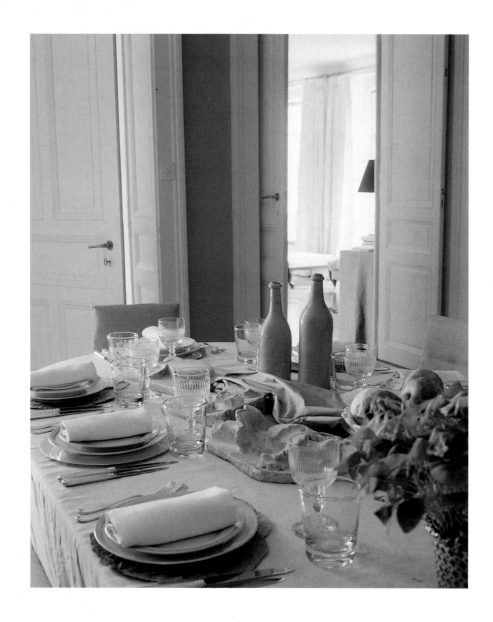

CHAIRS AND TABLE
DRESSED IN **FULL COSTUME**

For interior decorator Federica Palacios, a monochrome scheme is calmer and, above all, more elegant than a palette of vivid colours. Here, in the dining room of her apartment in the historic quarter of Geneva, she has demonstrated that neutral tones, while restful, need not result in a blandly middle-of-the-road style of decoration. The room has a pretty, theatrical edge with many unexpected decorative touches, such as the dress-like treatment of the chair covers with their full-length skirts and buttoned-up backs. (In fact, the covers conceal folding chairs which can be stored away when not needed.)

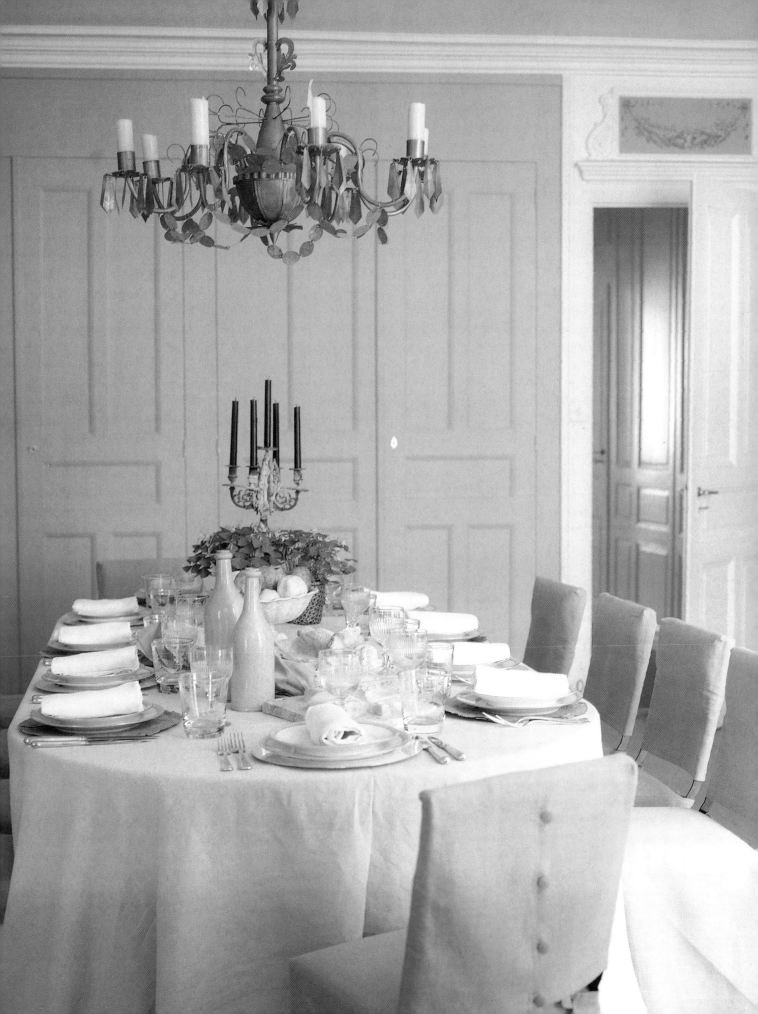

Continuing the costume simile, the scallop-edged tablecloth sweeps over the floor at the corners like the train of a skirt. The table is set with traditional porcelain and crystal but the ornaments – the candelabra and plants – are placed, unpredictably, off-centre. The chandelier is also unconventional: instead of choosing a typical European one with glass pendants, Federica Palacios introduced a Mexican design in brass. All these details give the room a youthful air whilst maintaining a sense of traditional decoration. The designer's individual, rather dichotomous approach is also seen in her choice of a large-scale, nineteenth-century oil painting hung without an elaborate, period frame. The shadowy, forest tints in the painting are in perfect harmony with the tone of the walls and beige textiles.

■ A monochrome colour scheme is calm and sophisticated.

■ Pretty slipcovers conceal folding chairs which can be removed and put away when not needed.

■ The fastenings on the slipcovers are more than mere essentials – they are prominent and decorative.

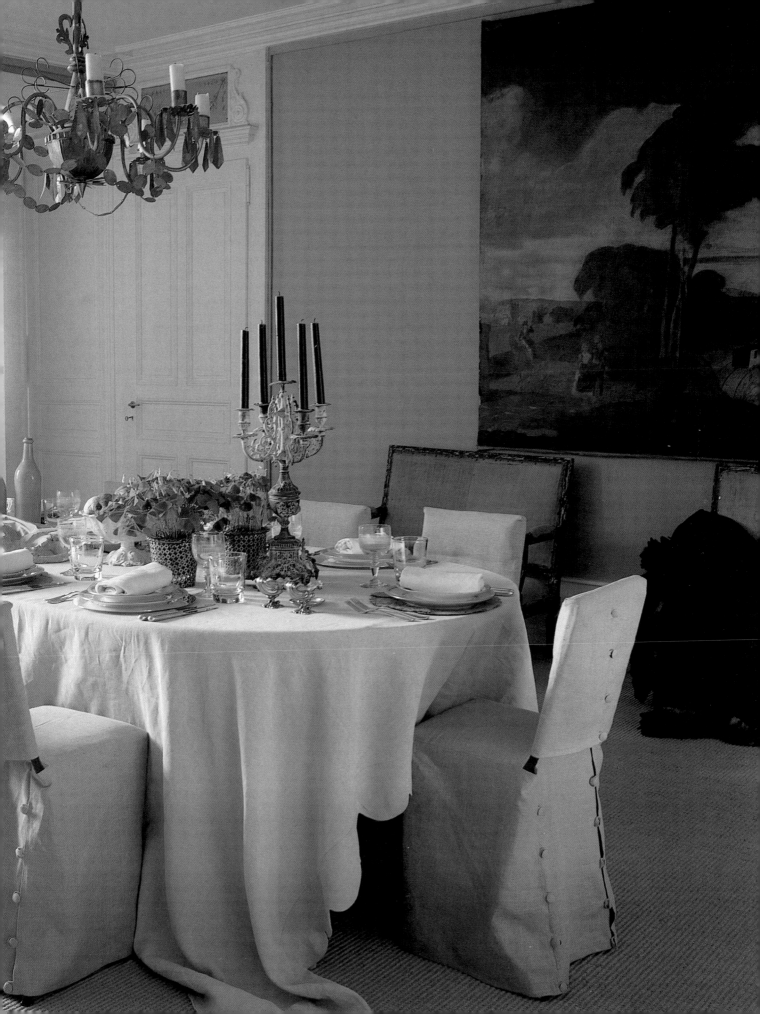

AN AUTHENTIC
AMBIENCE

The story behind this room in Newport, Rhode Island, is a romantic one. The house was built in the 1770s for a stone-cutter; then, in 1791, it was bought by a sea captain; in the nineteenth century, it belonged to a young widow who supported herself by setting up a dispatch service, delivering packets and goods on horseback. That is when it first acquired its name: 'The Penny Post House'. In that era, such a modest dwelling would probably not have had a separate sitting room; instead, all family life would have been carried on in the 'keeping room', or kitchen. Richard Nelson and James Michael, partners in the Red Unicorn Interior Design Co, specialize in the restoration and decoration of historic houses, so they were the ideal people to take on the Penny Post House as their home and recapture the mood of the place. Getting the right colour for the paintwork is critical in achieving an authentic, period ambience, and in this evocative dining room, converted from the 'keeping room', we see a shade of green which was typical in colonial interiors. Also harking back to the past is the fireplace with its original irons. Displayed on the long mantelshelf, and in the slope-backed alcove above, is James Michael's collection of pewter.

■ The correct colour for paintwork is fundamental in recapturing the mood of a particular era.

■ Although the room has been gentrified, the modest charm of the original architecture has been sympathetically preserved.

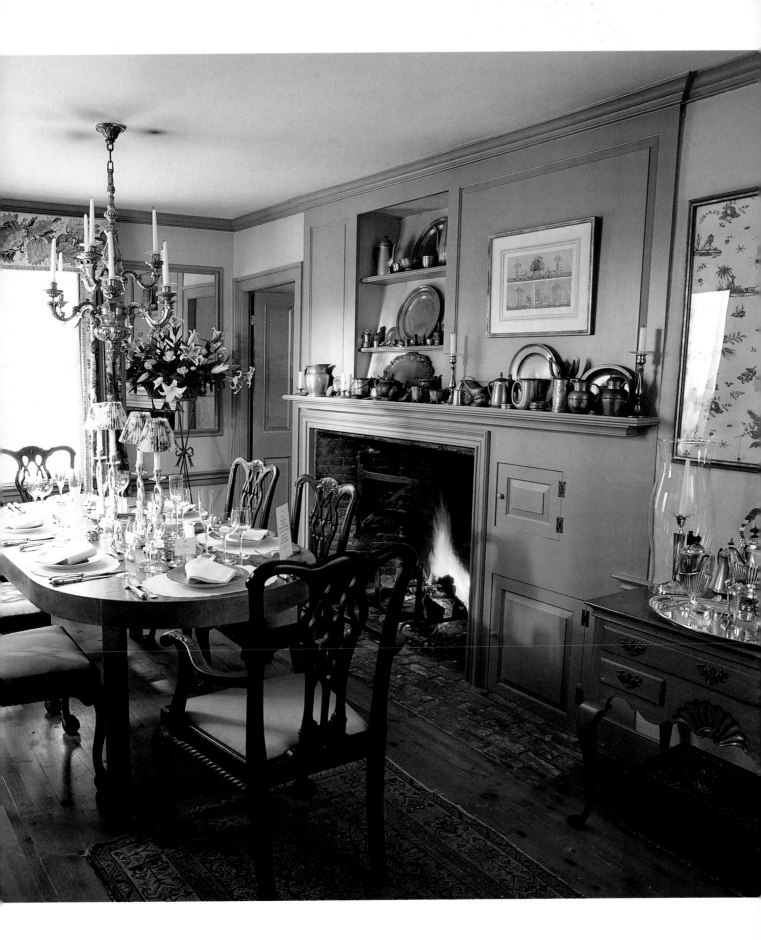

FARMHOUSE
INFORMALITY

Seen from the front, Simon and Tania Lowe's home in Sussex is the perfect Queen Anne 'box', but from the back it presents a picturesque medley of accretions dating from several different periods. 'This isn't a formal house, it's a farmhouse – quite sophisticated, but a farmhouse, nevertheless,' says Simon, 'so I felt the decoration had to have an informal character, too. In the dining room, for instance, I wanted to emphasize the simplicity and strength of the flagstones and beams, so we avoided anything too flowery or precious.' The dining-cum-breakfast room leads off the hall and its structure of criss-crossed beams and brick piers is openly expressed while the plasterwork is painted a soft white. The chairs around the antique refectory table – placed, unconventionally, on the diagonal – have quilted slipcovers in plain white. Reaching to the floor, the fabric has a softening influence against the stone without making the room look overdecorated. Through a wide opening is the kitchen where a more rugged table is used for food preparation and informal eating.

■ The farmhouse stamp of the interior still comes through, even though fashionable elements, such as tailored slipcovers, have been introduced. Simple styling is pivotal to achieving this balance.

■ When in doubt, use white. White – providing it is not a harsh, 'brilliant' paint – always looks good in country interiors and with country furniture.

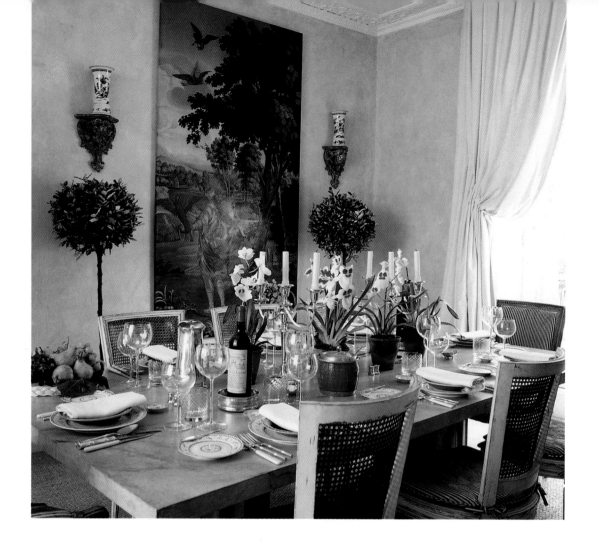

BACKWARD GLANCES

For decorator Lee Wheeler, the earthy tones and matt, gently decayed look of the painted plaster and stucco walls characteristic of old Italian interiors has a special quality that she wanted to recreate in this dining room in London. The particular colour and texture she was after – and commissioned Lauriance Rogier to realize – was that of 'a faded, terracotta pot'. As finding the right table for such a background proved difficult, Lee Wheeler had her own design made up by François Lavenir. This comprises a pair of columns for the base (painted in a shinier version of the wall finish) and a top with a matt finish. The cream-coloured curtains are headed with wide pleats and simply looped back, while the French-style chairs have been painted and distressed by Lauriance Rogier to harmonize with the faded effect of the walls. The rooms leads through double doors to the conservatory/kitchen (see page 139).

■ Furniture is usually improved by being painted and distressed if it is to be used in a setting which is itself 'aged'.

■ Arranging pictures and decorative objects symmetrically gives a finished, restful effect.

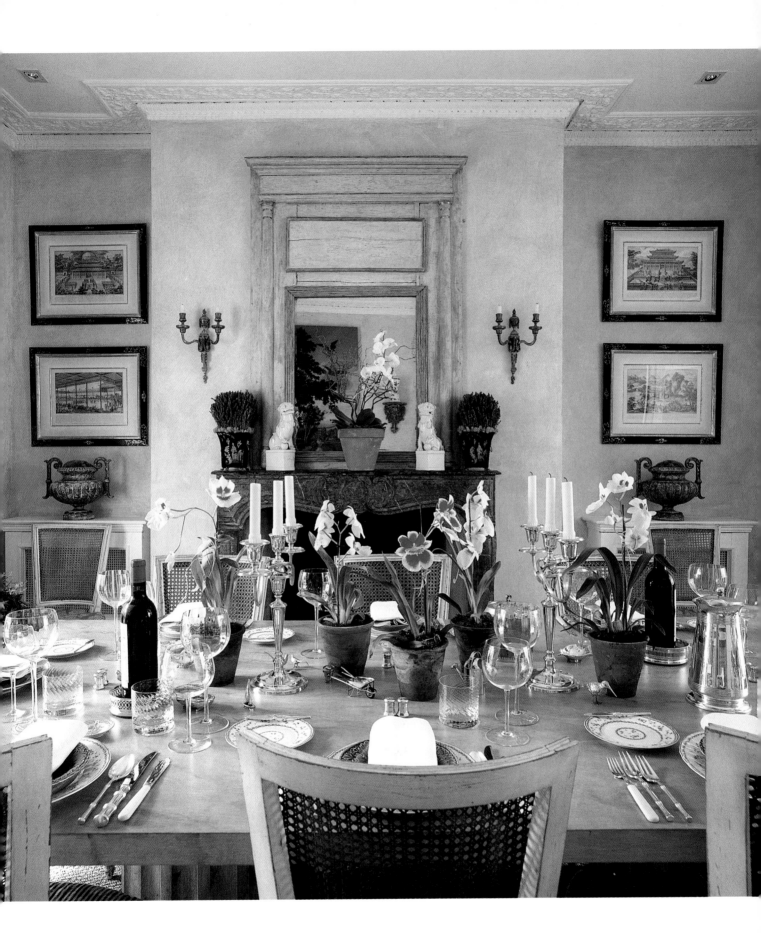

FURNITURE AS ART

With its avant-garde furniture, art and accessories, this room by Elizabeth Delacarte, a Paris decorator who is also a modern-design specialist and patron, achieves the status of a three-dimensional artwork in its own right. Guarded by an African mask, a wide opening leads off the hall into a space bare of pictures except for a large Lanskoy abstract which establishes the pace of the room's colour scheme. The *buffet*, or sideboard, beneath the picture was designed by Thierry Peltrault and has box-like, rectangular cupboards in shades of green, supported on metal legs. On it are glass sculptures by Christina Kirke. The table by Alan Buchsbaum and chairs by Jean-Michel Cornu and Veronique Marcourant are more muted in tone but their angular shapes, springing from the floor, have a lively momentum. The walls of the room have been stuccoed and lacquered in a mix of white, beige and grey to give a neutral background that is less harsh than white and provides a sympathetic foil for the furniture and art. The floor has been treated with a finish which allows the woodgrain to show through.

■ The finishes of the walls and floor provide a neutral, but not bland, canvas against which an interesting collage of modern furniture and accessories is seen to maximum advantage.

■ Within a comparatively minimal interior a patterned rug has something of the effect of a painting.

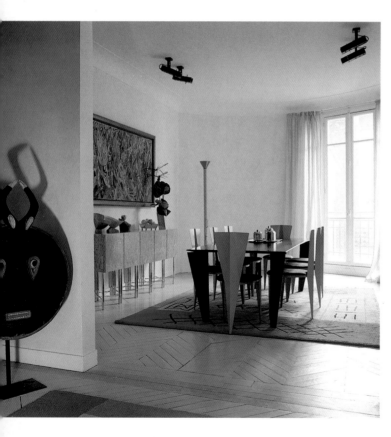

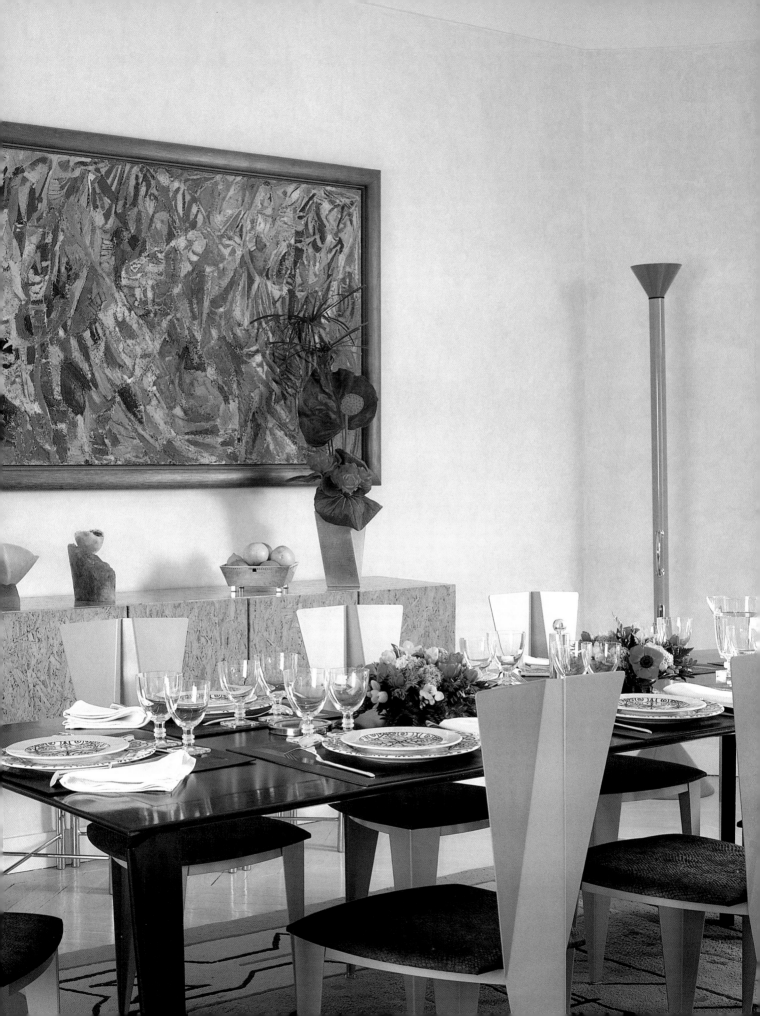

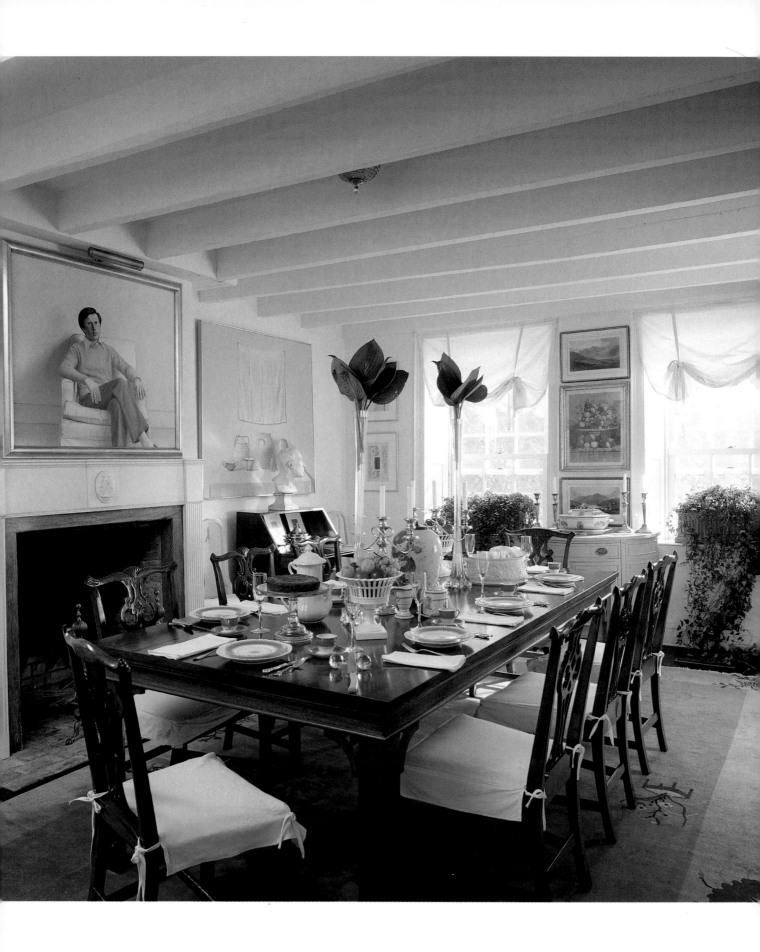

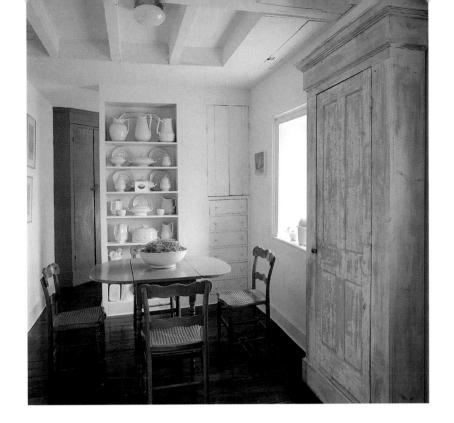

WHITER THAN **WHITE**

Paul Kellogg and Raymond Han are both involved in the arts, though in different areas, and their careers have undoubtedly had a bearing on the decoration of their remote stone house in upstate New York. Both feel a need for calm and simplicity – Paul, because he values an escape from a frenetic role in the world of opera, and Raymond because he is a still-life artist and requires quiet and good light for his painting. The interior of their house has been completely reshaped, transforming uninteresting, poky little rooms with plasterboard ceilings into a white retreat that is full of attractive, unusual features and, above all, relaxing. Some of the first things to be changed were the ceilings: exposing the beams has added height as well as interest. But the really striking hallmark of the house is its whiteness: several shades of white have been used for the walls; there is

a slightly creamy note to the light-filtering duck blinds in the dining room (opposite); and even Raymond's paintings are in a pale palette. The eating area shown above is in fact in the kitchen but its charmingly simple style would also be inspiring for a separate, small, country dining room. It shows part of Raymond's collection of white ironstone which can often be spotted in his paintings, such as the one to the right of the fire in the dining room. The portrait of Paul is also by Raymond.

■ Displaying white china *en masse* against white is unusual and effective.

■ If you cannot find the perfect antique table, than have one made in an antique style. This one in the dining room was taken from a design in Chippendale's *Director*.

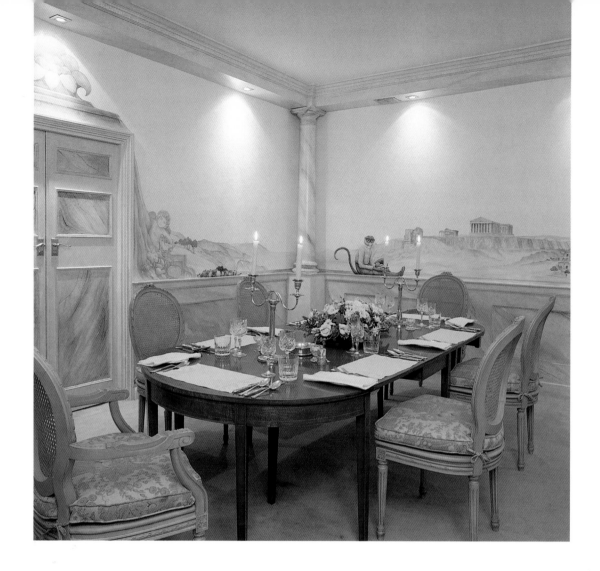

LIVING OUT A **FANTASY**

For artist Phyllida Riddell O'Brien, the way to add a garden to a gardenless flat was to paint a mural depicting a classical landscape. Covering three walls and the ceiling, the mural depicts rolling, Arcadian views with a lake and temple beneath a blue, summer sky. The whole is set within an architectural framework that includes a *trompe l'oeil* wall on which sits a bowl of colourful fruits and a monkey. However, the marbled column in the corner, seen above, is three-dimensional and is one of a pair at this end of the room. At the opposite end, marbling is used on the

door and continued onto the fourth wall, creating a classical loggia complete with an alcove displaying an urn. The Continental spirit of the setting is taken up by the painted chairs.

■ Rather than leave the ceiling white, painting it to simulate sky continues the landscape fantasy of the walls.

■ Painted furniture looks appropriate in a garden-like setting. Canework backs give comfortable support and are less of a visual barrier than solid designs in a small room.

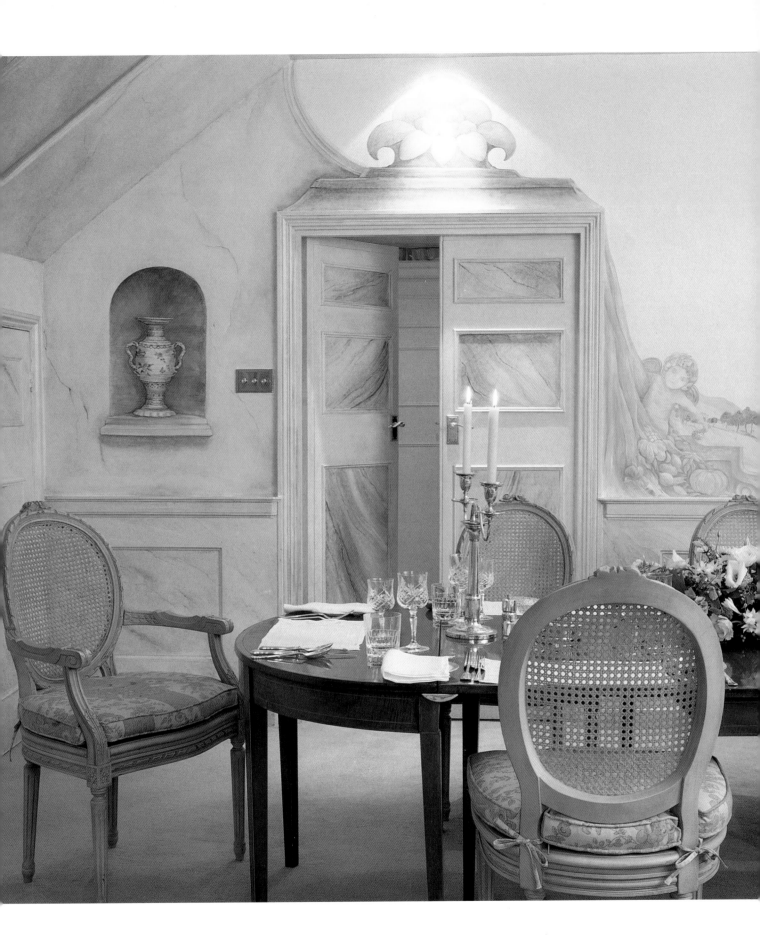

WHERE **TWO** ARE BETTER THAN **ONE**

A dining room with a large table surrounded by a set of close-spaced, matching chairs often generates an overbearing atmosphere, especially when the room is not set up for eating. An alternative arrangement is seen in this penthouse, where Lyn Rothman opted for two circular tables to be used singly or together, depending on the number of guests. When only one table is needed, the second table is covered with a Slavic kilim and displays a colourful still-life of plants, Chinese and Moroccan pots, and African figures. Many of the objects in the room were brought back from travels abroad and have an exotic theme: on the far wall are two nineteenth-century wood figures from Goa and a pair of sixteenth-century Russian royal doors. One of the most notable characteristics of the room is the relaxed tenor: the floor is covered with natural-coloured matting with painted edges; there are several different textiles; and the furniture is a mixture of styles and dates – the seating, for instance, is a combination of eighteenth-century English Windsor chairs and twentieth-century metal ones by Diego Giacometti – but the overall scheme is harmonious, thanks partly to the consistent background. The windows have box frames and openwork panels beneath concealing radiators.

■ Low cupboards across the full width of the room are practical without being obtrusive.

■ Using the same striped fabric on the cupboard doors and walls is an elegant way to integrate storage space.

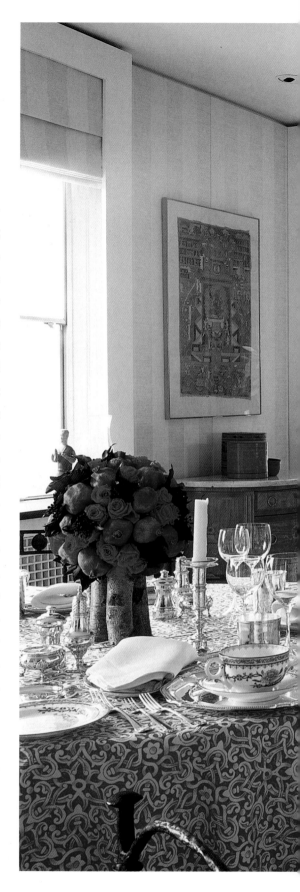

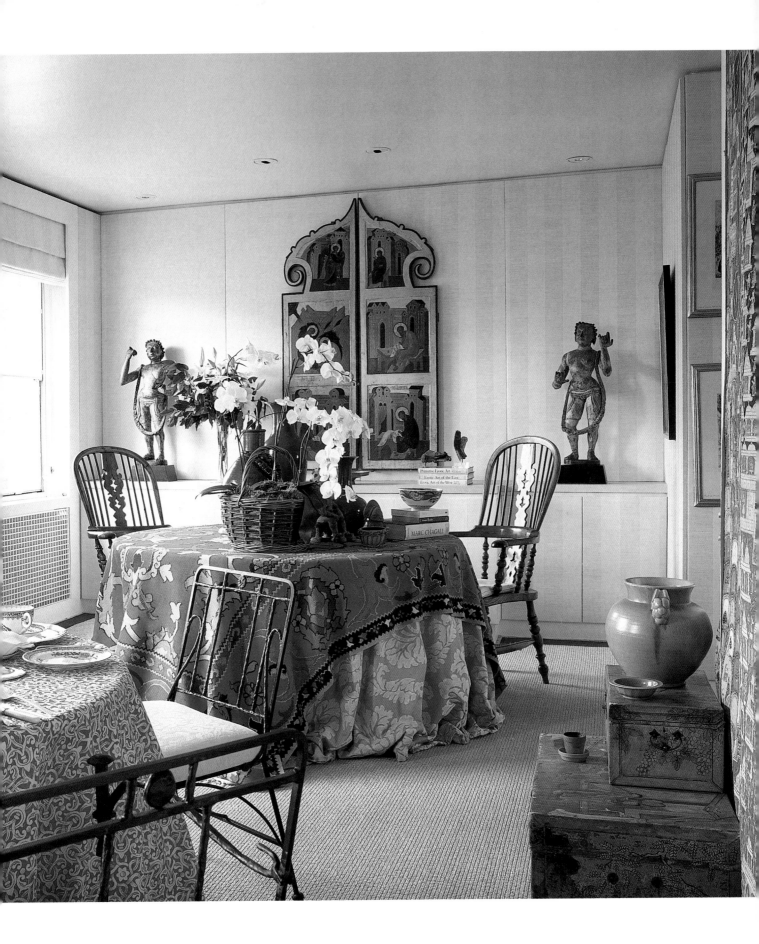

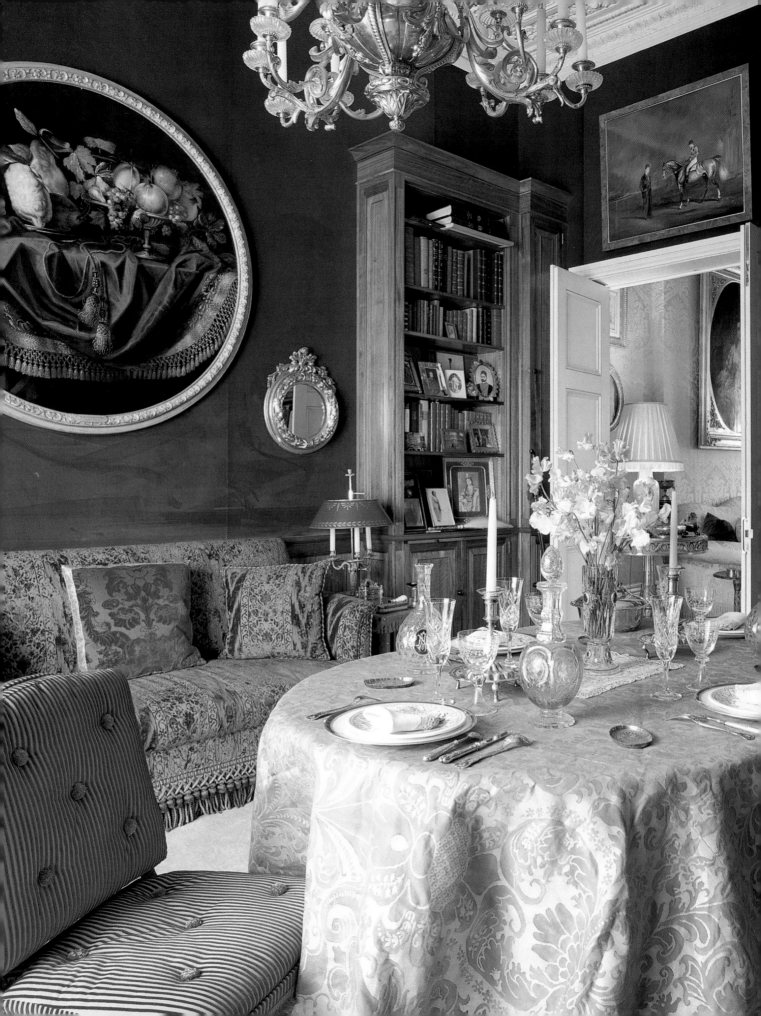

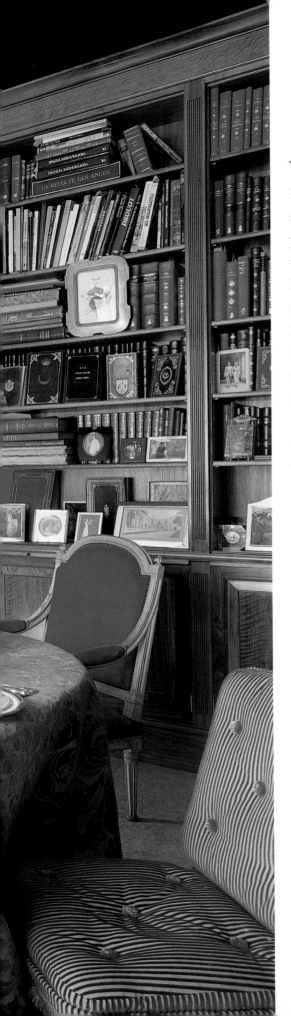

DUAL-PURPOSE DINING-ROOMS

Having a separate dining room is a spatial luxury that is not always achievable. Sometimes, a reasonable-sized eating area can be incorporated in the kitchen, but where greater formality is wanted, a workable option is to twin the dining area with, say, a library or a large hall. The library combination works especially well, as evidenced by the interiors seen at left and on pages 196-197 and 202-203, where the richness of colour and texture suits both roles; it is also seen successfully in the room overleaf, which has an almost monastic simplicity. Simplicity is a linchpin in some of the other rooms in this chapter, particularly in Pieter Brand's scheme (pages 204-205) and Sophy Morgan-Jones's (pages 206-207), both of which combine a dining area and hall. Sophy's is a triumph of skilful planning as it also includes a kitchen. Bernadette Fredet-Morris has been very clever in giving her hall (page 198) the feeling of a room rather than a through-way, by using a handsome French chimneypiece and an overscaled wall-decoration. Wall-decoration of another kind features prominently in the scheme by Sasha Waddell on page 199, where *trompe l'oeil* stonework and urns are juxtaposed with the real thing.

Combining a library and dining area, this room overlooking a London square has an intense feeling of luxury, derived from jewel-like colours and deep textures. The walls are covered with velvet; a glorious damask by Fortuny enrobes the table; and the upholstered furniture is silkily cushioned and buttoned. The grandeur and hospitable feeling of Prince Naguib Abd Allâh's scheme reflects his collecting and cultural interests as well as an enjoyment of entertaining.

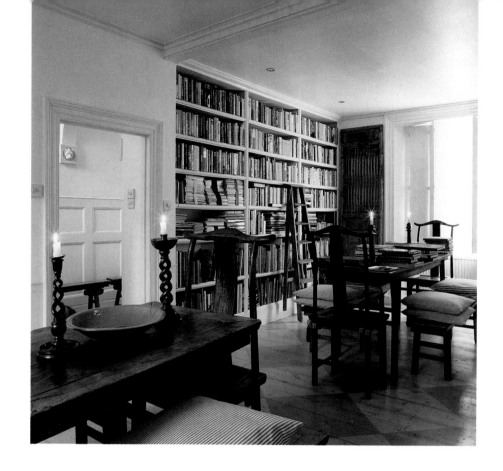

LOOKING TO THE **EAST**

As a sweeping generalization, oriental decoration can be put into two categories: one is heavy and opulent, the other is spare, almost monastic. Mimmi O'Connell used to live in a dark mews house which she fitted out in the former style, brimming with rich colour and texture, but then she moved to a place with lots of natural light and felt it called for a totally different response. The simplicity of her library-cum-dining room sums up her new style, 'signifying a sort of cleansing,' she says, 'a mood that will take me well into the future'. There are two long tables, eight chairs and some basic benches, all of which are antique, peasant pieces from Northern China and typical of the sort of furniture Mimmi sells in her shop, Port of Call, in London. Neither the floor nor the walls are completely devoid of decoration, but you could hardly describe them as elaborate: the floor is painted with a chequerboard pattern and the walls have a *trompe l'oeil* dado echoing the panelling in the hall. There is almost nothing else in the room to introduce extraneous decoration: no pictures, no rugs, no soft upholstery. And yet... the interior emits a chaste luxuriousness.

■ Wood and simple country furniture are the constants in this room, generating a purity of material and design.

■ In keeping with the austerity of the scheme, the chimneypiece is a minimal structure, barely projecting from the wall, so there is no shelf for bits and pieces.

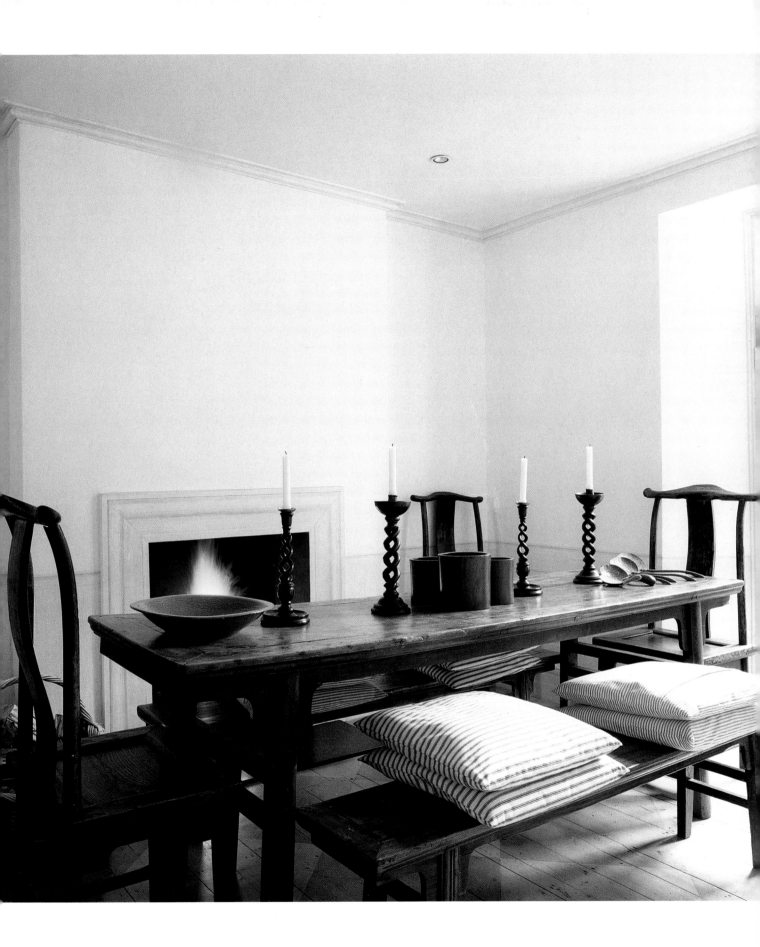

AN ELEGANT CORNER IN **NEW YORK**

No one would guess that this elegant dining room, with its French marble chimneypiece and formal arrangement of shelves, was once a maid's room. It is in a New York apartment which was originally part of a huge triplex – there were twenty rooms – and has spectacular views of trees and river. The triplex had been divided up during the Depression, and when Ambassador and Mrs Angier Biddle Duke moved into it a few year ago, the layout and architectural detailing needed sorting out. One problem the Dukes had to solve in the apartment was where to house numerous books; another was the need for a dining room to cope with frequent entertaining. The room shown here provides the answer to both: a combined library and dining room with generous space for books and an extending table that can seat fourteen. The previous dull interior was gutted; mouldings and bookcases were added; and – a particularly ingenious detail – panels of mirror were installed alongside the windows to double the outdoor aspect. Placing a large mirror between the windows also adds to the light, open effect. Another sophisticated refinement is the concealing of the air-conditioning behind louvred shutters. Two decorative features which underwrite the room are the eighteenth-century French over-door (seen above the mirror), which dictated the room's colour scheme, and, over the chimneypiece, a painting by the late-Impressionist, Pierre Eugene Montezin. Note, too, the interesting treatment (shown at left) of a corner – a space that in many rooms is wasted and boring. Here, converging shelves put both walls to good use, and a circular table covered with a beautiful cloth displays personal memorabilia and photographs.

■ Panels of mirror adjacent to the windows multiply light and external views.

■ Mirror between the windows continues the room's feeling of openness.

■ Visual interest is created in a corner by a paisley-covered circular table displaying massed photographs.

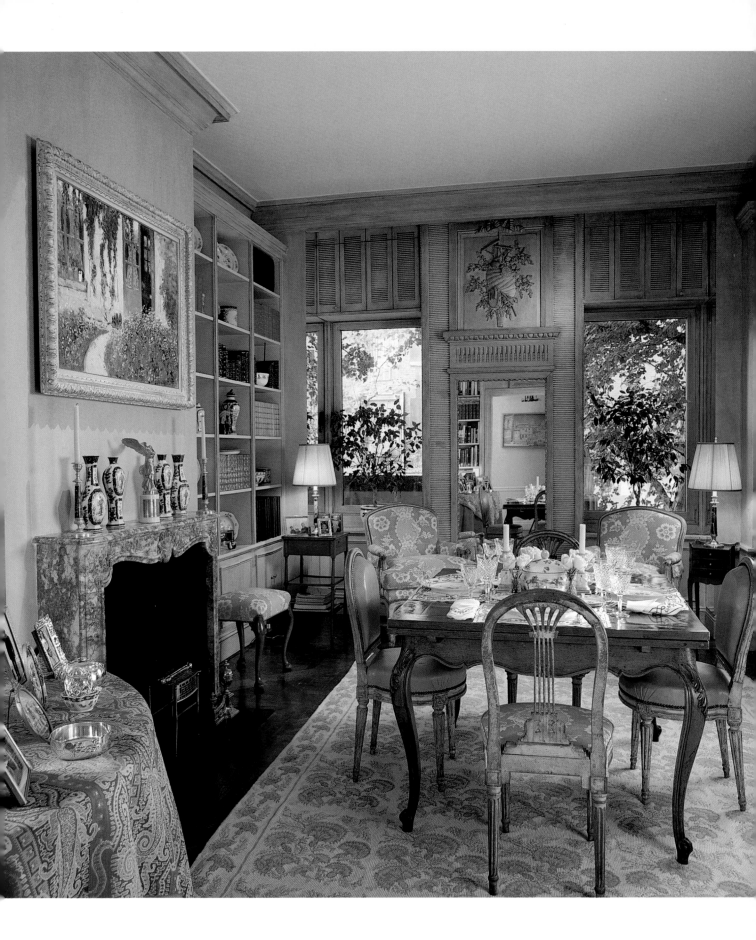

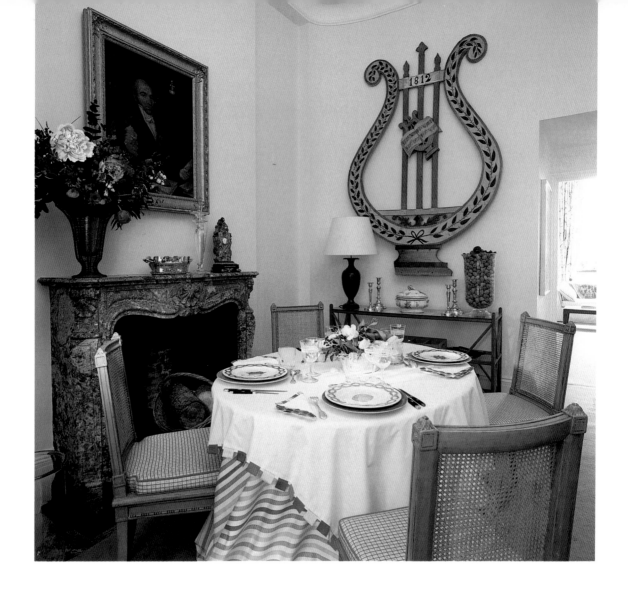

INFLUENCES FROM ABROAD

One of the reasons French interior designer Bernadette Fredet-Morris was attracted by a maisonette in central London was its similarity to the high-ceilinged, mid-nineteenth-century Haussmann buildings she knew when she lived in Paris. As is frequently the case in French apartments – but rarely in Britain – the hall (above) is relatively large, and this gave Bernadette the opportunity to use it as a dining area with a handsome French chimneypiece instilling the feeling of a room rather than a transitory space.

Bernadette likes to mingle objects of different provenance – hence the traditional painting and chairs contrasting with a modern side-table and bright fabrics – and she also enjoys experimenting with scale, exemplified here by the huge 'lyre' on the walls. Probably Austrian, it is dated 1812 and has a wonderfully decorative shape.

When actress Sian Phillips moved from a small house in Islington to a flat (opposite) in Kensington, she wanted a complete re-cast in interior decoration.

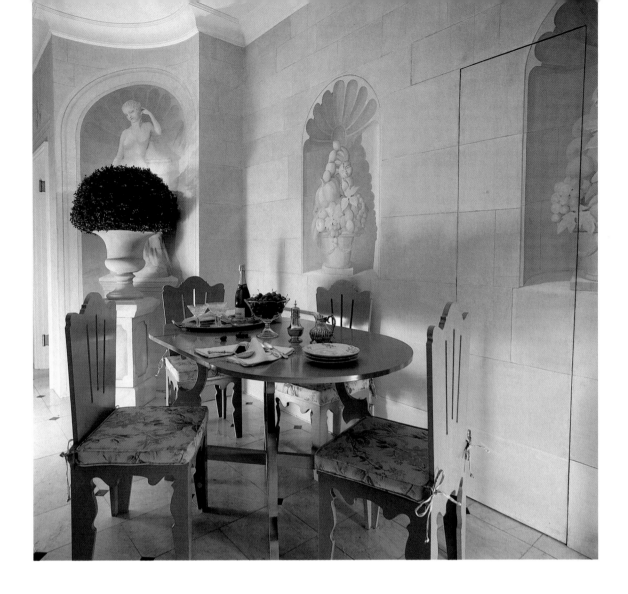

She felt that a more citified ambience was needed in this central location, and, with the help of designer Sasha Waddell, swapped the cottage look for a dressier style. The hall, visually aggrandized by stone-effect paintwork, has *trompe l'oeil* shell alcoves housing a statue and an elaborate pyramid of fruit. In keeping with the architectural treatment of the walls, the floor is hard-surfaced. The Scandinavian-style furniture was designed by Sasha Waddell; the indoor topiary is by Lena Urmossy.

■ A fireplace gives a hall the feeling of a living room.

■ Overscaled objects 'size up' a comparatively limited space.

■ Imitation stonework has an architectural quality that is appropriate for an entrance hall.

■ Juxtaposing real and fake is wittily engaging: above, a three-dimensional urn on a pedestal is seen alongside a *trompe l'oeil* plinth with a statue.

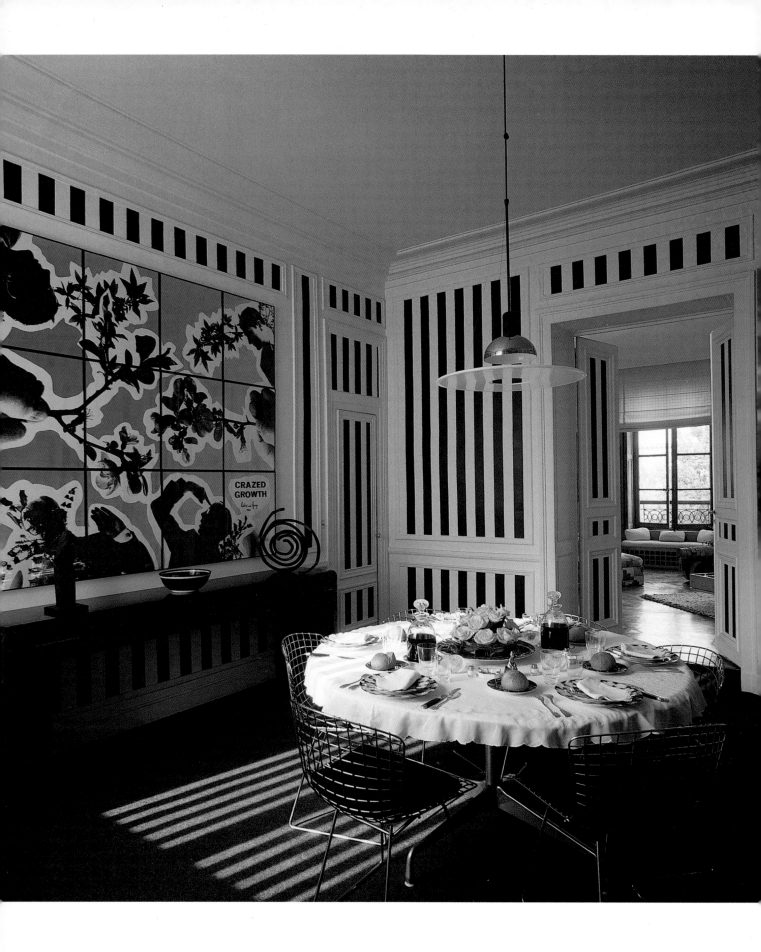

CRAZED
GROWTH

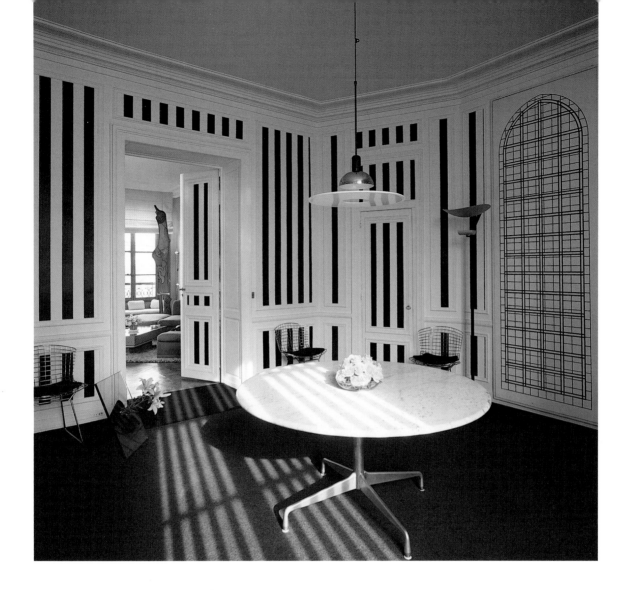

A **GRAPHIC** DISPLAY

This assertive scheme for a hall-cum-dining room centres on the large-scale monochrome painting, 'Crazed Growth' by Gilbert and George, and is definitely not a style for the timid. Black-and-white stripes, resolutely marching across the walls and doors, are clustered in panels defined by the room's architectural mouldings. The blue-grey carpet was specially designed by Patrice Nourissat to reflect the graphic lines on the walls, while the wire chairs, classics of their kind, also have a similarly geometric

distinction. The scheme was designed by Daniel Buren for Gilles and Marie-Françoise Fuchs when they updated their Paris apartment to suit their collection of contemporary art.

■ A disc-shaped pendant light echoes the circular form of the pedestal table beneath.

■ A limited palette and strong patterns work together for a forceful effect.

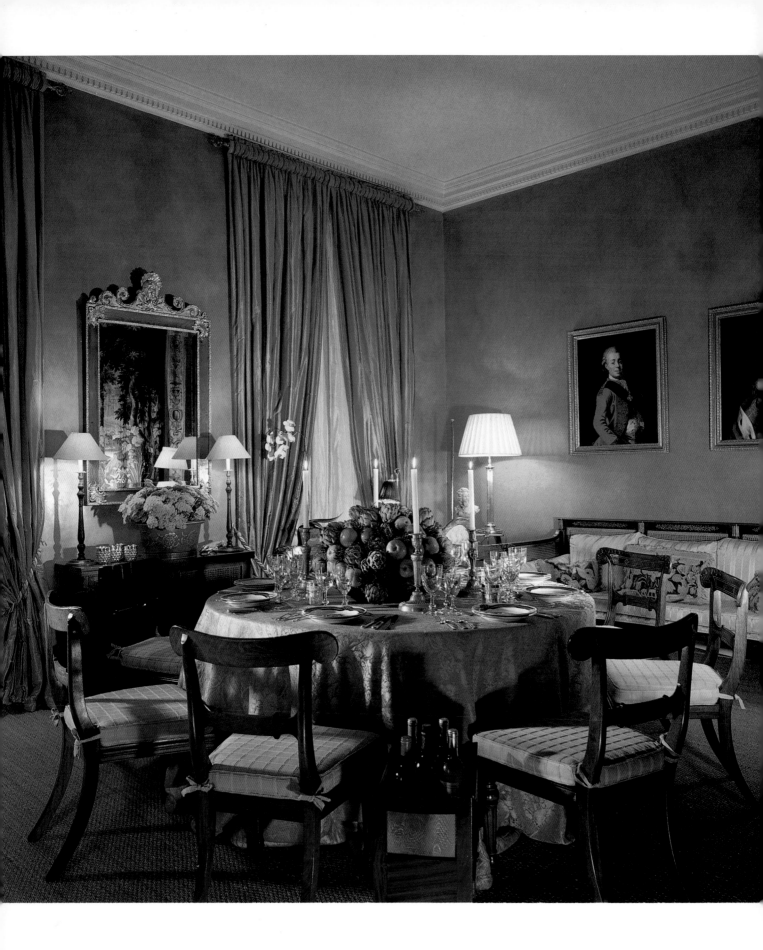

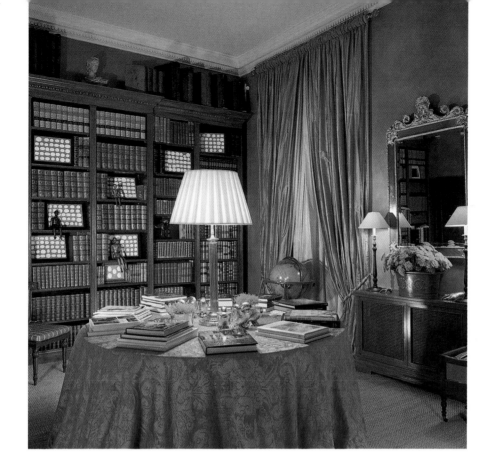

OPULENT COLOUR

Red is a well proven choice for decorating dining rooms. Providing it has a rich, 'rusty' tone, as opposed to a blue tinge, it is an intimate, welcoming colour, imparting a glow which is flattering to people and traditional furnishings alike. This gorgeously dressed room was designed by Lars Bolander for a couple who travel a great deal and wanted a London *pied à terre* that could be used for occasional entertaining. Rather than design a dining room that would have a limited role, Lars Bolander produced a dual-purpose scheme combining the functions of a library and an eating room. Opulent shades of red permeate the entire setting: the walls, striped silk curtains, damask tablecloth, lacquer mirror and book spines are all in the same colour league. When the room is not being used for dining, the chairs live in the kitchen, and the library character takes over, with a black-and-gilt canework sofa, cushioned in yellow silk, providing comfortable seating.

■ Red with a hint of burnt orange, rather than a bluish note, is especially successful at night when candlelight enhances its inherent warmth and throws the room's gold details into high relief.

■ A low table designed to hold wine (seen, foreground, in the picture opposite) is a neat way to keep bottles near at hand but off the main table.

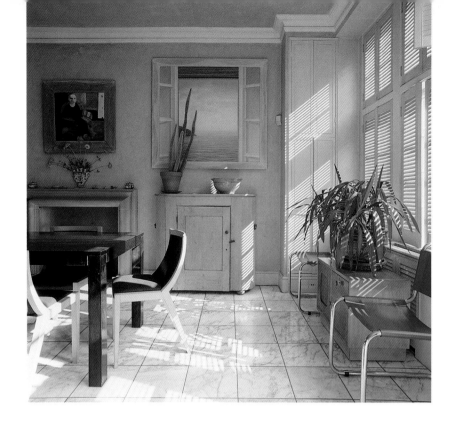

A **PRIVATE** WORLD

City mews houses are appealing in that they combine a tucked-away charm with a central location, but the disadvantage is that they can be dark and overlooked. Pieter Brand encountered both these problems when he took on an urban mews building which, originally, comprised stables on the ground floor and a rather gloomy flat above. As he was able to add to the house another storey which incorporates large areas of glass, he gained plenty of natural light at the top. Lower down, however, natural light was still at a premium – and so was privacy. In the hall-cum-dining room, there was little he could do about the first problem but he could at least deal with being overlooked. His solution was to use plantation shutters wall-to-wall and then continue the louvred panels beneath the windowsill to make a unified expanse. In contrast to the linearity and texture of the shutters,

there is a sleek, black-lacquer table, specially designed and made by John and Stuart Lever, and elegantly curved chairs with limed oak frames. To the right of the chimneypiece is a bleached-and-limed pine cupboard, also notable for its curved form, and a *trompe l'oeil* painting by Nicholas Rea, simulating an outside view – to compensate, perhaps, for excluding the real outlook. The walls of the room are finished with grey plaster, sponged lightly with white, then varnished to give a cool, serene ambience.

■ Continuing the louvred panels beneath the windowsill gives uniformity and the opportunity to conceal cupboards and/or radiators.

■ A marble floor complements the tailored scheme and suits the room's role as a hall as well as a dining room.

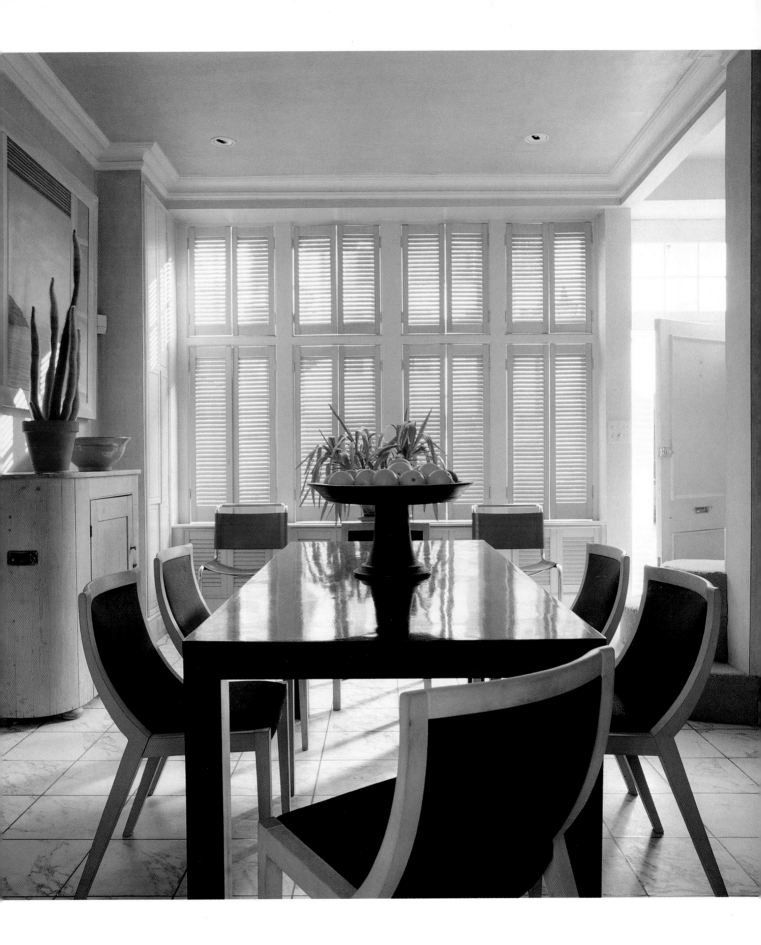

TURNING A CORRIDOR TO **ADVANTAGE**

When Sophy Morgan-Jones was looking for a flat, she had a preconceived idea that she would never choose one in a basement. However, that is what she and her husband Charles Farr ended up getting – chiefly because it offered generous space for the main living areas and, above all, it had what every designer wants to find: potential. As the flat is not a full-time home – the couple also have a house in the country –

Sophy Morgan-Jones felt she could decorate it with what she calls 'an element of fun'. She explains: 'It's almost certainly not the way I'd have arranged it had we been going to live there all the time. And it was not intended to be used frequently for entertaining.' For those reasons she covered the drawing-room walls with a mural evocative of Tuscany and decided to site the kitchen in an L-shaped bend in the expan-

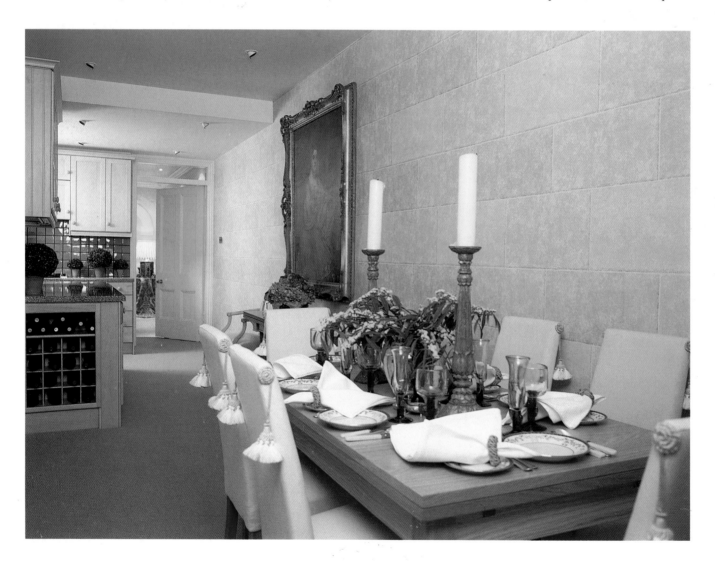

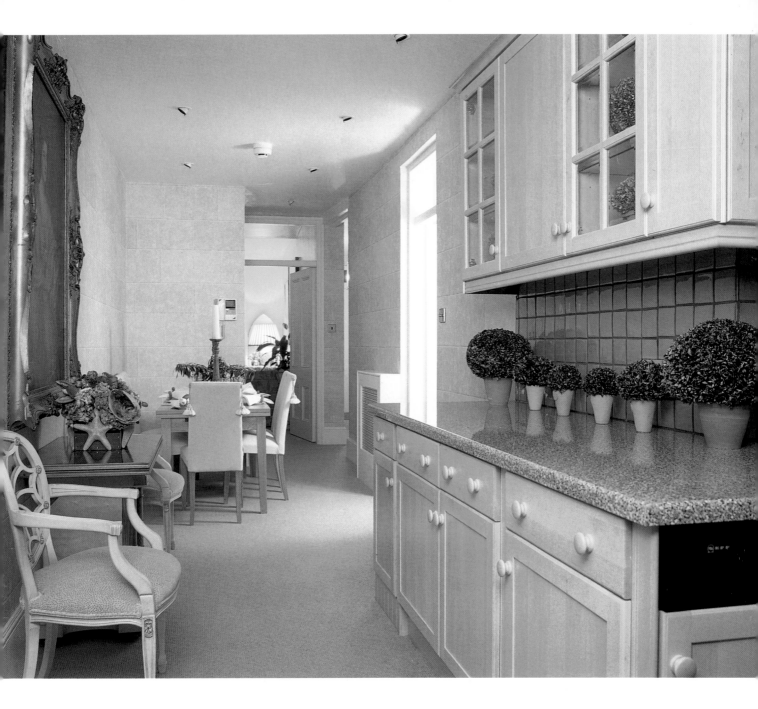

sively proportioned entrance hall. The kitchen is per-
fectly functional but all the necessary accoutrements
are kept behind doors so that there is minimum sur-
face clutter – an important factor, given that the
kitchen is very much on view in this walk-through
site. The dining area is furnished with a simple, rec-
tangular table and six chairs with calico upholstery.
In keeping with the landscape subject of the mural in

the drawing room, the walls in the hall are lined with
a stone-effect wallpaper.

■ Sculptural plants in plain pots are tidy yet ornamental in a
kitchen which, because of its location in a hall, needs to be
orderly and play down a 'kitcheny' look.

■ Tassels are decorative additions to chair upholstery.

Acknowledgements

The photographs reproduced in this book are from features previously published in HOUSE & GARDEN magazine. They are by:

Peter Apprahamian: 28-29, 112-115, 129

John Bassett: 168-169

Tim Beddow: 104-107

Henry Bourne: 10, 20-21

Rory Carnegie: 13, 102-103, 120-123, 134-135

Tim Clinch: 9, 12, 82-85, 98-101, 148-151, 158-159, 174-177

Michael Dunne: 186-187

Andreas von Einsiedel: 38-39, 54-55, 57, 60 (Text & Image), 128, 138-139, 142-143, 164-165, 182-183, 184-185, 204-205

Mark Fiennes: 8, 188-189

Tim Goffe: 94-95

Brian Harrison: 170-171, 180-181 (Text & Image)

Gavin Kingcome: 86-87

Jason Lowe: 61

Simon McBride: 206-207

Robin Matthews: 198

James Merrell: 46-47, 130-133

James Mortimer: 6, 14, 15, 17, 40-43, 48-51, 108-111, 118-119, 126-127, 192-193 (The Interior Archive), 199

Jonathan Pilkington: 5, 116-117, 136-137, 166-167

David Radcliffe: 200-201

Ian Sanderson: 3

Fritz von der Schulenburg: 2 (The Interior Archive), 22-25 (The Interior Archive), 44-45, 58-59, 70-71, 76-77 (The Interior Archive), 90-93 (The Interior Archive), 124-125 (The Interior Archive), 140-141 (The Interior Archive), 144-145 (The Interior Archive), 146-147, 160-163, 194-195 (The Interior Archive), 202-203

Keith Scott Morton: 34-37, 152-153, 154-157, 178-179, 196-197

Christopher Simon Sykes: 11

Tim Street-Porter/Elizabeth Whiting & Associates: 18-19, 26-27, 74-75

Simon Upton: 16 (Text & Image), 30-31 (Text & Image), 32-33, 52-53, 56 (The Interior Archive), 66-67, 68-69, 72-73, 78-81 (The Interior Archive), 88-89, 172-173

Nathan Willock: 96-97

Jeremy Young: 190-191

Elizabeth Zeschin: 62-65

Many of the rooms were originally researched for HOUSE & GARDEN by Lavinia Bolton (Locations Editor), Liz Elliot (Features Editor) and Sally Griffiths.

The following authors were also involved in the features when they appeared in the magazine: Darlene Bungey, Ros Byam Shaw, Stephen Calloway, Caroline Clifton-Mogg, Jonathan Dawson, June Ducas, Lucy Elworthy, Arabella Fitzmaurice, Nick Foulkes, Virginia Fraser, Catherine Haig, Dinah Hall, Anne Hardy, Amanda Harling, Sophie Lund, Nonie Niesewand, Sarah Phillips, Carol Prisant, Dennis Puzey, Caroline Seebohm, Jane Tidbury.